MW00799688

MAKING

VIDEOGAMES

〉

MAKING

VIDEOGAMES

DUNCAN HARRIS & ALEX WILTSHIRE

〉

240 ILLUSTRATIONS

ALEX WILTSHIRE is a writer and consultant for videogames, design and technology. He is the author of *Home Computers* (2020) and the bestselling book *Minecraft Blockopedia* (2014), and the editor of *Britsoft: An Oral History* (2016). Previously editor for *Edge*, he has also written for *Rock, Paper, Shotgun*, *PC Gamer* and *Eurogamer*.

DUNCAN HARRIS is a screen capture artist for videogames, with over a decade of game industry experience. He has created official in-game imagery for titles such as *Tomb Raider*, *Hitman*, *Crysis*, *Minecraft*, *EVE Online* and *The Evil Within*. His clients include EA, PlayStation, Crytek, the V&A and many more.

Front cover – The vast spaces in Remedy Entertainment's *Control* are articulated by the play of light and dark

Back cover – In *Half-Life: Alyx*, Valve Software's artists tell stories with the details included in the world

Page 2 – *Thumper*'s visual abstraction never obscures its core gameplay, since developer Drool ensures every element is distinguished and legible

Pages 6–7 – In *Paper Beast*'s surreal world, natural landscapes and creatures exist against expressions of data and media – from streams of tape reels to red, green and blue pixels

Page 256 – Valve Software's return to City 17 in *Half-Life: Alyx* imagines the impact of alien incursion on the everyday urban environment

First published in the United Kingdom in 2022 by Thames & Hudson Ltd, 181A High Holborn, London WC1V 7QX

First published in the United States of America in 2022 by Thames & Hudson Inc., 500 Fifth Avenue, New York, New York 10110

Making Videogames © 2022 Thames & Hudson Ltd, London

Text © 2022 Alex Wiltshire

Photographs © 2022 Duncan Harris

All Rights Reserved. No part of this publication may be reproduced or transmitted in any form or by any means, electronic or mechanical, including photocopy, recording or any other information storage and retrieval system, without prior permission in writing from the publisher.

British Library Cataloguing-in-Publication Data
A catalogue record for this book is available from the British Library

Library of Congress Control Number 2021938443

ISBN 978-0-500-02314-3

Printed and bound in China by 1010 Printing International Ltd

Be the first to know about our new releases, exclusive content and author events by visiting
thamesandhudson.com
thamesandhudsonusa.com
thamesandhudson.com.au

VIDEOGAMES ARE A VISUAL ART

Though games comprise many other media, real-time imagery provides the experiential heart of playing them. A blazing shotgun, treasure glinting through a waterfall, a bowed knight. Their show of light on the screen is a bridge across the chasm between silicon and the player's mind. Dust motes in a deserted office, a road winding across an open moor, a charging berserker. Look closely and the screen will devolve into pixels, but lean back and these will coalesce into an image that is deep with meaning. A darkened turbine hall, a leaping plumber, a burning sun.

This book captures and reveals the beauty and design behind twelve of the most visually exciting videogames of the past few years. Game development is an extraordinarily complex craft, and the visual thinking that lies behind these examples represents some of the most fascinating decisions that went into their creation. It also unlocks the often-surprising reasons for why they look as they do. Every element of a game is subject to a swirling tumult of ambitions, conventions, problems, considerations and compromises, and all these factors converge when it comes to something as critical as visual art.

Game artists often dedicate themselves to specific visual fields, such as lighting, character modelling or environments, but the huge endeavour of building everything that goes into rendering a single frame touches all development disciplines at some point. Writers will help to conceive the world, articulating the stories that explain what it looks like. Concept artists will visualize those ideas, building on them further as they paint and draw. Sound designers will decide what this world sounds like and underscore its emotional character with music. Game and level designers will construct its spaces and write the rules that govern what happens within them. They'll also take part in the grand negotiation between what looks good and what plays well. And with them all work the programmers, who will prepare and fulfil the technical foundation for the entire team's ambitions.

Even the most mundane object in a scene – such as a teapot sitting on a kitchen surface – is subject to a vast number of considerations. Does its style and condition fit the setting? Do its material qualities sit well in its environment? Should the player notice it, or only see it as part of the backdrop? Do its textures and other assets take up an appropriate proportion of the console or PC's memory and rendering budget? Do the art director and the creative director like it?

But beyond the work of visual design in games, there's the magic. At root, game graphics are a project in synthesizing our perception of reality, and their object is to make us understand and believe in a space enough for us to want to play in it. It's not necessarily about realism, though many games take that approach. Instead, it's about establishing consistency and clarity, so we know what we can do in the world, what it wants us to achieve, where the limits lie, and how it responds to our presence. Visual design is also about inspiring emotions, stimulating us into action, pulling us into and through a story, helping us to understand the motivations of the character we're playing.

All these things work in parallel to help transport us into a game world, and they often lean on our natural ways of seeing. Think about the first-person perspective and how it mirrors our visual experience of being in our real bodies. Think about the way games represent our eyes adjusting as we open a door to the outside from a dark room by flooding the image with brightness, and how the view bobs up and down as if our legs are moving. But also think about the visual effects games use that are often lifted from film: depth of field, vignetting, lens flare, film grain. Videogames are fictional, and their makers know that trying to replicate human vision too closely tends to make them feel unreal, laying bare their artifice and flaws. They also know the power of telling stories in the way we're familiar with being told them: through cameras and framing, cuts and edits. It was not by cute accident that *Super Mario 64*, as an early 3D game, explicitly characterized its virtual camera as a videographer flying on a cloud.

A common word used to describe videogames is 'immersive', which is often interpreted as being the ideal of enveloping us in alternative existences. Partner to that idea is the assumption that it's the destiny of videogames to achieve realism. But realism is a subjective thing, the product of many decisions and assumptions on the behalf of both maker and player. Games are impressionistic, setting out to capture the sense of a recognizable reality with just a few brushes of light and texture: a reflection on a polished floor, dappled shadows gliding across a character's shoulders. Similarly, immersion reflects a limited appreciation of what games are really trying to do. Few games are setting out to make us believe so much in their experience that we forget about the real world. The reality of the unreality of games is that we play with a foot in both worlds, quite aware of the boundary and shifting our weight between the two as we like. Games facilitate and play with that fact, whether in a tricksy, winking way like *Metal Gear Solid*, or simply by letting you pause the action.

Instead, games are usually trying to disappear. They don't want you to be distracted by things they're not trying to convey. The lucidity of 2D platformer *Spelunky*'s visual design, which pushes the background into the shadows and features outlines around every foreground element, is intended to highlight the way its world works, helping you understand the ways its many enemies, traps and objects behave and interact together. In comparison, *Red Dead Redemption 2*'s heightened naturalism, by way of the Hudson River School of Art movement and a minute level of detail, wants to push its world to the front of your attention and downplay the thousands of systems that govern it. Visually, both are beautifully designed.

Keeping the special thing about a game at the forefront of the player's awareness is a difficult thing to do in a medium that has to teach you so much about how to use it. Quite apart from the nuts and bolts of learning to use a gamepad or a mouse and keyboard, and remembering which button does what, from moment to moment a game's visual design has to tell you about the options available to you, the dangers that are closing in, where to go next, what's happening, and why. Game artists and designers use many subtle tools to guide players, often crafted from the substance of the world. Lighting can highlight the way to go, movement can direct the eye. Distant landmarks can be given a sense of importance when they're framed by a window or tree branch. Tricks of perspective can be used to delineate places where the player can go.

This is all to say that the visual design of games is a tightly sprung combination of function and form. Every element, no matter how apparently inconsequential, is doing something; many of them are performing several functions. Nothing is wasted: the economics of game production, whether the render-time budget or the financial one, simply won't allow it. The visual design of videogames, then, is product of a bewilderingly dense set of creative decisions. The twelve games in this book set out to describe some of those decisions, with screenshots by capture artist Dead End Thrills which show their results. Each game reveals a facet of visual design in games today, cemented by insights from some of the principal figures who made them.

We start by examining three games that exemplify the building blocks of modern visual design. *Hardspace: Shipbreaker* is a model for the art of textures – the 2D images which are wrapped around the geometry of a game world. Textures are the source of colour and detail, and in *Shipbreaker* they were vital to building the theme and the credibility of its setting. A second foundation of visual design is lighting, and in *Control* we'll see how it articulates its spatial volumes and conveys the qualities of surfaces in precisely the same way it does in real-world architecture. Lighting in 3D games is rarely recognized for its profound impact on the way a game looks, but with the advent of new technology like *Control*'s global illumination and ray tracing, it's only becoming more important. The third is the shader, the elemental mathematics that transforms pixels and produces many of the beautiful effects games use today. Shaders directly generate a large proportion of *Paper Beast*'s surreally material world, and they show the expressive creativity and imagination that maths can unlock.

We next look at three games which express how specific visual elements of games were created. *No Man's Sky* explores further the idea that mathematics can have a hand in creating visual experiences. Here, sets of algorithms procedurally generate landscapes and patterns of flora and fauna across a galaxy of countless planets, so many that *No Man's Sky*'s developers don't know precisely what they'll find as they explore – and yet they know broadly what to expect because they designed the systems that generated them. We follow the creation of Amicia de Rune, the player character in *A Plague Tale: Innocence*, whose journey from noble daughter to desperate survivor is expressed in every

aspect of her design, from her costumes to her animation. Then we turn to ZA/UM's *Disco Elysium*, in which the story of the world is wordlessly expressed through its environment art, which was drawn and painted in a two-way conversation with the game's writers.

From there we explore the creation of three very different visual styles. The first is highly stylized: *Return of the Obra Dinn*'s striking art direction was in part conceived as simple enough that a lone developer could realize it on their own. The truth wasn't so easy – it took hard work, technical invention and a little compromise to make it work, but the result is both personal and surprisingly expressive of its period setting. In *Grid* we turn to what would seem to be the opposite: a game about capturing the realism of the racetrack, complete with licensed cars. But instead, it reveals the conversation that exists between realism and stylization, because even attempting to depict the real world is an act of interpretation. And in *River City Girls* we see how modern technology and pixel graphics come together to celebrate the arcade brawlers who inspired it, and how honesty of intent and a little vision can faithfully represent a form no longer held back by the severe technical limitations that first shaped it.

Finally, we look at three games which bring together many facets of visual design into cohesive wholes. *Thumper* is a game with incredible frame-by-frame attention, where its visual effects are tuned to creating its unique flavour of 'rhythm violence', in which every button-press and every sound is an emotional act. With *Half-Life: Alyx* we see how designing environments for virtual reality imposed stern – and surprising – challenges, even for veteran artists of the legendary *Half-Life* and *Half-Life 2*. When a player is made to be part of a game world, many of the principles that they learned for flat-screen games simply didn't apply any more. And in *SOMA* we discover the art of designing horror for a first-person perspective. Here, the potential for delivering fear knows no limit, if only players can be trusted to be looking the right way. Frictional's careful management of player agency highlights the way games are ultimately a partnership of player and developer.

This book can't attempt to encompass all the invention and design that go into making art for games today, nor all the technical principles underlying it. But these insights reveal the deep thinking behind worlds that look alive.

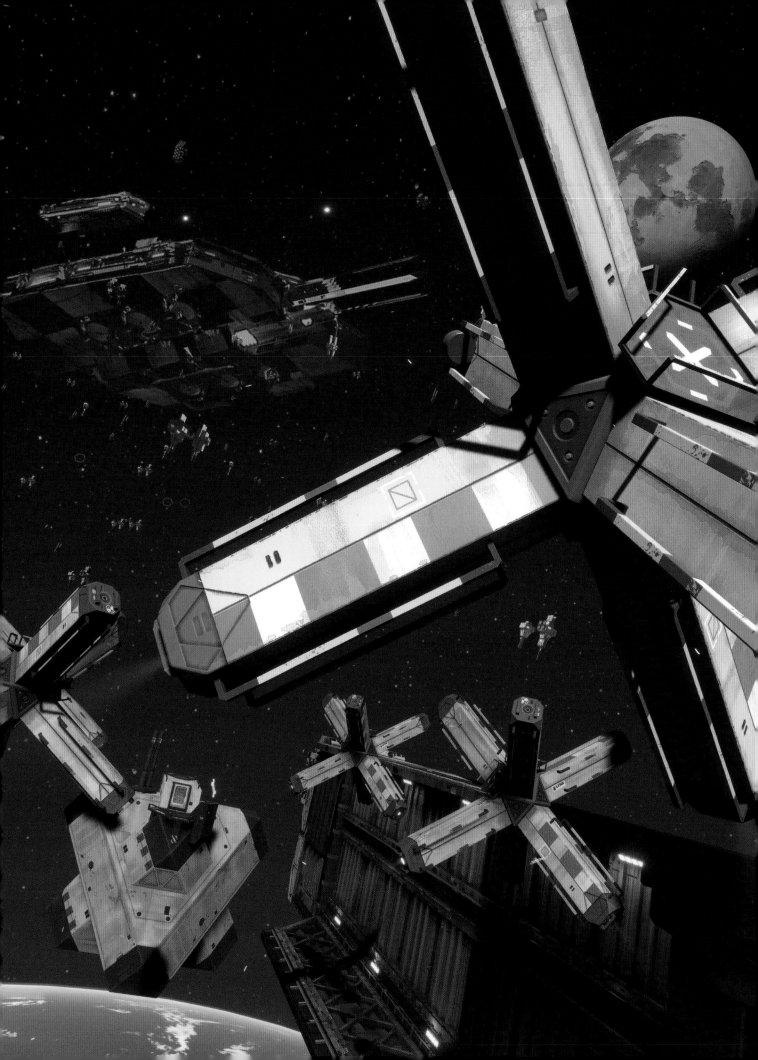

MAKING SPACE-
SHIPS →

1

DEVELOPER BLACKBIRD INTERACTIVE

YEAR OF RELEASE 2020

PLATFORMS PC PLAYSTATION XBOX

HARDSPACE: SHIPBREAKER

GAMES RARELY PORTRAY THE DIRTY NUTS AND BOLTS OF SPACESHIPS, INSTEAD PREFERRING TO FOLLOW THE HEROIC DRAMA OF FIGHTERS AND CRUISERS IN ACTION. BUT *HARDSPACE: SHIPBREAKER* PUSHES THE INDUSTRY OF SPACE TO THE FORE. IMMENSE AND AGED VESSELS HAVE BEEN HAULED INTO ORBIT AROUND EARTH SO THE PLAYER, A SHIPBREAKER, CAN DISMANTLE THEM FOR SCRAP. EVERY PART CAN BE CUT INTO PIECES WITH A SERIES OF LASER CUTTING TOOLS AND THEN PUSHED IN ZERO-G TOWARDS AN APPROPRIATE COLLECTION POINT FOR A CUT OF ITS SCRAP VALUE.

Developed by Vancouver-based Blackbird Interactive, which was founded by the creators of hard sci-fi strategy series *Homeworld*, *Shipbreaker* emerged from an internal game jam as a game about grappling between asteroids to mine ores. It seemed a perfect small-scale commercial project for a sub-team to develop. They turned for thematic inspiration to Alang on the western coast of India, where cargo ships are driven onto a wide beach and broken down by hundreds of workers who constantly risk injury and death.

In *Shipbreaker*, the player is bound into perpetual service for the Lynx Corporation. Hire of tools, oxygen and fuel refills – and fines for sending components to the wrong collector – cut into wages, which are re-invested in upgrades that see them work more efficiently. All the while, the player risks radiation, cutting into explosive hazards, reactor meltdowns, and running out of air. The game becomes a commentary on industrial servitude, and one which hinges on *Shipbreaker*'s sense of physicality: the scale of the hulk around the player, the weight of the hull panels they cut from it, and the materials from which they're made. ▒

▶ **Waste disposal**

Shipbreaker's world is skinned with textures which impart what they're made from, their function and, through damage, their history

◀◀ **Interplanetary**

The dock is in orbit around Earth, which gives a sense of orientation in zero-G. Distant ships lend an awareness of shipbreaking's place in this science-fiction world

PROCESSOR

02 03 04 05

05 04

The fantasy of 3D game worlds is expressed through an infinitely thin skin of colour and shading that coats every surface and object. These textures, which in the early days of 3D real-time graphics were a simple 2D image wrapped around a 3D form, bring substance to the mathematics of polygons, allowing artists to grant them a sense of history and identity through imagery of paint and scuff marks, mud and moss, metal and wood. *Hardspace: Shipbreaker*'s textures explore what the everyday experience of industrial work in space might be like.

Shipbreaker's materialism is not about photorealism, however. Its visual direction was informed by *Homeworld*, which was developed in 1999 by Blackbird Interactive's founders and established a similarly hard sci-fi fantasy through painterly cutscenes and texturing. *Homeworld* evoked the work of classic sci-fi artists like Chris Foss and Peter Elson, who from the 1970s envisaged a strikingly colourful yet hulking physicality for spaceships. So would *Shipbreaker*, guided by concept designer Brennan Massicotte, aiming for a digital speed-painted look which preserves live drawn edges and can involve photo-bashing – compositing photography into the image to achieve quick, realistic results.

WITH *SHIPBREAKER* WE WERE TRYING TO GET A BLUE-COLLAR ENVIRONMENT, LIKE *COWBOY BEBOP* AND SOME CYBERPUNK STORIES – THAT EVERYMAN VIBE. WE ALSO WANTED AN INDUSTRIAL SCI-FI VIBE, SO WE DIDN'T WANT ANYTHING TOO *STAR TREK*, TOO GLOSSY, TOO MAGICAL WITH THE TECHNOLOGY. WE WANTED IT TO BE QUITE UTILITARIAN AND TO HAVE A STORY TO IT, SO IT'S WORN AND HAS AN IMPLIED FUNCTION.

> CHRIS WILLIAMS, ART DIRECTOR

◀ **Scan lines**
The Cross-Spectrum Scanner allows you to see through the ships and highlights hazards and valuable salvage, so you can plan your cuts accordingly

NO MATTER HOW BASIC AND FLAT THE TEXTURE LOOKED, YOU COULD FLY RIGHT INTO AND SMACK YOUR FACE ON THE PANEL AND – WE CALLED IT THE DETAIL SHADER – WOULD KICK IN. EVERYONE IN THE ROOM WOULD GO WHOA! BECAUSE AS YOU CAME UP TO IT, IT WOULD BLEND IN AND ALL THESE ROUGH PAINTSTROKES WOULD APPEAR, AND WHEN YOU FLEW BACK IT WOULD GO BACK TO THE MEGA-BASIC LOOK.

> CHRIS WILLIAMS

For this style, textures were everything. The team renounced physically based rendering, or PBR, which simulates the way light reflects from different materials, so that metallic objects gleam, stone looks rough, leaves are translucent, and scratches show up as light shines across surfaces. Instead, leaning into the ethos of digital speed-painting, Massicotte would paint directly on to the top and the side view of the ships, allowing him to control the expressive simplicity of every surface.

Massicotte and art director Chris Williams were proud of what they'd created. And then came disaster. *Shipbreaker*'s small and budget-constrained team realized these beautifully handcrafted ships were each taking three months – far too long – to build. They needed a way of creating many more ships for players to take apart. The solution was clear: rebuild them from modular blocks, so the game could generate countless permutations of a couple of different ship types.

▶ **Hull breach**
As you fly closer to the painted hulls of the ships, paint strokes will begin to appear on their surfaces, supporting the expressive layers of wear and rust visible at a distance

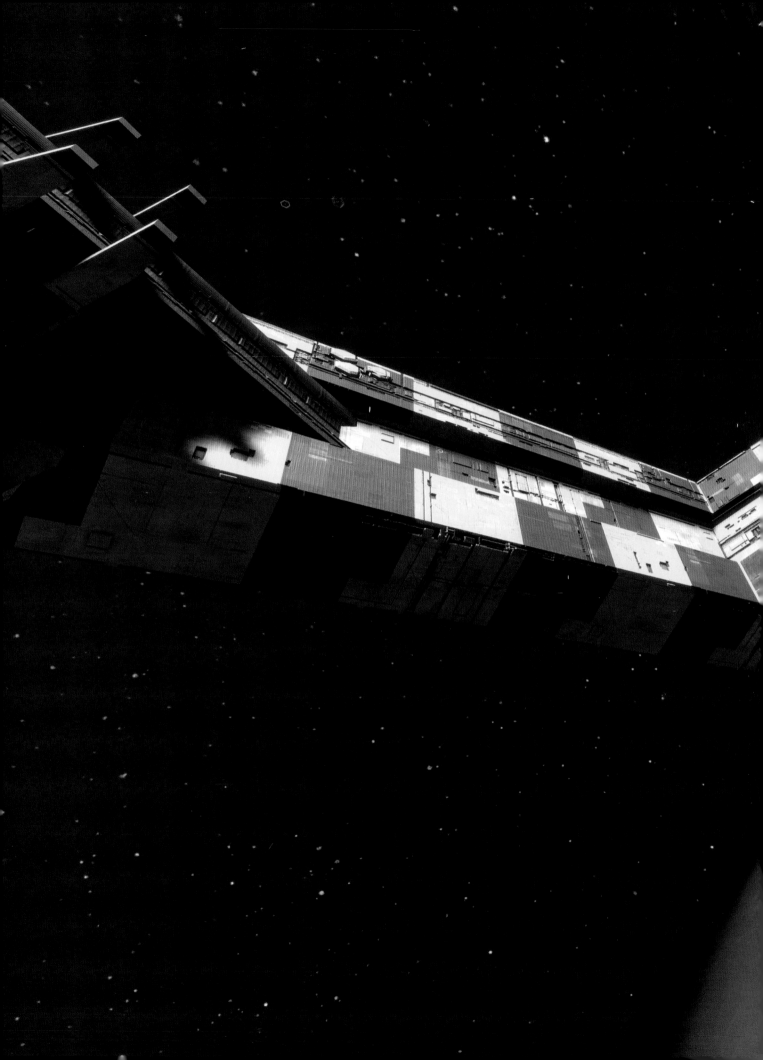

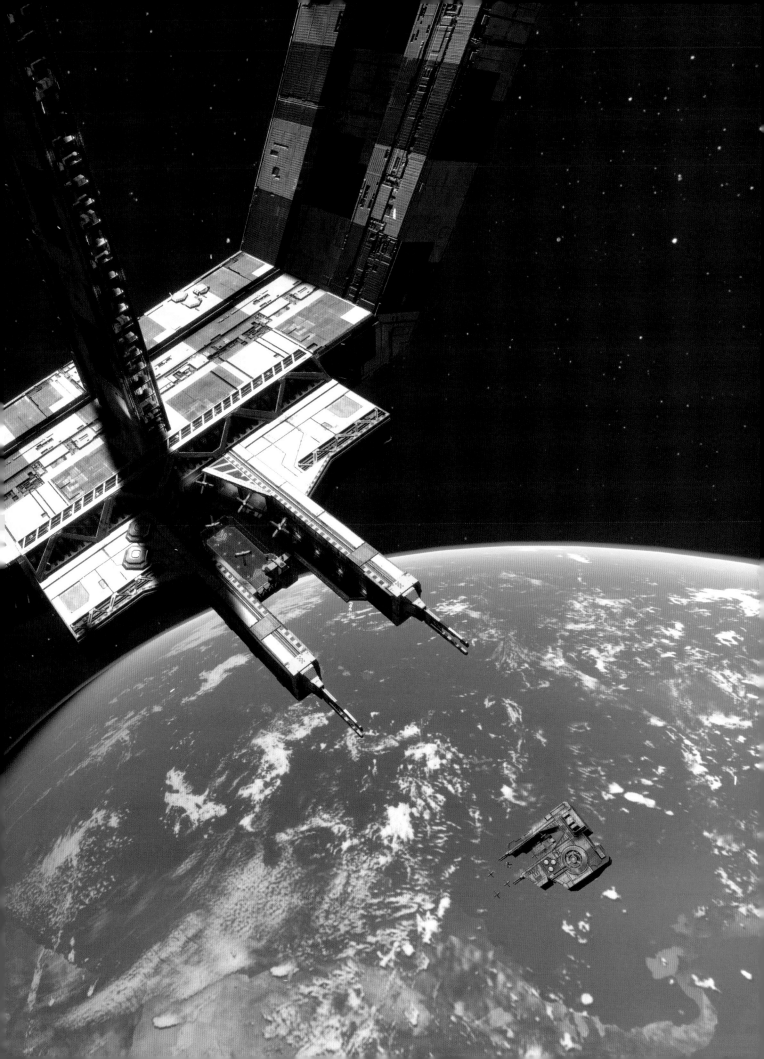

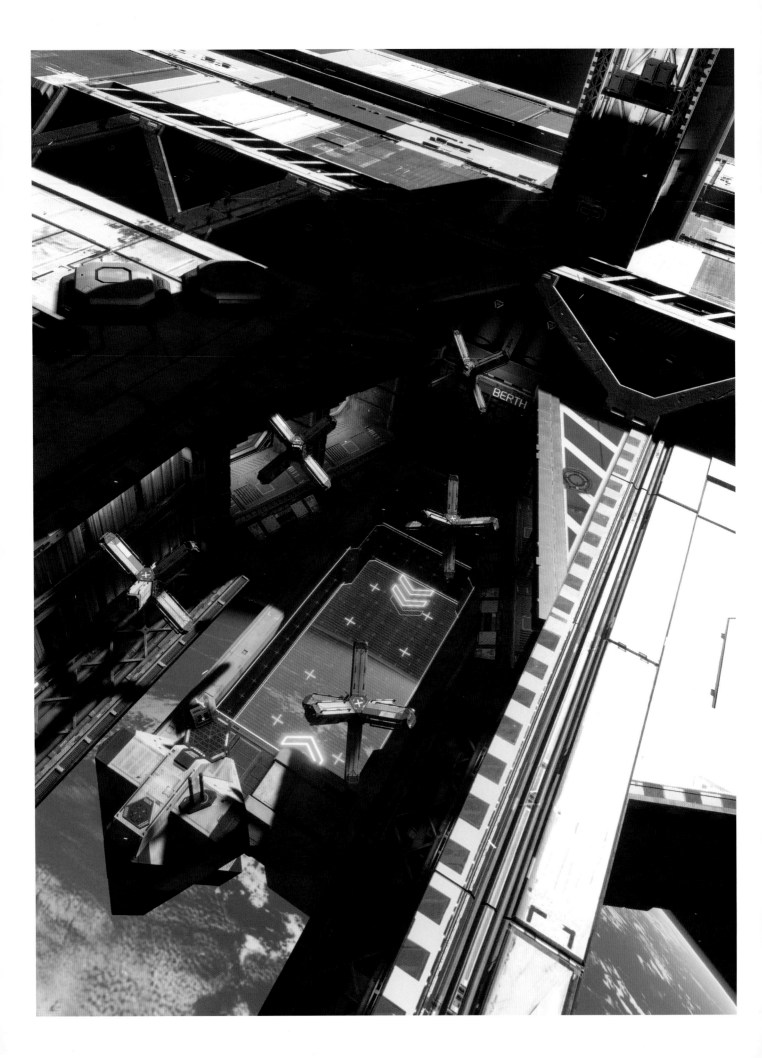

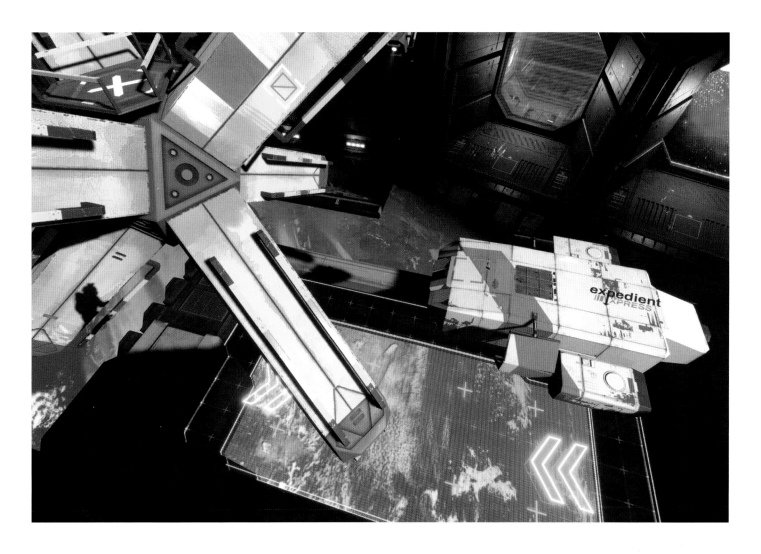

◀◀ Scale model

In space, it's very hard to impart a sense of scale. The dock's surrounding superstructure is vital in setting the bounds of the play space

◀ Docking procedure

The breaker's yard is just a tiny part of the dock's overall structure. Large objects hang at the edges to further bound the space

▲ Shipping lane

The game features several classes of ship. The Mackerel is its smallest, a shuttle designed for light freight and transit

The entire art workflow had to be thrown out. Rather than detailed and unique, the ships suddenly looked like unfinished office buildings, or cereal boxes, betraying the repetitions of the modular blocks that comprised them. The change was hard on the team. They had to figure out a way of adding texture layers of decoration, grime and wear to the ships to mask their Lego-brick nature.

The result is a system which paints a ship with texture sheets after it's generated and just before you start to play. To avoid breaks and sheering as the sheets are wrapped around the ship, the system uses triplanar mapping, which applies them at three different angles. Parts of the hull will receive a Chris Foss-like chequerboard pattern; a rust texture sheet is sprayed across others; metal is exposed on the edges of panels so they look worn.

To avoid the human eye's effortless ability to notice visual repetition, the team used a mathematical function called Perlin noise to disrupt the texturing, all vital to fabricating the sense that you're working on vessels that have lived long lives and are now ready to be scrapped.

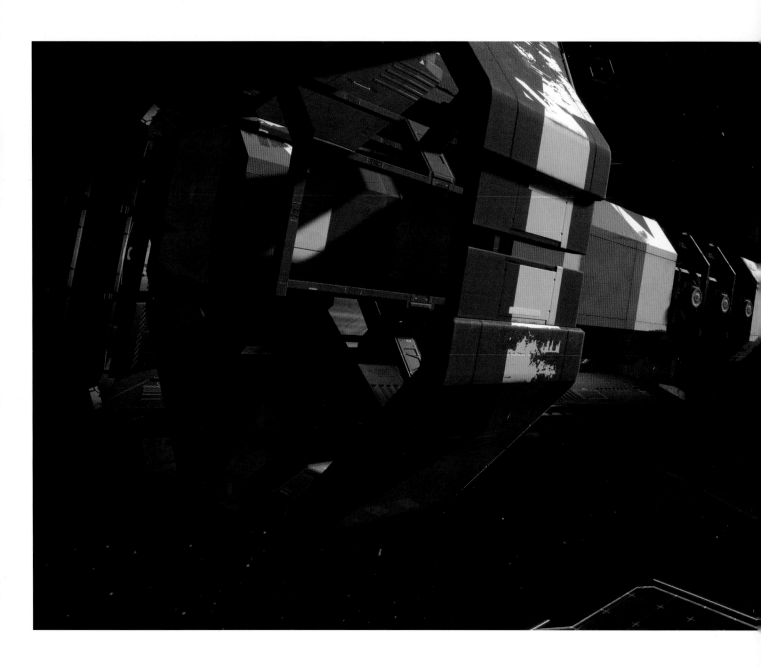

WE WORKED WITH OUR TECHNICAL ARTIST, KARL KENT, TO CREATE A RECIPE THAT WOULD TAKE NOISE, FILTER IT, LAYER IT IN DIFFERENT WAYS, AND VERY EXPRESSIVELY SPLATTER IT OVER THE SHIP, GENERATING FLAVOURS OF LIGHTLY AND HEAVILY RUSTED SHIPS. WHEN WE STARTED TO BE SURPRISED BY WHAT IT WAS PICKING OUT, THAT'S WHEN WE SAID, OK, WE'VE GOT SOMETHING HERE.

> BRENNAN MASSICOTTE, CONCEPT DESIGNER

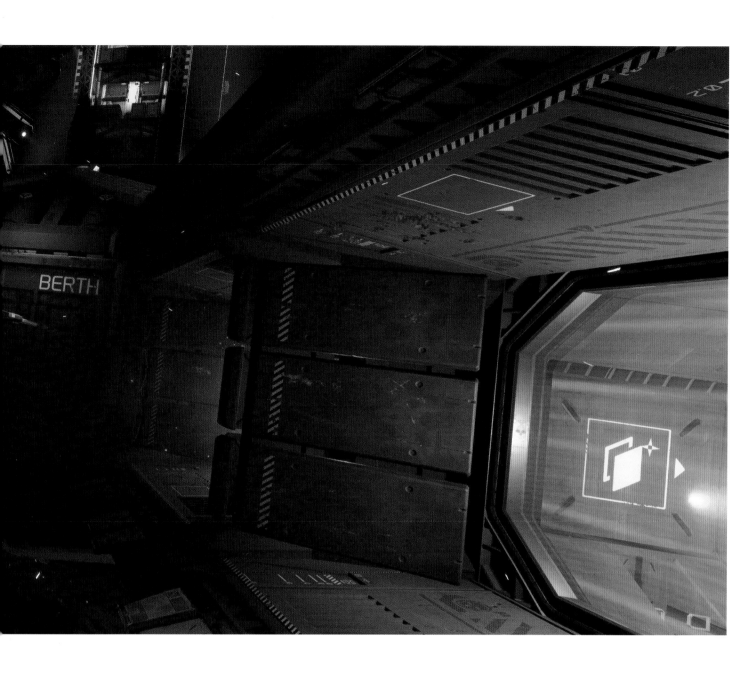

▲ Panel beating

Shipbreaker generates the patterns of wear
and rust on a ship as it loads at the start of
a play session, so they're always different,
just as the ships are always different

At close range, the ships have to become a series of components and panels that can be cut apart; again, textures play a leading role in selling the fiction. The team carefully introduced PBR effects, a response to the requirement that scenes be dynamically lit so that sliced pieces cast shadows and reflect light as they slowly rotate in zero-G. PBR is usually used for photorealistic image-making, but for *Shipbreaker* the team used it to reinforce the stylized approach they'd initially adopted, placing brushstrokes in roughness maps so they're revealed as light reflects off a surface.

Every object also had to look like it has an identifiable purpose as part of a spacefaring vessel, with cabins and fuel storage, superstructures and cockpits. And to sell that purpose, when you cut into them, they needed an interior, a nest of wires and components which would make them believable. But most objects were generic and modular so the game could assemble them into a generated ship: they couldn't be given unique interiors. The team needed a one-size-fits-all solution.

FOR A REALLY LONG TIME, THE PANELS LOOKED LIKE FOUR-INCH-THICK SOLID PANELS, ALL JUST MASSIVE HUNKS OF METAL THAT WEREN'T TELLING YOU ANYTHING. SO WE STARTED TO DEVELOP THIS LOOK FOR THE INTERIOR OF THE PANELS TO GET PEOPLE BOUGHT IN: 'OH, I REALLY CUT A SPACESHIP PANEL.' IT HAD TO LOOK LIKE IT HAD COMPONENTS IN THERE, SUBSYSTEMS.

⟩ BRENNAN MASSICOTTE

⏶ Pattern match

Ships are painted with chevrons and chequerboard patterns inspired by sci-fi illustrator Chris Foss, their clean lines roughened by rust and wear

⏷ Cut above

As you slice through panels, textures on their cut edges show that they're not simply solid metal but credible pieces of space engineering

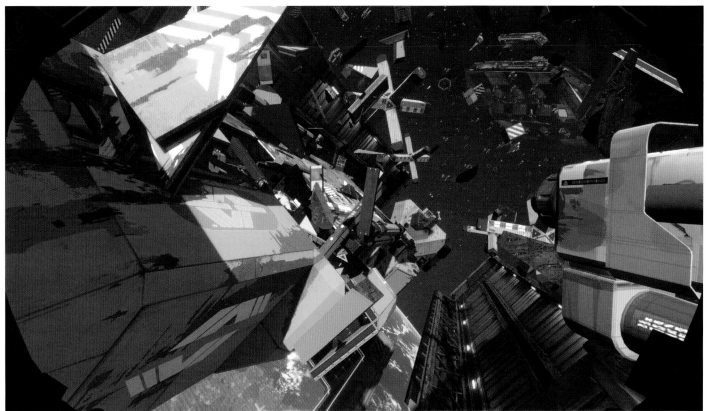

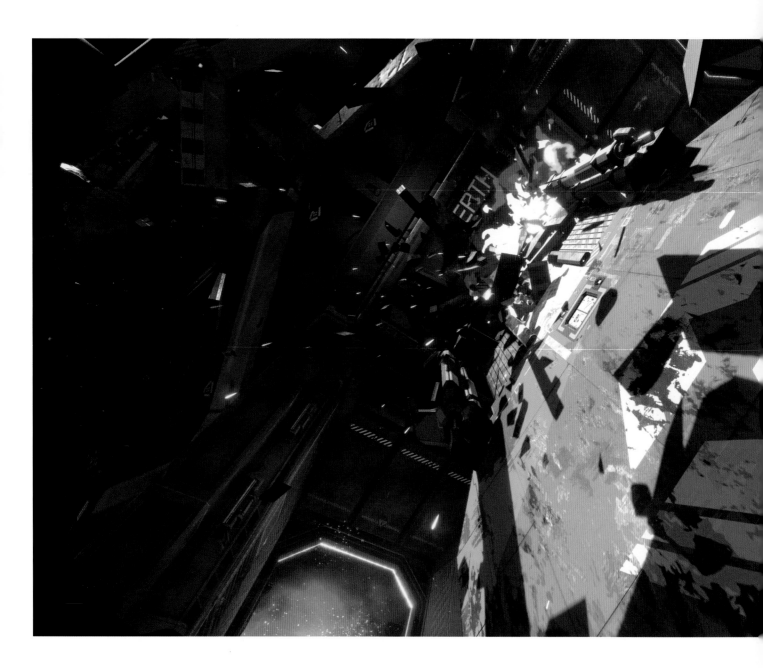

WHY BOTHER TO DO ALL THAT WORK, ESPECIALLY WITH THIS SMALL TEAM AND WITH A TIGHT BUDGET? I THINK IT COMES BACK TO BELIEVABILITY AND FANTASY. YOU MIGHT SAY, OH SURE, EVERYONE WANTS FANTASY IN THEIR GAME, BUT IT'S A LITTLE MORE SPECIFIC FOR US. BEING A SHIPBREAKER IS A KEY PART OF THE FICTION; IT'S ALL ABOUT SLICING PANELS. IT'S THE GUTS OF THE FANTASY; IT'S FEELING LIKE YOU'RE RENDING METAL IN HALF, PUNCHING YOUR WAY THROUGH THE HULLS OF GIANT SPACESHIPS.

> BRENNAN MASSICOTTE

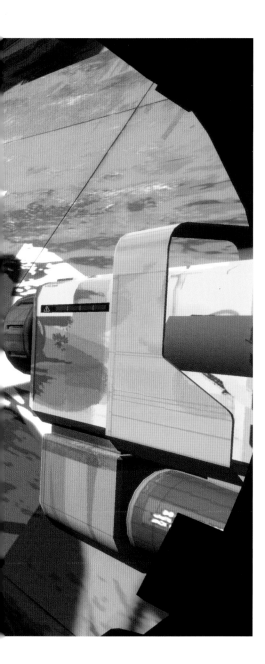

The answer was interior mapping, a piece of tech-art magic which makes it look as if a flat surface has 3D innards. Often used to create visible but geometrically non-existent rooms in office-building windows, interior mapping uses parallax maps to give the illusion of depth. *Shipbreaker*'s technique adds a lip around the edge of a cut to simulate the casing of an object, then with layers of images creates a series of compartments inside, each presented as if in cross-section. A layer of scorching, along with burned edges and molten metal around the lip, completes a convincing effect which is really just a series of textures: flat images, manipulated and layered to produce immersive fiction.

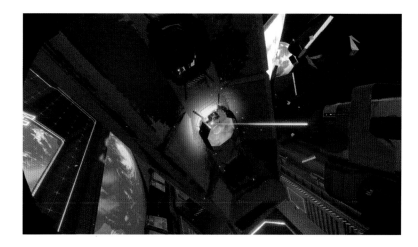

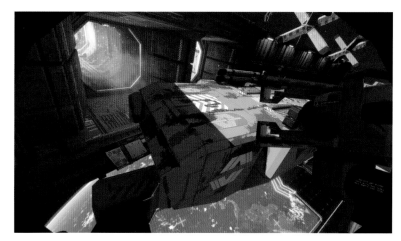

⏶▸ Destruction derby

Shipbreaker's cutting tools leave glowing trails as they punch through panels and components, leaving scorch marks and molten metal on their edges

▸▸ Fog up

Space doesn't have distance haze in reality, but it's such an effective way to impart a sense of distance that *Shipbreaker*'s artists used it anyway

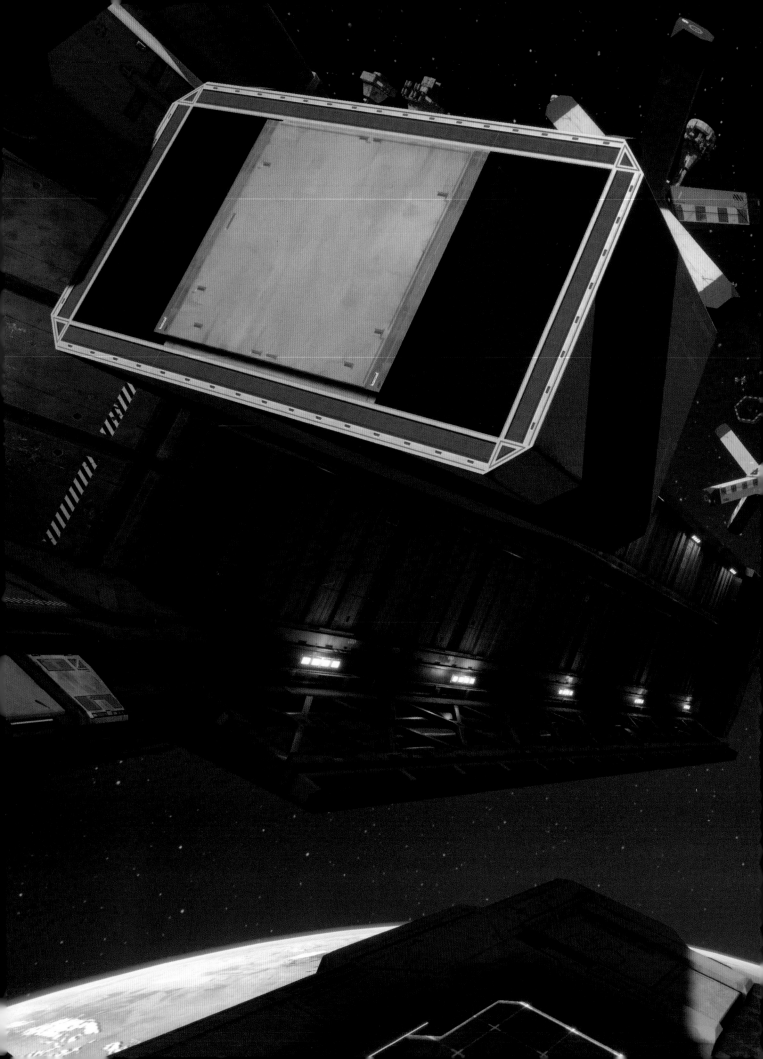

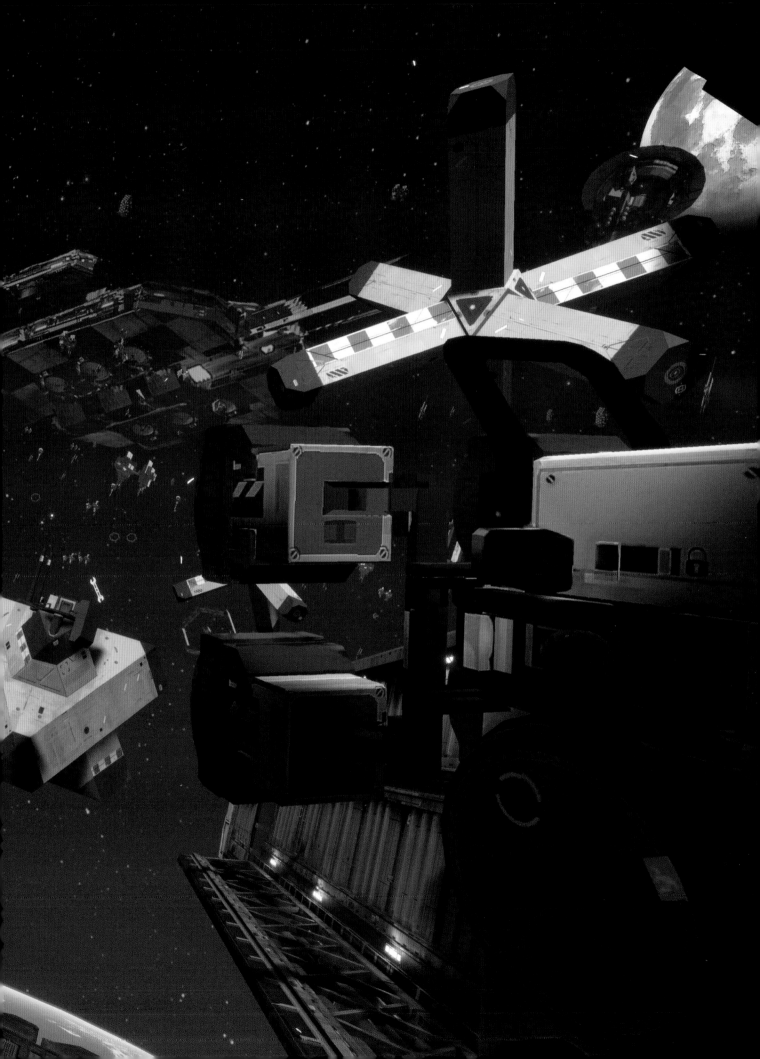

DIMENSIONS OF LIGHT →

2

DEVELOPER REMEDY ENTERTAINMENT

YEAR OF RELEASE 2019

PLATFORMS PC PLAYSTATION SWITCH XBOX

CONTROL

IN THIS THIRD-PERSON ACTION GAME YOU PLAY AS JESSE FADEN, WHO HAS COME TO THE MYSTERIOUS HEADQUARTERS OF THE FEDERAL BUREAU OF CONTROL ON A SEARCH FOR HER MISSING BROTHER. IT'S NOT LONG BEFORE THIS PARANORMAL SPACE HAS MADE HER ITS NEW DIRECTOR, PITTING YOU AS ITS DEFENDER AGAINST AN INCURSION OF BIZARRE REALITY-BENDING BEINGS CALLED THE HISS.

The headquarters, known as the Oldest House, is on the surface a Brutalist edifice of mundane offices and stunning orthogonal atriums. In fact, it exists beyond our own dimensions as a shifting metaphysical space which contains both the everyday bureaucratic operations of a government agency and the fantastical objects and phenomena that it attempts to study – and control.

Developer Remedy realized this dramatic and dynamic setting by using new rendering technologies including global illumination, a process that simulates light as it bounces around an environment. With it, surfaces reflect their colour and gain shadows and highlights, and this lends them a sense of presence and form that older lighting effects can't match. It's fitting that Remedy, a Finnish studio with roots in the technical showmanship of the mid-1990s demoscene, should take on the mantle of applying leading-edge lighting tech to abstract videogame space. But in *Control*, these effects aren't for the sake of ostentation. They're never less than an essential part of the world you see around you, and in service of the strong storytelling for which the studio is equally known. ▨

▶ **Jesse Faden**
The player is a young woman who has come to the Oldest House in search of her brother and soon finds herself made its Director.

◀◀ **The Panopticon**
Control features cavernous spaces like the Panopticon, where 'objects of power' are contained for safety.

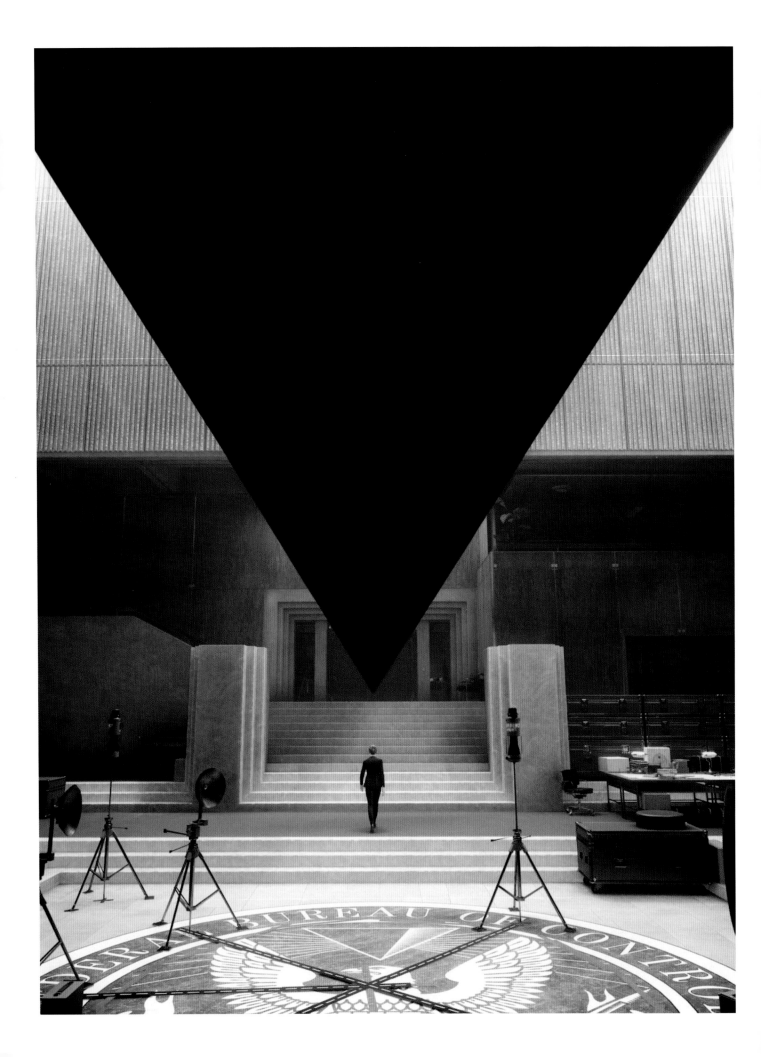

Whether Tadao Ando's Church of the Light, Louis Kahn's Jatiya Sangsad Bhaban or Denys Lasdun's National Theatre, light is as much a material as the solid concrete from which these classic modernist edifices are built. Light, in all its subtle and shifting forms, brings volume to their halls and rooms, and it articulates the flat planes and curves that bound them. And so it does in *Control*, a game which uses purist Brutalist architecture – stripped from the reality of the Long Lines Building in New York City – as the foundation for a journey into the paranormal.

Here, the everyday solidity of the raw concrete that defined the Brutalist movement, textured with the wood-grain imprints of the formwork in which it was poured, is constantly manipulated, broken up and moved around by forces far outside the normal. Vital to establishing this tension between the physical and the metaphysical was making the Oldest House feel grounded and real, and that challenge started with nailing its architectural style.

◀ **Central Executive**

In the main hub for your expeditions into the Bureau hangs an inverted pyramid. The sheen of its black faces contrasts with the rough concrete walls.

▼ **Astral Spike**

Many of the strange enemies and phenomena found in the Oldest House, such as the Astral Spike, are characterized by distorting visual effects.

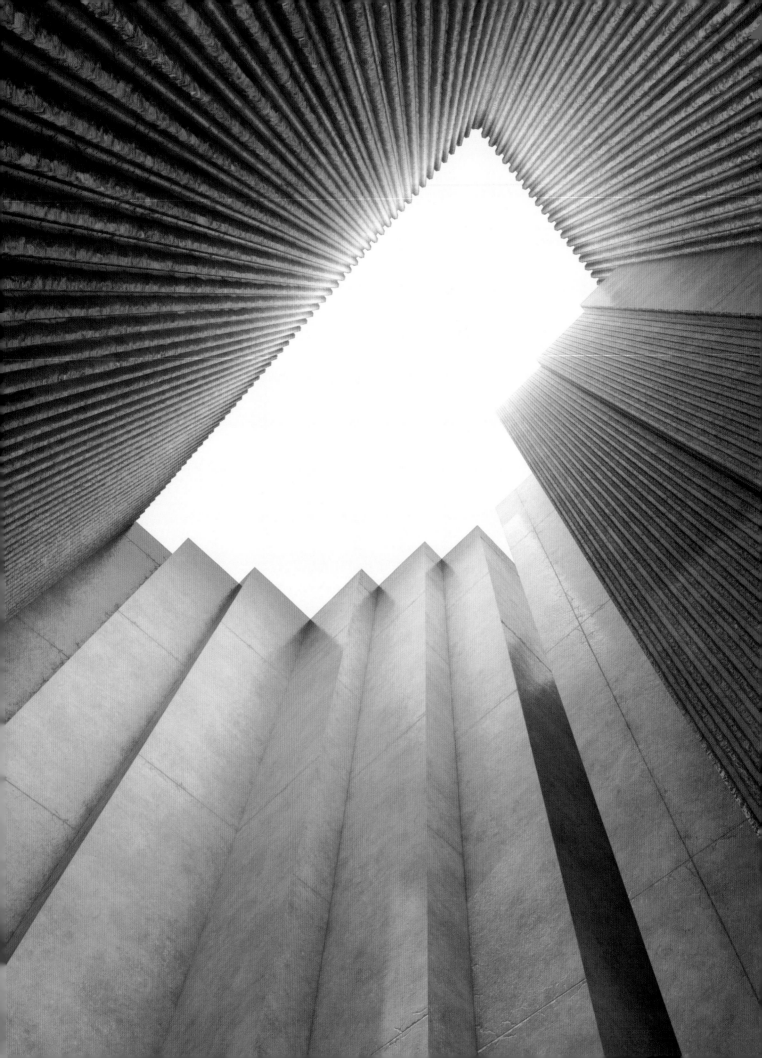

BRUTALISM'S NOT EASY. IF YOU LOOK AT IT IN THE WORLD, AS A STYLE, IT'S ONE OF THOSE EASY-TO-REPLICATE-BUT-HARD-TO-MASTER THINGS. THERE'S ONLY A VERY SMALL PERCENTAGE OF GOOD BRUTALIST BUILDINGS OUT THERE; THAT SENSE OF SCULPTURAL COMPOSITION, WEIGHT AND STRUCTURAL EXPRESSION IS DIFFICULT. IF YOU TRY TO REPLICATE IT WITHOUT DEEP UNDERSTANDING, YOU CREATE A VERY NAIVE PASTICHE.

> STUART MACDONALD, WORLD DESIGN DIRECTOR

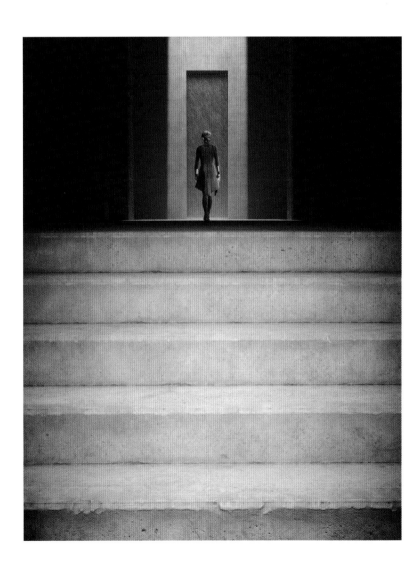

◀ **Béton brut**

Concrete's many finishes react to light in very different ways, giving every space a variety of textures with the same fundamental material.

▶ **Patina**

Imperfections in surfaces provide a sense of solid reality in an environment which might otherwise feel abstract.

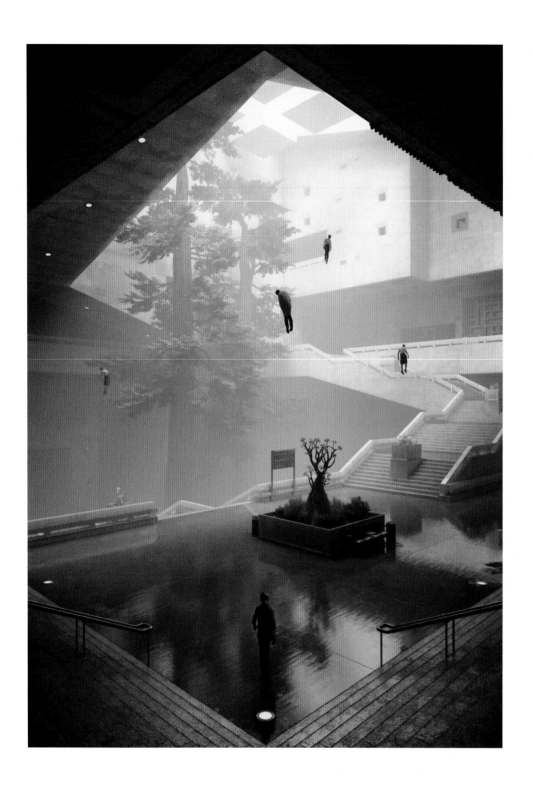

▲ Ray tracing

Real-time reflections create contrast against the diffuse nature of concrete surfaces and emphasize the physical nature of the spaces.

▶ Polished up

Reflective materials on floors and walls enable a large space to be lit by dramatically directional light sources.

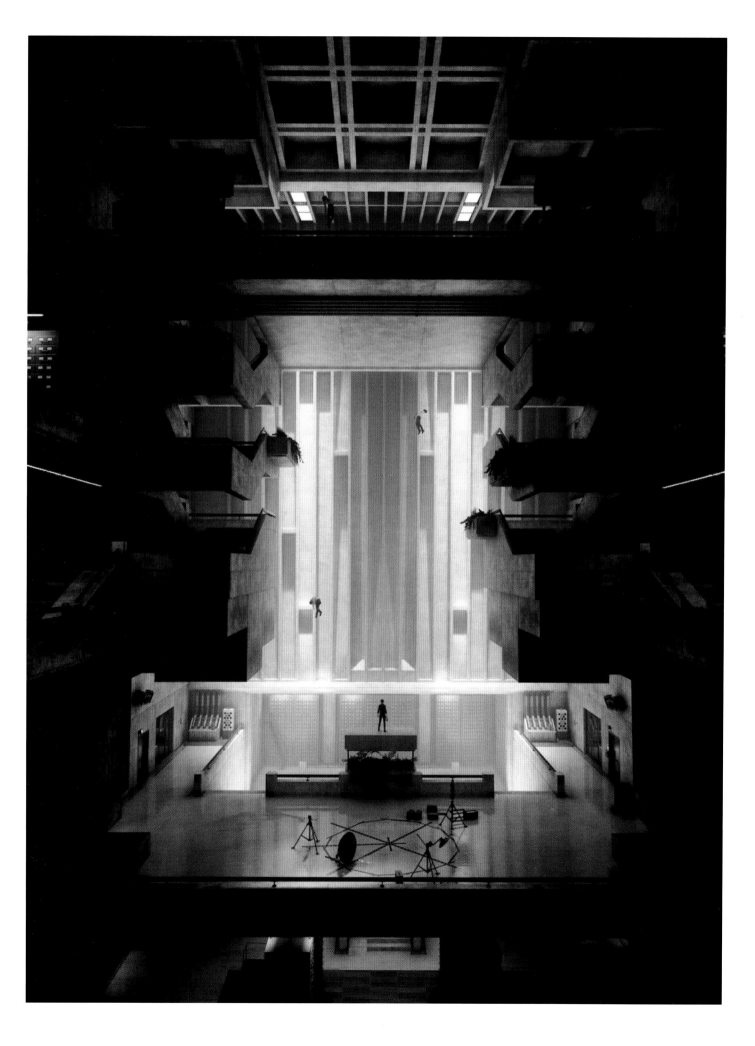

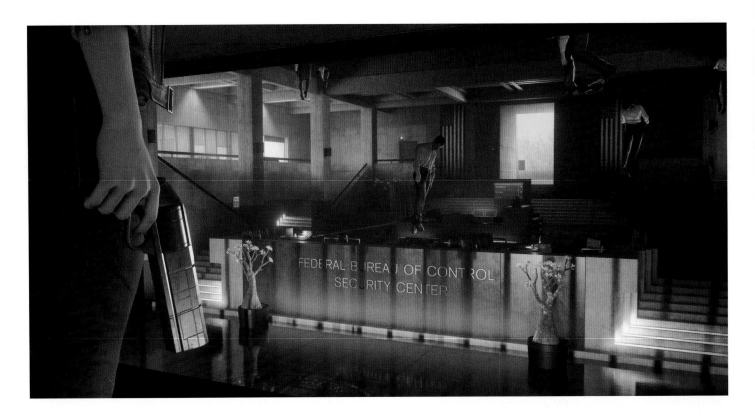

It was also important for the Oldest House to avoid a sci-fi look, since it was meant to be a monument to 1960s US government bureaucracy, with Bakelite phones and networks of pneumatic tube transports. Stuart MacDonald, who led the design, had to ensure its walls followed straight lines and right-angles, which, it turned out, were great for emphasizing lighting. *Control* uses lighting to set mood, to communicate scale and form, to impart material texture, and to establish rhythm and direct attention. It also uses light to create naturalistic reality in a world that's always threatening to splinter into abstraction.

Though the Oldest House is tectonically vast, the objects inside it – the rows of desks and the computer terminals and papers that sit on them – are loose and can be picked up, thrown, shot at and destroyed. The challenge for Remedy was that the way most games of *Control*'s generation model realistic light is to 'bake' it into the world. This means that the lighting on every surface is calculated as the textures are produced – and, once set, it can't change. That's fine for parts of an environment that are static, but it will look wrong for objects that can move, or when lights can change in luminescence or move around. Generally, games get around this by rendering the lighting on static geometry differently from lighting on geometry that's dynamic, and this tends to allow you to see the difference between the two, particularly in terms of shadows and tone.

⬆ Kept company

(Top) The suspended bodies are the Bureau's staff, now claimed by the mysterious Hiss. (Above) 1960s-like computer and control boards are studded with glowing lights.

▶ Pneumatics

Messages are sent around the Oldest House by pneumatic tubes. Diffuse lighting gives this central hub an otherworldly air.

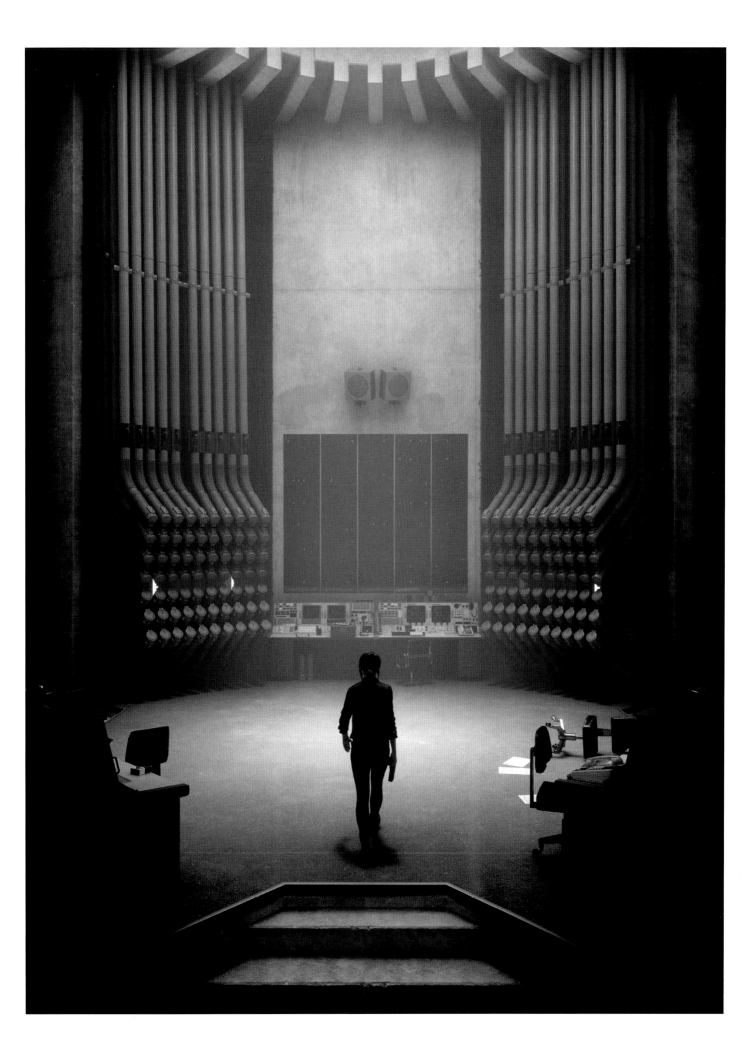

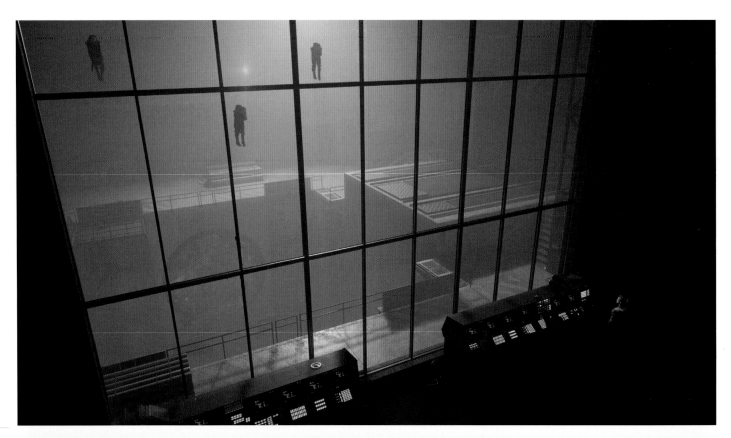

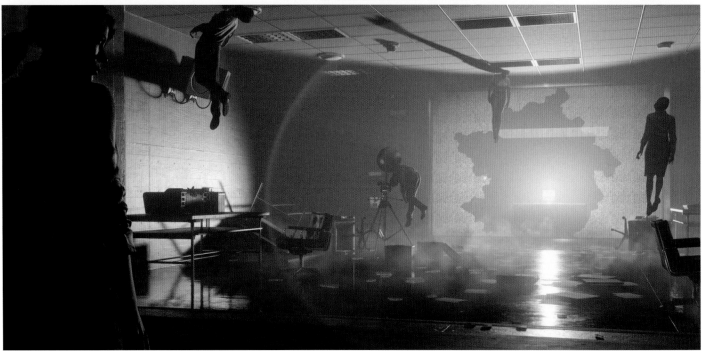

▲ **Black and white**

Control's lighting artists played with degrees of contrast and creating silhouettes in monochromatic settings.

▶ **Black Rock Quarry**

The dynamic nature of *Control*'s global illumination meant every change to lighting would affect the look and play of the whole space.

WE VERY CONSCIOUSLY LEFT THE SHAPES AND
ARCHITECTURE CLEAN, WITHOUT MUCH DETAIL,
SO THERE WAS ROOM FOR DETAILED LIGHTING.
THAT'S ONLY JUST BECOMING POSSIBLE IN GAMES,
WITH BETTER LIGHTING SOLUTIONS. WE ALSO HAD
THE CONSTRAINT THAT THINGS WERE VERY DYNAMIC
AND DESTRUCTIBLE, WHICH HAS BEEN A BAD
COMBINATION IN THE PAST: LIGHTMAPS CAN DO
GOOD-QUALITY LIGHTING, BUT IT ENDS UP BEING
VERY STATIC.

〉 JANNE PULKKINEN, ART DIRECTOR

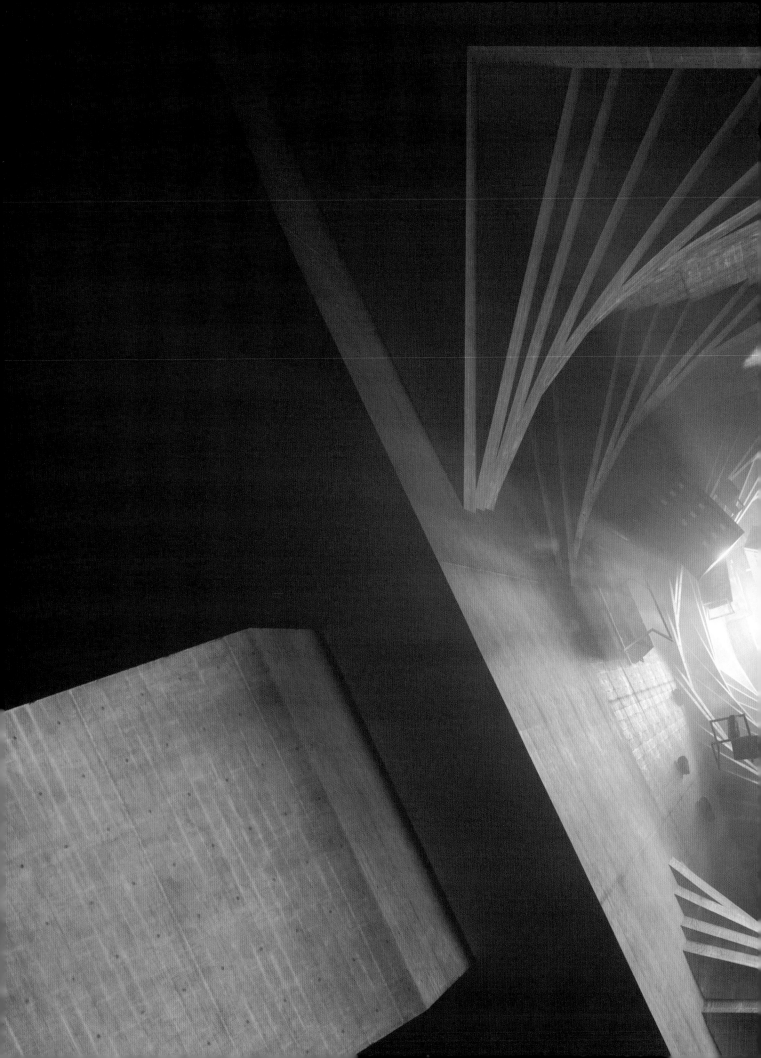

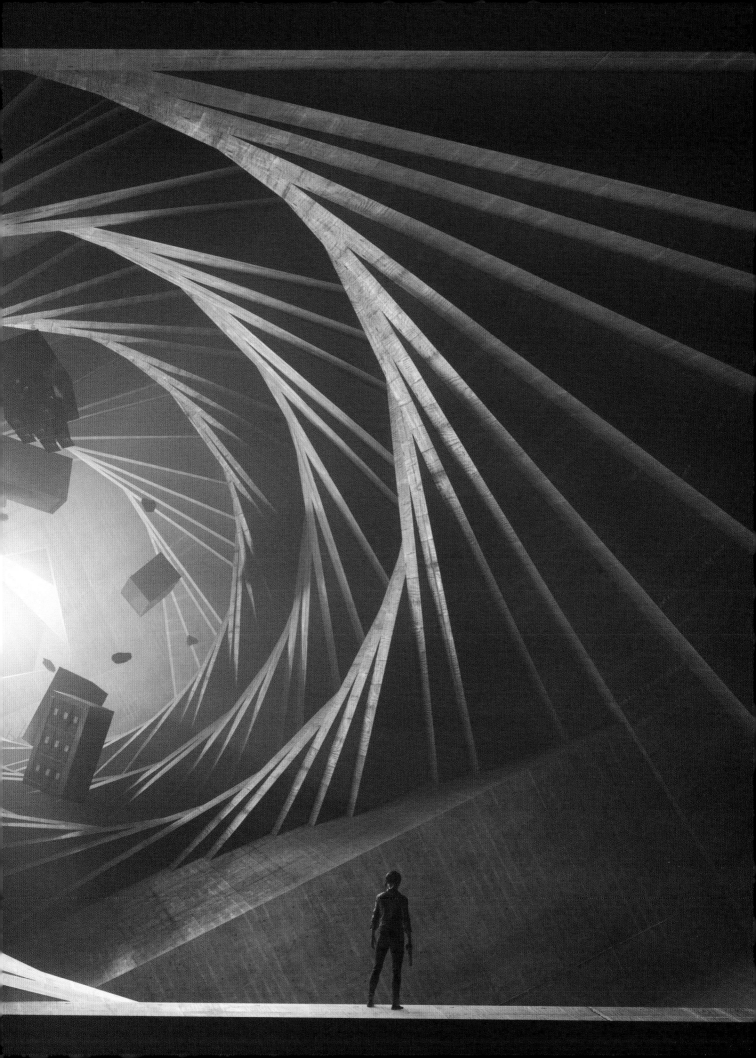

A LOT OF GAMES HAVE THE LIGHTING APPLIED ON THE SURFACE OF A BUILDING – LIGHT FITTINGS AND THE LIKE – WHERE IT'S A VERY KIND OF SPOTTED THING, WITH POOLS OF LIGHT. BUT NOW, WITH AREA LIGHTS, LIGHTING IS PART OF THE SUBSTANCE OF THE BUILDING: WE CAN USE ARCHITECTURAL LIGHTING, SO A LOT OF LIGHT SLOTS, AND WAYS TO WASH LIGHT ACROSS THE SURFACE OF A BUILDING. WE CAN PAINT WITH LIGHT A LOT MORE, WHICH IS CINEMATOGRAPHIC BUT ALSO ARCHITECTURAL.

> STUART MACDONALD

Remedy, anxious to achieve a grounded and naturalistic look for *Control*, took a hybrid approach in the Northlight engine in which it runs. It combines a baked approach with a dynamic one, for a solution that's efficient enough to run on PS4 and Xbox One consoles. Its spaces are crisscrossed by a grid of light probes, each of which stores pre-calculated information about the light quality at that point. The game then renders any object, whether Jesse Faden walking through a hallway, a mug on a table, or a fixed wall, according to the pre-calculated light quality set in the probes around it. For example, the probes near a brightly lit orange wall will lend any object entering their space an orange tone. The colour, tone and intensity of ambient lighting therefore naturally change throughout spaces, lending them volume and mood and ensuring everything within them looks natural and consistent.

Lighting in *Control* is very much part of its level design, so lead lighting artist Damian Stempniewski worked closely with environment artists and level designers. They all learned together that it was important to aim for simple forms and to avoid the kind of heavy detailing that games usually use to hide the inexact and inconsistent nature of their lighting. In their place, Remedy thought hard about the material reality of the place, and how the image could relate it: the smooth reflectivity of polished floors, the subtle hardness of concrete, the warm glow of wood.

▶ **Board Room**
The lighting above this safe space's conference table evokes Ken Adam's set design for *Dr Strangelove*.

◀◀ **Transformation**
The extraordinary transformations of the Oldest House are aided by high-contrast lighting, which picks out the architecture's sharp edges.

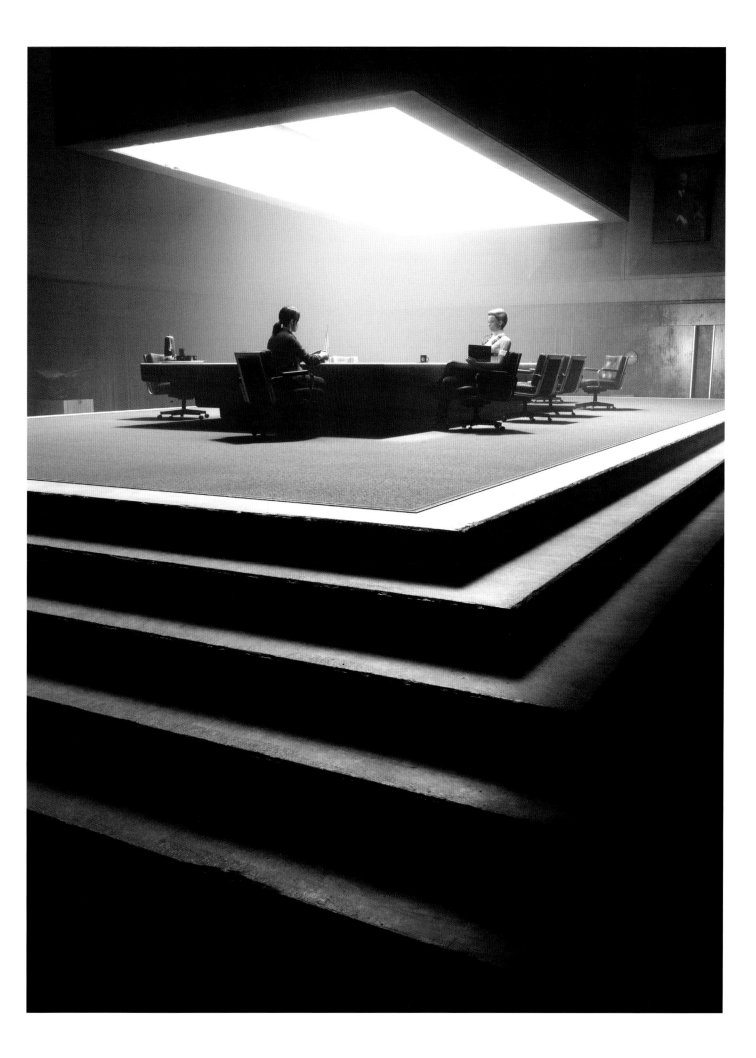

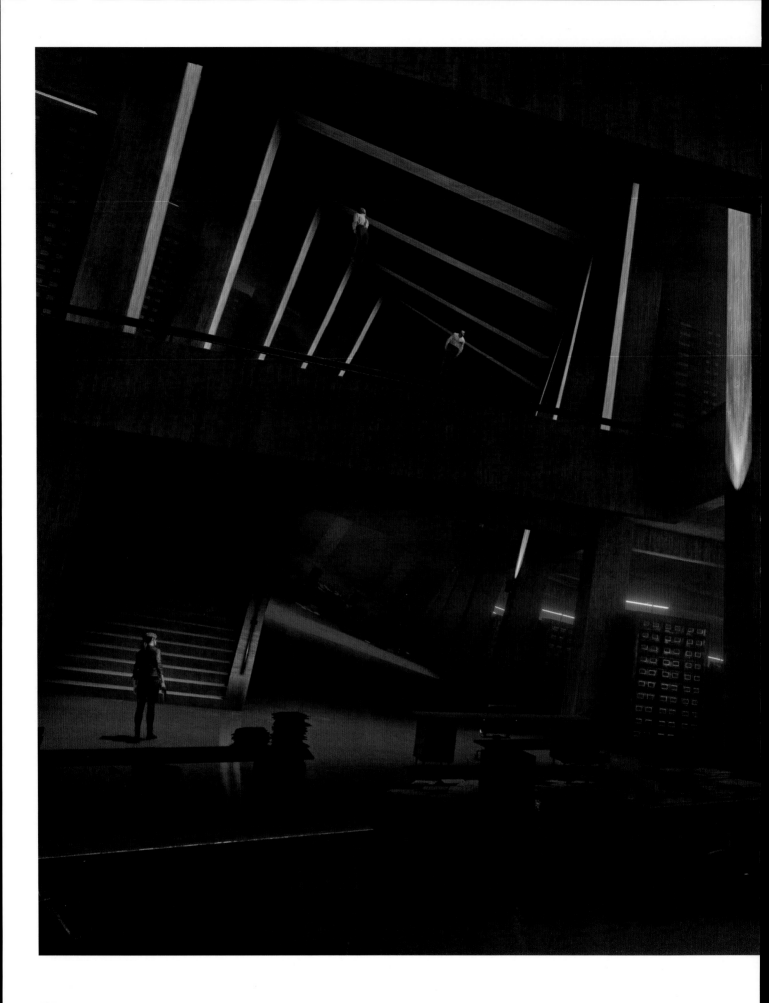

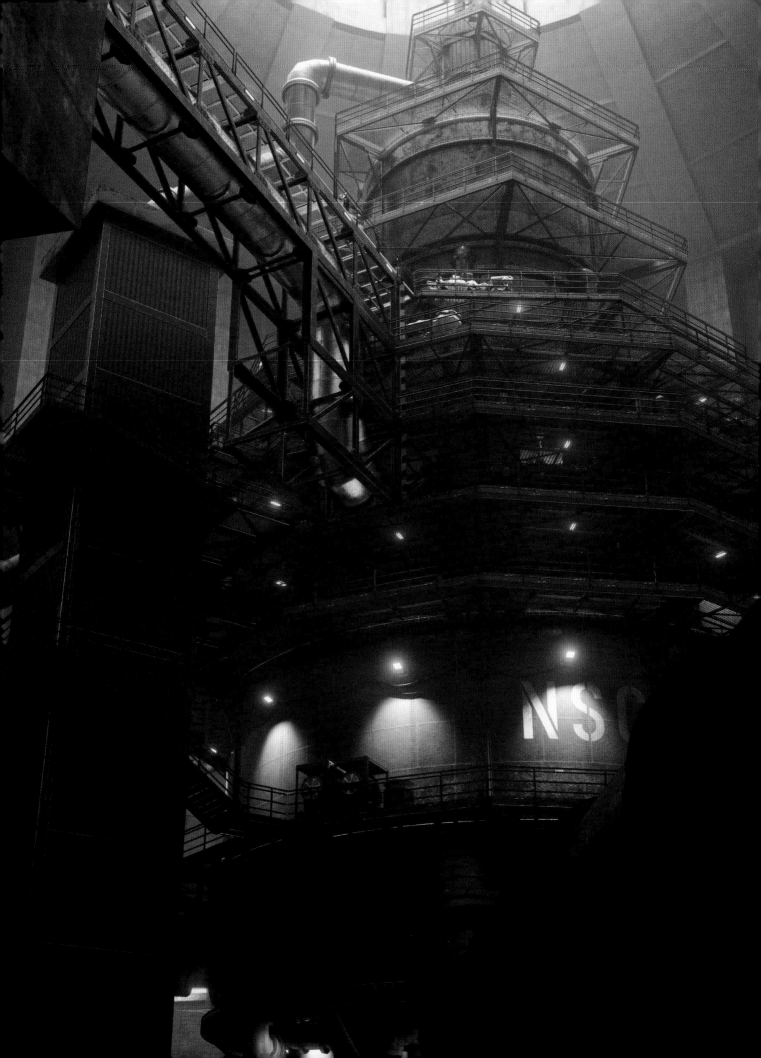

Like many game engines, Northlight performs physically based rendering (PBR) to simulate the play of light from a multitude of different surfaces. *Control*'s art team could try out different surface treatments to achieve the effect they wanted for a space, while also ensuring the player has an instinctive awareness of its properties: whether it can break or shatter, stand firm or chip. Among these surfaces was an entire library of different types of concrete, since this remarkable material is much more expressive than many might assume, comprising rough surfaces, shiny ones, patterned and smooth.

The art team also had to design spaces for the fact that many of them would be played under two lighting schemes, depending on whether they're under attack from the Hiss, which is signalled by deep shadows and washes of red. For inspiration, the team looked to Dario Argento's *Suspiria* and the films of Nicolas Winding Refn, attempting to ensure that the world can create similarly arresting images wherever the player looks.

The balance, however, was to ensure that *Control* remained good to play, with enemies lit well enough to be defeated. The art team pushed high-contrast compositions in spaces, hoping that giving the enemies expressive silhouettes would allow players to identify them from their outlines. Sometimes the effect was too extreme, leading the gameplay teams to push back; indeed, early on, there were doubts that the stark and expressive lighting the art team wanted would be possible. But over the course of the game's development, the teams learned to understand and trust each other. With the importance of lighting in achieving the Oldest House's monumental weight, they had to.

◀ **NSC Power Plant**

Control's art direction was not about photo-realism, even if its spaces are designed to be believable, but more about atmosphere.

◀◀ **Office space**

Much of *Control*'s power lies in the way it establishes expectations, with mundane bureaucratic spaces, and then breaks them.

◀ ▲ ▶ **The Hiss**

The presence of *Control*'s enemy, the mysterious Hiss, is signalled by red light, a shocking warning of action to come. It's made possible by the Northlight engine's dynamic lighting technology, which doesn't rely on baking lighting into textures.

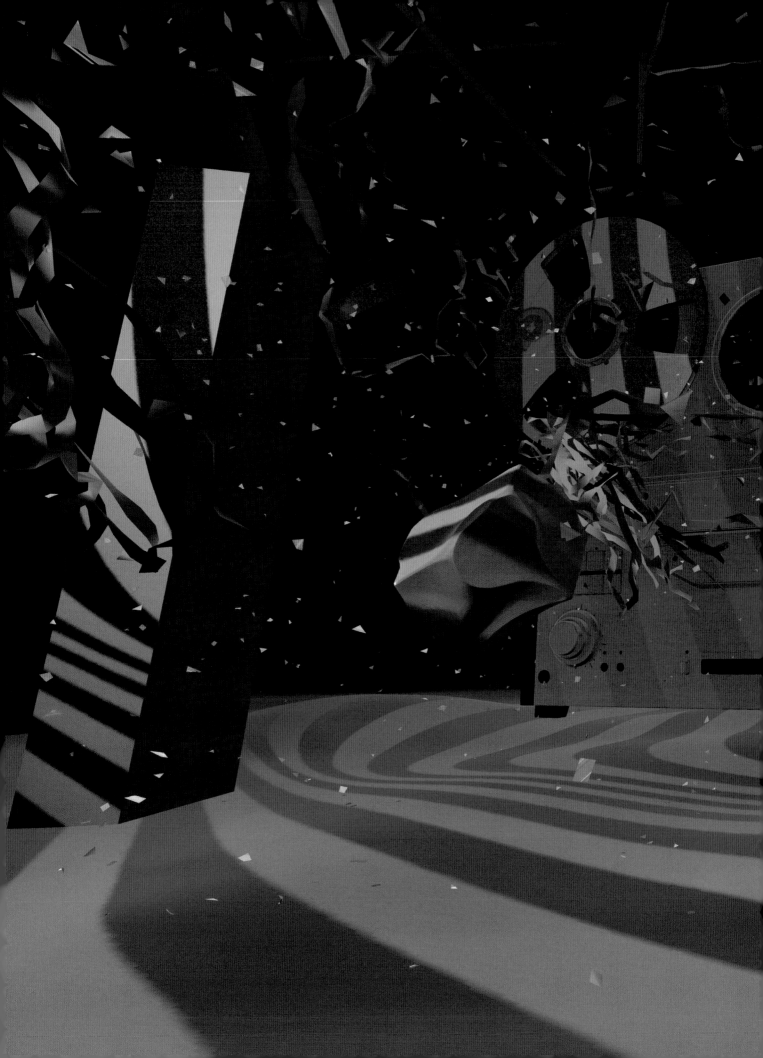

ART THROUGH MATH- EMATICS →

3

DEVELOPER PIXEL REEF

YEAR OF RELEASE 2020

PLATFORMS PC PLAYSTATION

PAPER BEAST

SINCE HE BEGAN MAKING GAMES IN THE 1980S, ÉRIC CHAHI HAS PAIRED HIS STRONG VISUAL IMAGINATION WITH LEADING TECHNICAL EFFECTS. HE MADE HIS NAME WITH HIS 1991 ADVENTURE GAME *ANOTHER WORLD*, WHICH STUNNED THE WORLD WITH FLUID ANIMATION CREATED BY ROTOSCOPING VIDEO AND TRANSLATED INTO POLYGONS.

He went on to release *From Dust* in 2011, a simulation-based game in which the player directs a tribe of people through a world of volcanoes and tsunamis by manipulating the elements: solidifying water to stop it carrying away the tribe, putting out fires, carving up the land to divert lava flows.

There are many shadows of *From Dust* in *Paper Beast*, but this game, which was originally made for VR, started out with Chahi playing around with simulating animal locomotion, first in 2D, and then in 3D. From there, *Paper Beast* steadily evolved into an immersive and expressive puzzle game in which the player can interact with origami-inspired creatures in a series of connected scenes in a wildly reactive world, watching as they're attracted to food, prey on each other, move earth from place to place. Soon, you're helping these creatures survive in increasingly hostile conditions. With the game giving no explicit tutorials or storytelling, it's up to you to figure out how. ▓

▶ **Fantasy zone**

The game takes place in a surrealistic, science-fiction cover-inflected world of sand, mountains and origami creatures under skies of billowing clouds.

◀◀ **Paper streamers**

Paper Beast opens with a sequence of paper confetti and streamers swirling in time to TsuShiMaMiRe's song, 'Speedy Wonder', all generated with shaders.

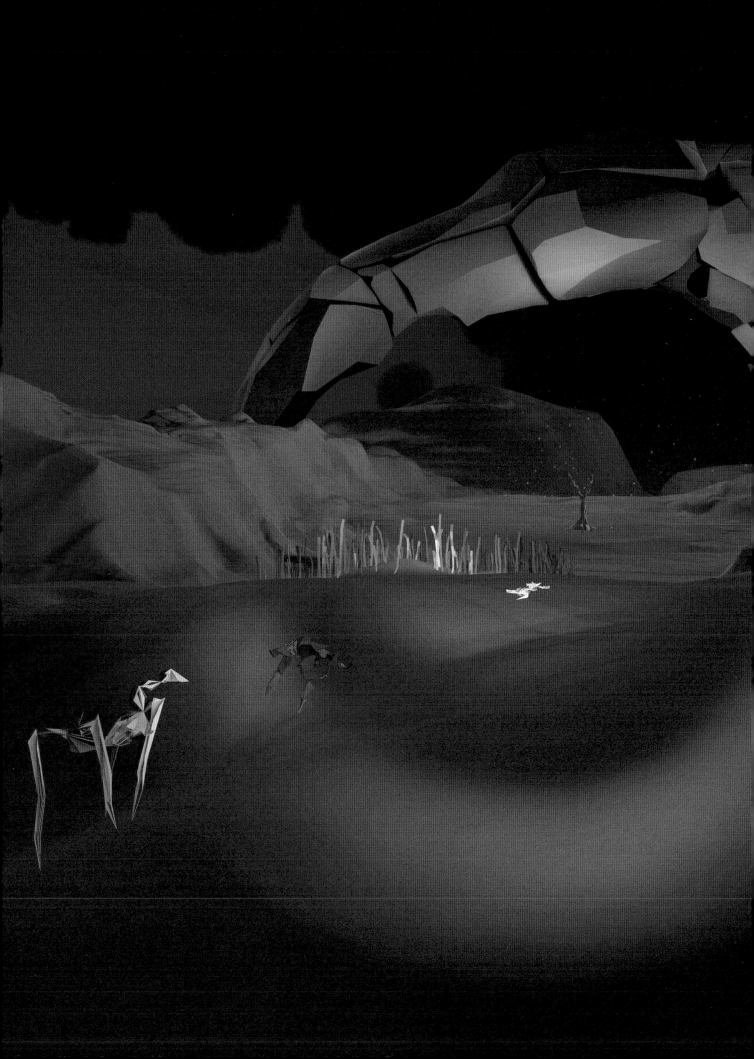

A great deal of the visual beauty of the modern videogame is the result of shaders, maths that can conjure the dull metallic gleam of metal and glossy hair; reflections on water; shafts of light falling from tree canopies. Put simply, a shader is code that's run on a graphics processing unit (GPU), and in games, shaders are where maths meet art. They started out in games as a method of adding visual effects by modifying the colour value of pixels on the screen. A shader can use information about the object or surface a pixel is depicting to create a new colour value. By referencing a surface's angle in relation to a light source, for example, a shader can add a shiny specular highlight to it. Shaders are a profoundly powerful and flexible way to create stunning visual effects that don't rely on artists adding more geometric complexity to the 3D environment. So, in *Paper Beast*, shaders render its dreamy surreal landscapes, the soft fall of sand, footprints and rippling fur. But today shaders do much more, because GPUs are so powerful, and in *Paper Beast* they also run the simulation of its world. They animate and control its paper animals and they govern the flow of its water and wind.

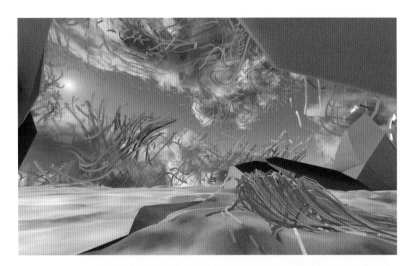

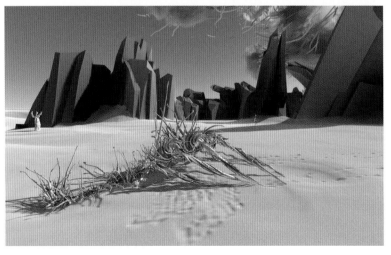

◀ ▲ Scene set

After the introductory sequence, day breaks, tape streams from a reel-to-reel player in a bright desert, and an eight-legged beast, apparently made from bleached, spiny bones, appears.

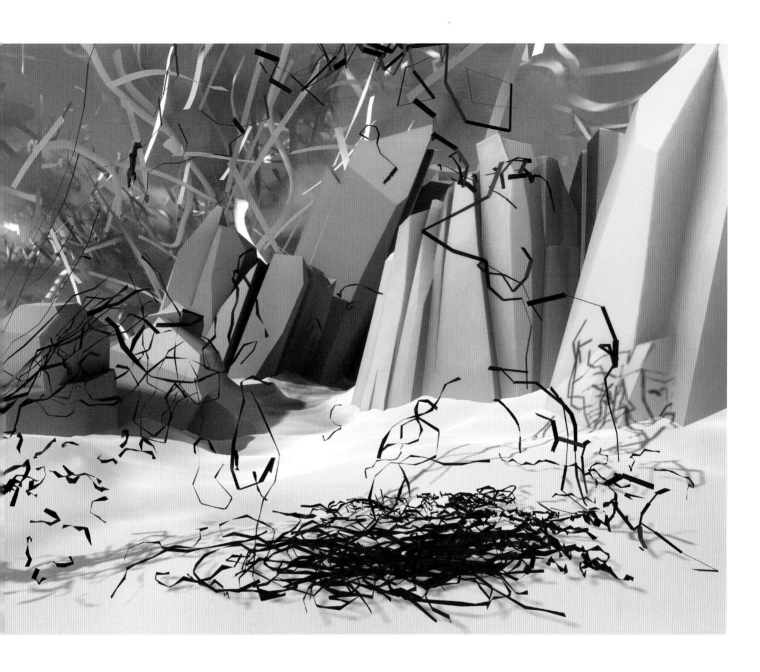

WE DIDN'T WANT TO GO WITH A *MATRIX* KIND OF
VISUAL, BUT SOMETHING ON THE EDGE OF NATURAL
AND ARTIFICIAL. THE CREATURES IN *PAPER BEAST*
FEEL ALIVE BUT THEY'RE MADE FROM DIFFERENT
MATERIALS, NOT JUST PAPER, SO IT'S MORE A
SYMBOLIC AND SURREALISTIC WORLD THAN IT IS
TECHNOLOGICAL, BUT THE WORLD IS SIMULATED,
SO THERE'S A STRONG UNITY BETWEEN THE CORE
MECHANICS, THE TECH OF THE GAME, AND ITS THEME.

> ÉRIC CHAHI, CREATIVE DIRECTOR

LIVING CREATURES CAN COLLIDE OR INTERACT
WITH ANY TREE, EVEN A SINGLE LEAF, AND THEY
CAN LEAVE FOOTPRINTS. BECAUSE THE ENVIRONMENT
IS STORED IN TEXTURES AND BUFFERS, AND ANIMALS
ARE ALSO SIMULATED ON THE GPU, THEY HAVE
DIRECT ACCESS TO THE SURROUNDING ENVIRONMENT.
INFORMATION IS CONNECTED AND IT'S MUCH EASIER
TO CREATE DYNAMIC INTERACTIONS THAN IF WE
HAD THE PHYSICS ON THE CPU AND ONLY THE
RENDERING PART ON THE GPU.

> FRANÇOIS SAHY, GRAPHICS AND PHYSICS PROGRAMMER

Paper Beast's theme, which unifies nature and
mathematics, really does run right through its fundamental
workings, because its dreamy world is so much the product
of its shaders, written by graphics programmer François
Sahy. *Paper Beast* is made in Unity, but Sahy didn't use its
native central processing unit (CPU)-based physics or its
shader-based rendering systems. He wanted to unify them
on the GPU, calculating and rendering the world in the same
place in order to make it seem more alive and reactive.
This architectural configuration simplifies the flow of data
between the world simulation and the image the player
sees. More information can exist about what's in the world,
and that information can be better connected.

▶ **Ecosystem**
Much of the game is about observing and
playing with the ways its creatures behave.
These beetle-like beasts can cling to the
ground in strong winds and tow objects
behind them.

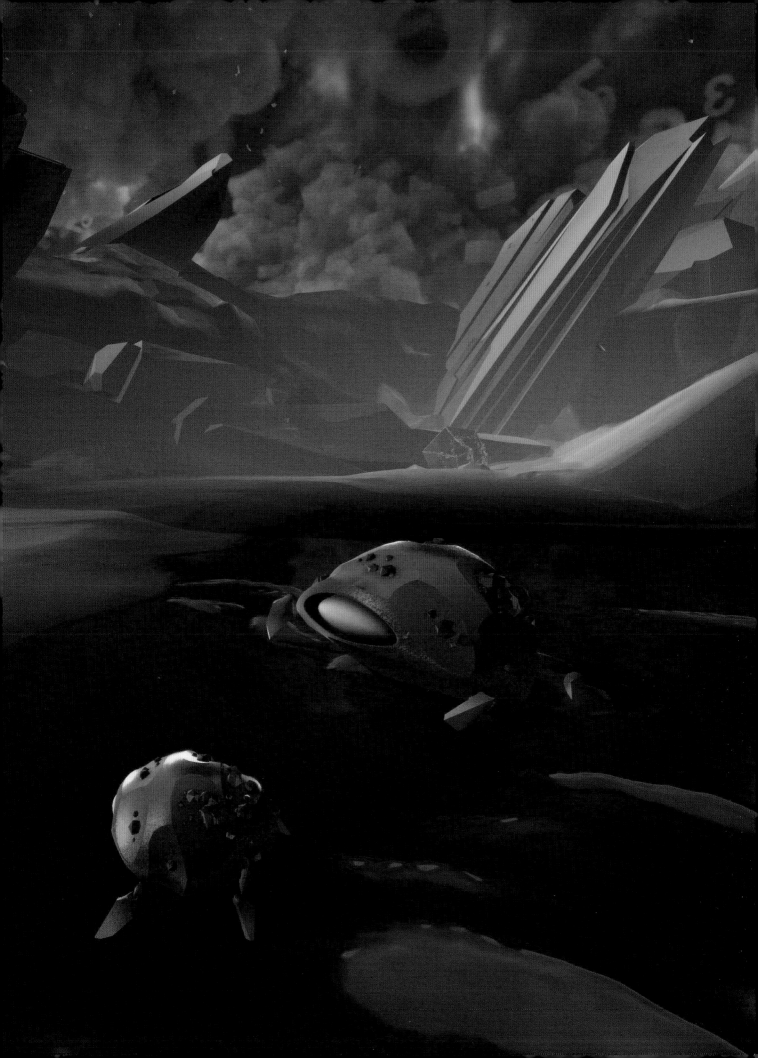

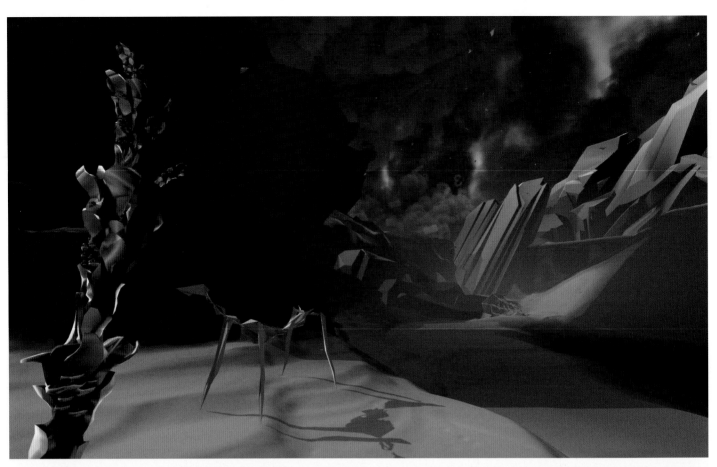

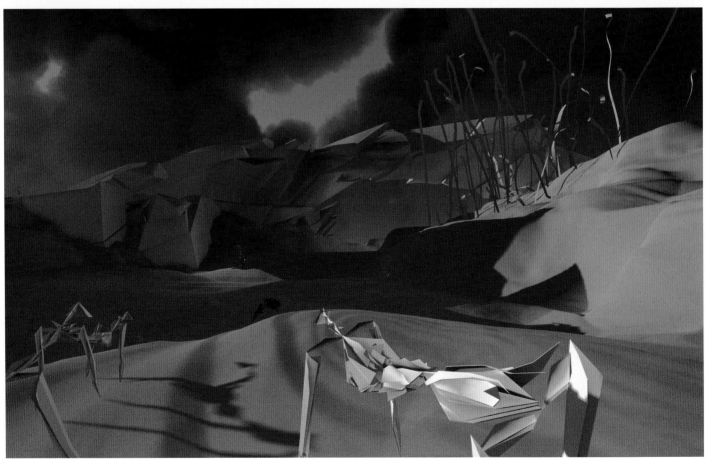

Paper Beast's creatures are not typical videogame non-player characters (NPCs), either. Rather than animated 3D meshes, they comprise physics-based skeletons that are subject to force and tension. These structures are naturally pulled downwards by gravity, so the game adds upward forces to parts of each creature so they can stand, and applies combinations of forces to their limbs so they can walk. Once calculated – by a shader – the game then adds a 3D mesh so it can be rendered.

A series of shaders then give each beast further detail, such as a fur shader, which creates the effect of hairs on the creatures' bodies that move as they do. But the fur shader does much more besides: it's used throughout the world, creating the strips of paper that you can see gently waving and rippling from the ground like seaweed, moving with the wind and parting as you move through them.

THE FUR SHADER IS GREAT BECAUSE IT BRINGS LIFE INTO THE UNIVERSE. NO MOTION IS PRECOMPUTED, SO EVERYTHING CAN REACT TO THE PLAYER; YOU CAN PLAY WITH FUR ON THE ANIMALS, PUSH PLANTS, DIG INTO THE TERRAIN … IT'S IMPORTANT TO HAVE DIRECT INTERACTION. THERE'S THE WIND, TOO – IT CONTRIBUTES TO THE FEELING OF A LIVING ENVIRONMENT.

〉 FRANÇOIS SAHY

▲ **Forage for food**

Plants can grow fruit, which will attract the beasts. Their metallic presentation stands out in the sand.

◀ **Herd mentality**

Part of the game is the challenge of shepherding beasts past predators and through dangerous terrain.

▶▶ **Carnival of animals**

Every beast is simulated, no matter its scale, and they all interact with the environment, leaving behind trails.

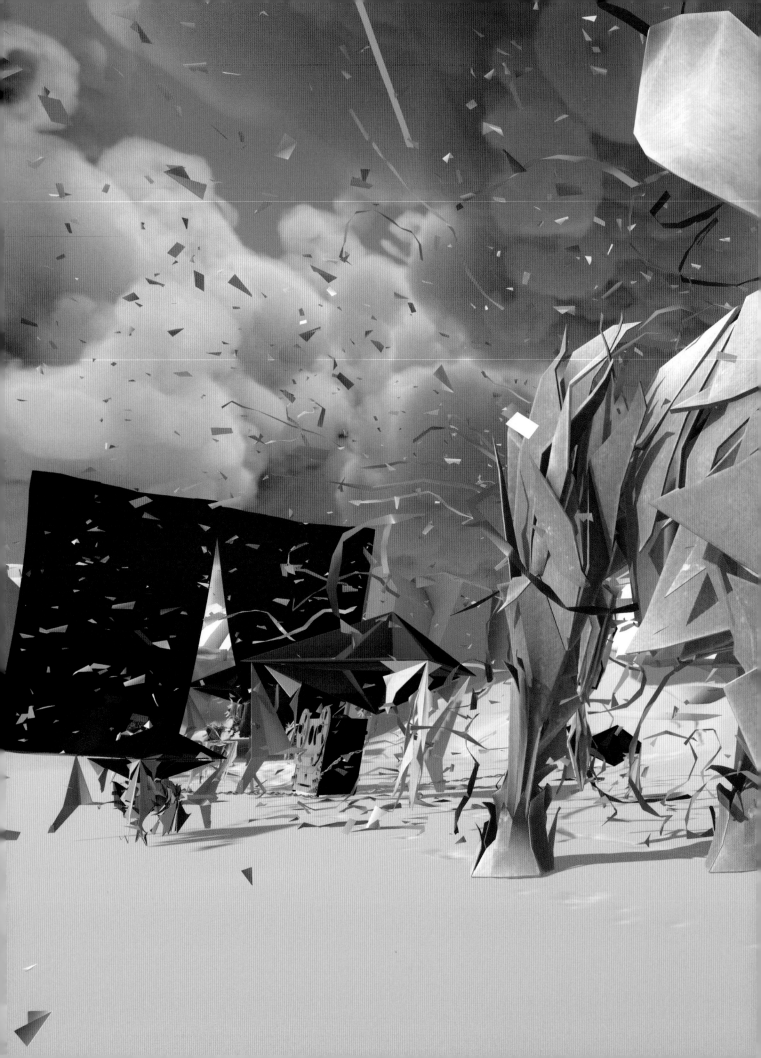

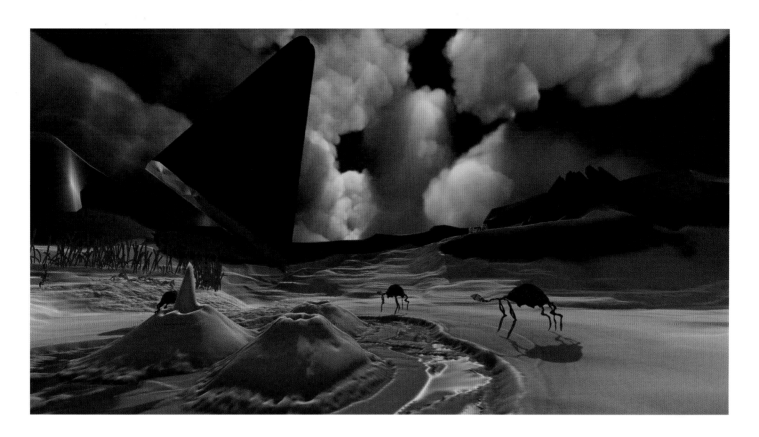

◀▲ Sand castles

Sand and mud can shift and flow, leading to playful puzzles about using certain beasts to move it from one place to another, clearing the way forward. Water will trickle into the holes left behind, filling them before overflowing, giving this surreal landscape a sense of believability.

Paper Beast's shaders also simulate the water that flows through the world, running around a pile of sand you dump into it, and pooling in divots you leave behind. But the team had to make it visible, otherwise players wouldn't know what was happening, so water's velocity and turbulence are communicated with reflections that are rendered on its surface. This wasn't easy, because Sahy's system had to render the water surface in a single pass, and usually games use multiple rendering passes to accurately capture the way light reflects and refracts underwater. This pass was then combined with the rendering of the overall scene. It was difficult to ensure the water surface lay at the same height at which the game showed the ground as being wet.

These effects are fascinating and wonderful because they offer the opportunity to experience being in a fantastical world that looks and feels real. But they're also vital to *Paper Beast*'s design, because it's a game that encourages play and experimentation. The world and its creatures need to react to you as you pile sand, freeze objects and place food, so you can understand your place in its systems, solve its puzzles, and discover its fun.

Pixel Reef didn't only rely on simulation for all of *Paper Beast*'s visual design. Surprisingly, the game doesn't fully use physically based rendering (PBR) to simulate its light and materials. PBR was the obvious choice, but during development, Sahy discovered that what would be 'correct' for an environment didn't necessarily fit with the game's visual needs. He also realized that PBR was making reflections and highlights that were uncomfortably bright when seen in VR, so he created his own version of PBR that allows a scene designer to customize and adapt scenes by painting light and colour reflections across the environment.

For example, the canyon at the start of the game appeared too bright with the game's default rendering settings, so technical artist Pascal Lefort and fellow artist Guillaume Lauer used Sahy's tool to paint it darker and added extra reflections to the water. With it, they could seamlessly blend human authorship with computer simulation. Though their changes are arbitrary, the system can take and apply them to anything that enters their space. When a beast walks into the darkened canyon, it will inherit its painted-in ambience, so it naturally fits within it.

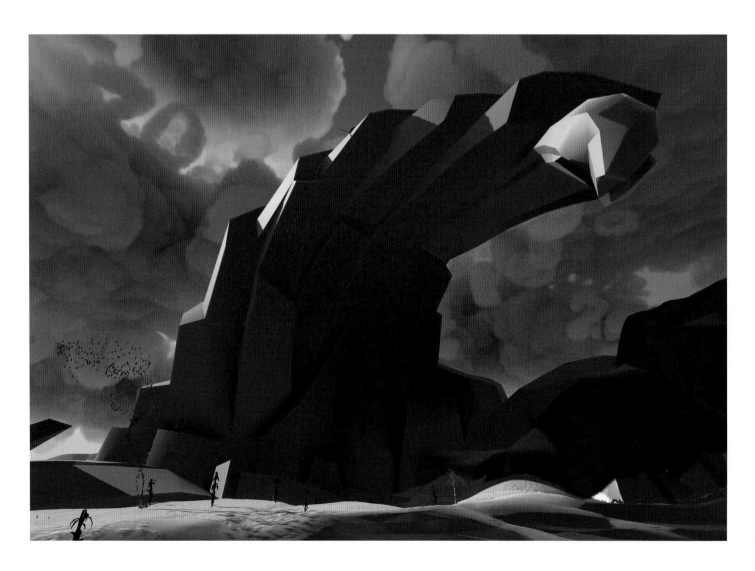

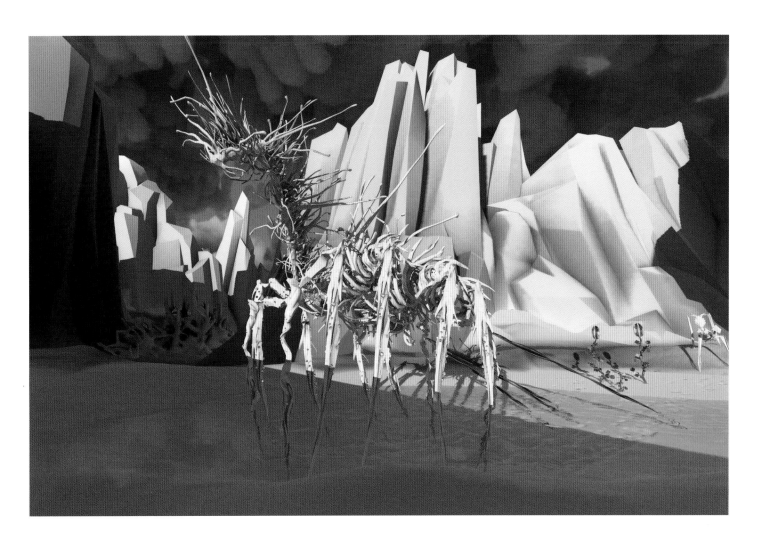

THE SYSTEM AFFECTS THE BEASTS, THEIR
SHININESS AND COLOUR. THE AMBIENT OCCLUSION
IS DRIVEN BY IT. IT'S VERY ORIGINAL. YOU DON'T
HAVE THIS IN OTHER ENGINES. WE HAD A LOT OF
TOOLS TO PAINT ARTISTICALLY INTO THE WORLD.

> PASCAL LEFORT, TECHNICAL ARTIST

◀ ▲ **Engine architecture**

As a VR game originally designed for
PlayStation 4, Sahy knew the traditional
way of using the CPU for simulation and
the GPU purely for rendering would be
too inefficient, so though *Paper Beast*
runs in the Unity engine, it's with an entirely
custom renderer and physics simulation
that run on the GPU.

The ambient light is also influenced by the dramatic skies under which you play. These are a critical part of *Paper Beast*'s visual design because they comprise such a large part of the image, and also because Sahy's custom PBR factors them into its rendering of the local environment. The world inherits the sky's colour tones and reflects it in materials such as water. The team could also create weather effects and change the time of day, with a sunset that was carefully colour-graded to achieve the precise transition from day to night that they wanted.

This is the power of shaders: though they deal in numbers and systems, numbers are inherently mutable and therefore are there to be played with and modified. In *Paper Beast* shaders gave Chahi and his team great creative control over their virtual world. There's a cliché about programmers that says their work is practical to a fault; that it takes on a strictly utilitarian role in a game's production. But Sahy, like many other programmers, played an essential role in imagining and realizing *Paper Beast*'s visual design, examining every pixel and changing the parameters that governed every shadow and reflection.

◀ **Night cycle**

Lighting the sky completely changes the ambience of the world, from night to day, and from sunshine to storms, courtesy of shaders.

▶▶ **Another world**

Chahi intended *Paper Beast* to sit on the boundary between natural and artificial, combining evidently computer-generated effects with ones that emulate real-world materials.

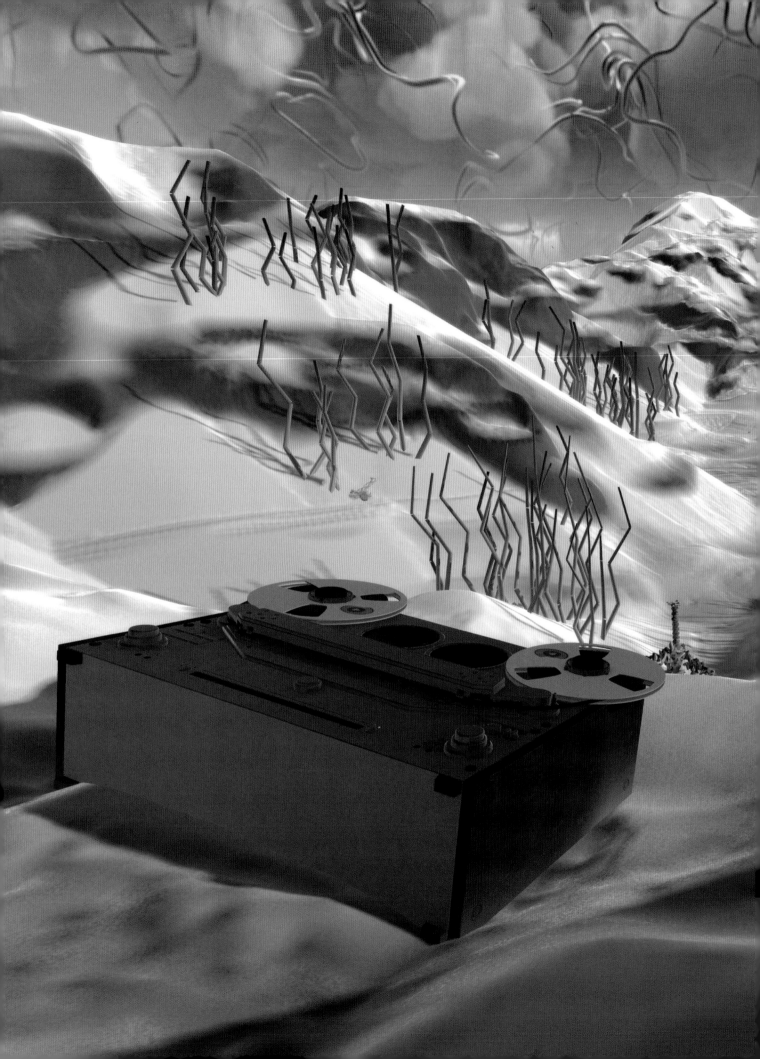

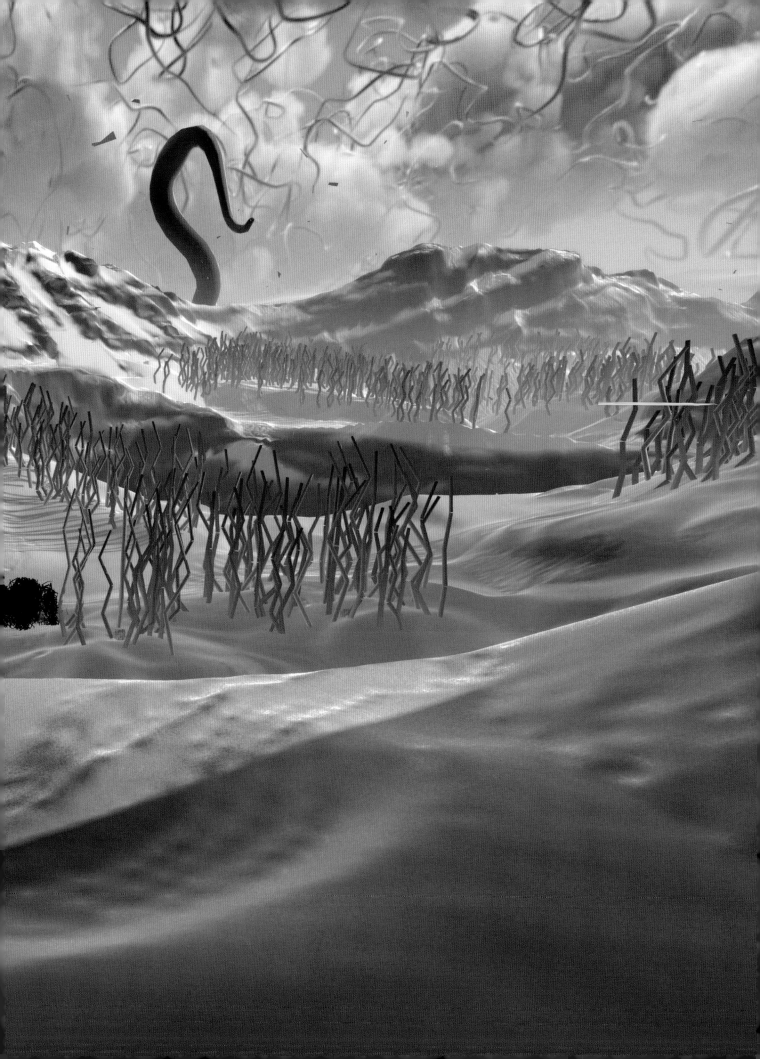

GENERATING WORLDS →

4

DEVELOPER HELLO GAMES

YEAR OF RELEASE 2016

PLATFORMS PC PLAYSTATION XBOX

NO MAN'S SKY

HOW DOES A SMALL TEAM OF GAME DEVELOPERS GO FROM MAKING A SERIES OF COLOURFUL PLATFORMERS ABOUT A PORTLY MOTORBIKE STUNTMAN TO SOMETHING BIG? REALLY BIG, BIG ENOUGH TO COMPETE FOR THE PUBLIC ATTENTION USUALLY FOCUSED ON THE CITY-SCALE WORLDS OF *GRAND THEFT AUTO* OR THE NATION-SCALE WORLDS OF *THE WITCHER 3*.

For British indie studio Hello Games, the answer was to make a world – a galaxy – of planets generated by mathematical functions, rather than authored by level designers. Using procedural generation to generate a galaxy wasn't a novel solution. All the way back in 1984, *Elite*'s galaxy was founded on the same essential principle. But *No Man's Sky* was still audacious: its galaxy comprises over eighteen quintillion unique planets, and you can land your spaceship on every single one, knowing that every other player is exploring the very same vast space.

This grand ambition set out to capture the feeling of exploration and discovery encapsulated by the golden age of science-fiction, from *Foundation* to *Dune*, supported by visual design – vibrant alien flora and fauna, sweeping geology, and distant planets suspended on the horizon – inspired by their book covers. *No Man's Sky* synthesizes into mathematical expressions the analogue imaginations of artists like Chris Foss, John Harris, Ralph McQuarrie and Moebius, and at a galactic scale. ▓

▶ **Alien terrain**

Procedural generation finds expression as dramatic landscapes of floating islands – a combination of mathematical formulae and artist-led design.

◀◀ **Planetary motion**

The planets hanging in the sky are real places; point your ship at one and fly to it and you'll seamlessly enter its atmosphere and can land on its surface.

IN A LINEAR THIRD-PERSON GAME YOU'RE EFFECTIVELY WALKING THROUGH A CORRIDOR AND WE'RE IN COMPLETE CONTROL OF WHERE YOU'RE GOING. TO GO FROM THAT TO HAVING NO CLUE ABOUT WHERE THE PLAYER IS AND WHAT THEY'LL BE LOOKING AT – PROCEDURAL GENERATION SCARED ME; EMBRACING THE CHAOS, NOISE FUNCTIONS AND THAT KIND OF THING. BUT I'VE BEEN WORKING ON THE GAME FOR A LONG TIME NOW, AND FOR WHAT YOU LOSE IN TERMS OF CONTROL, YOU GET A LOT OF WINS, ESPECIALLY IN A SCI-FI GAME.

> GRANT DUNCAN, ART DIRECTOR

No Man's Sky is made from systems. Systems that unfurl into landscapes; systems that plant trees and flowers, scatter rocks, cut rivers, dig caves; systems that govern the behaviours of their residents and the placement of resources that players will need to continue their journey. Every element exists in tension with others, a balance of one ambition for the game against another. Its makers wanted *No Man's Sky* to convey compelling realism and also to be excitingly varied – factors which tend to contradict one another. They wanted players to come across breathtaking grand vistas, but they also wanted planets to be fascinating at the micro scale. They wanted every planet to be rewarding to visit, but they also wanted players to soon move on to the next. After years of constant patching and expansions, the galaxy has evolved to meet all these ambitions, and still Hello Games isn't quite sure it's been perfected. But along the way, its artists have grown to understand what it means to create worlds with systems.

◀ **Galactic journey**

The basic object of *No Man's Sky* is to travel from the edge of the galaxy to its centre by collecting resources to power and upgrade your ship; a game design that encourages and powers exploration.

No Man's Sky's countless planets are the consequence of a close working relationship between its programmers and artists. The project started out with lead designer and programmer Sean Murray producing landscapes from mathematical noise functions like Perlin, which create pseudo-random gradients of values that look like clouds when displayed as a 2D image, and mountains and valleys when these values are used to define topographical height. Art director Grant Duncan would sit with Murray, painting over screenshots of what he'd generated, and showing him sketches, photographs and artwork with the look he wanted to achieve. Murray then tried to adapt the noise so it created the terrain that Duncan wanted. During these early days, they'd frequently hit on beautiful-looking scenes, but they soon learned these weren't enough on which to base a game.

Murray worked out ways to create new terrain features with mathematical functions and special-case code: caves, rocky promontories, plateaus, rivers, oceans, continental shapes. These formulae were difficult to develop: they might work perfectly for 100 planets, but when applied across millions of them they could unpredictably create glitched landscapes. But with Duncan's guiding eye pointing out when a forest looked too flat, or when bumpy ground caused low-growing plants to sit badly on it, they helped to add variety, points of interest that break up the noise's tendency to be continuous and unchanging, and also to introduce areas that better support the practicalities of play. Creatures had to be able to credibly walk around them, too, and players needed flat space to be able to land their ship.

▼▶ **Infinite variety**
Every change to the game can have unforeseen effects on the way the galaxy generates, so Hello Games created a series of bots, which fly to random planets. Live video from each bot is displayed on a TV in the studio so the team can see how the galaxy looks.

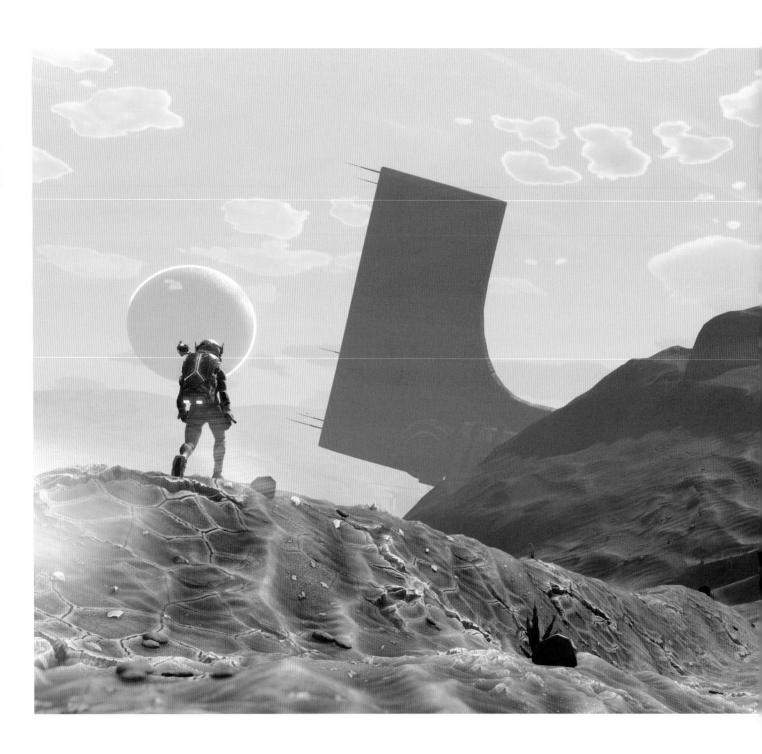

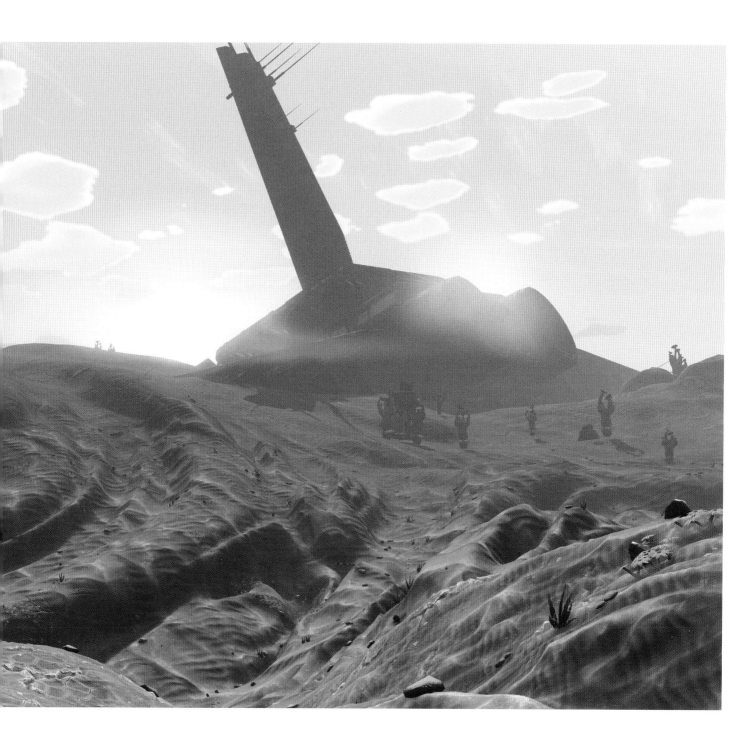

⬆ Space hulk

Some planets feature vast crashed
spaceships. To keep them from looking
repetitive, Hello Games ensures they're rare
and relies on their procedurally generated
environment to lend them uniqueness.

▶▶ Colour of magic

Players tend to be drawn to worlds with
blue skies and green grass, but these places
also lose a sense of alien wonder.

STRAIGHT NOISE FUNCTIONS ARE OFTEN REALLY
REPETITIOUS, SO YOU'D WALK OVER A MOUNTAIN AND
YOU SEE ANOTHER MOUNTAIN THAT'S MUCH THE SAME
SHAPE AND BECOME LOST. IT LOOKED PRETTY ENOUGH,
BUT IT DIDN'T MAKE FOR A PARTICULARLY INTERESTING
GAME, AND WHILE IT NORMALLY LOOKS GOOD WHEN
YOU'RE FAR AWAY, WHEN YOU'RE WALKING ON IT, IT
DOESN'T REALLY HOLD UP. SO YOU START TO THINK
OF ADDING MORE VARIETY AND SHAPES IN VISTAS
TO STOP THAT REPETITION.

⟩ SEAN MURRAY, PROGRAMMER AND DESIGNER

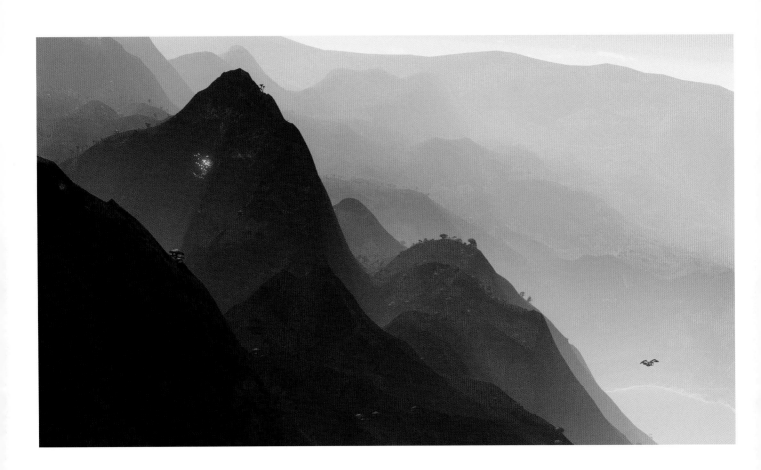

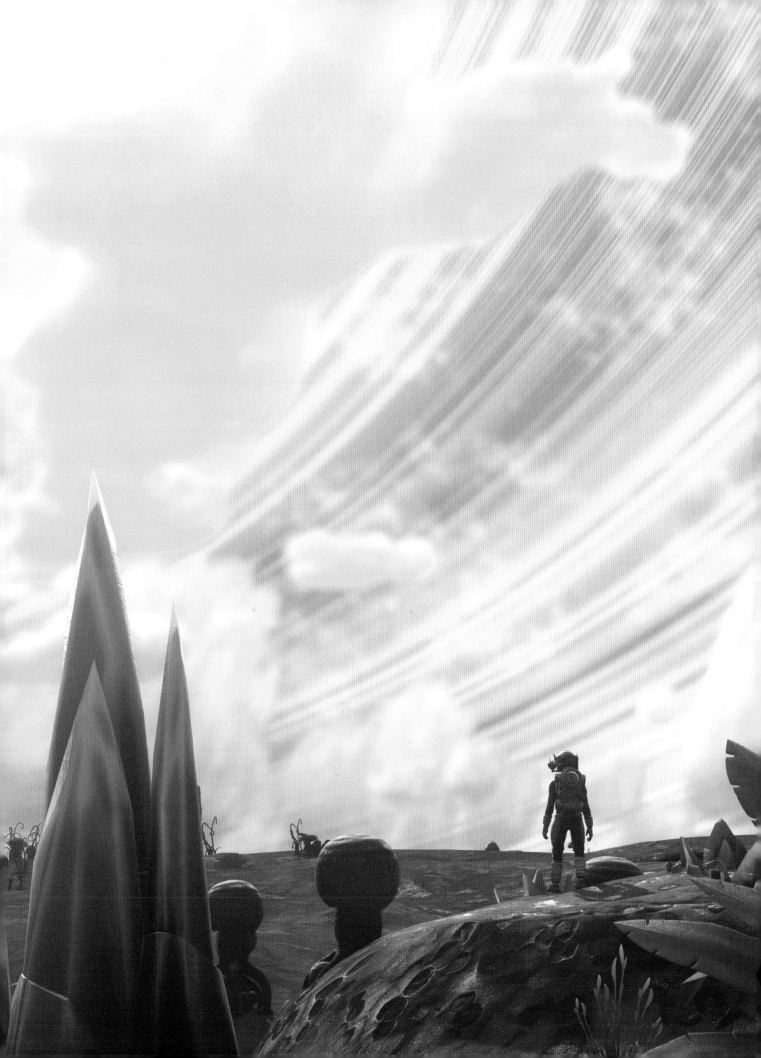

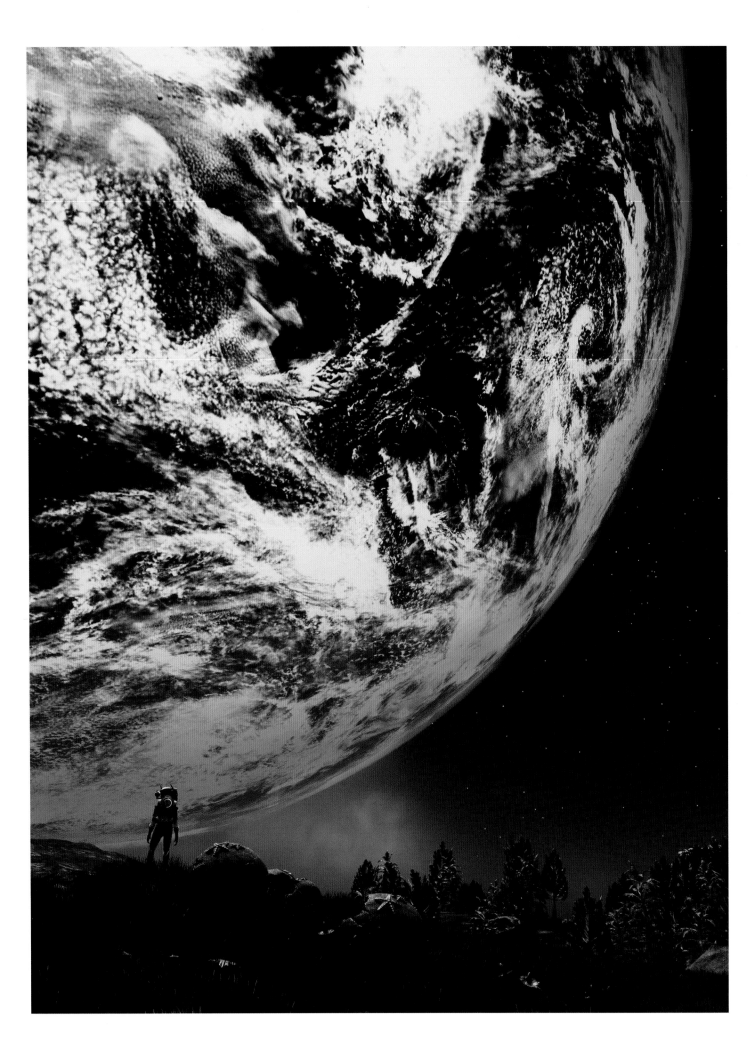

THE DISTANCE BETWEEN DIFFERENT LANDMARKS HAS A HUGE IMPACT ON HOW YOU PERCEIVE SCALE, LIKE HOW FAR APART MOUNTAINS ARE AND EVEN SMALL MOUNDS OF EARTH. WE'D BE PROTOTYPING AND WE COULD GO IN AND CHANGE THE NUMBERS FOR HOW FAR APART ROCK MOUNDS AND MOUNTAINS ARE, AND CHANGING THEM HAD A HUGE IMPACT ON HOW IT FELT TO MOVE AROUND. IF YOU SPACE THINGS OUT TOO FAR, YOU FEEL LIKE YOU'RE MOVING SO MUCH SLOWER. SO WE HAD TO FIND A SWEET SPOT WHERE YOU'RE GETTING THAT SCI-FI SENSE OF AN ENORMOUS PLACE, BUT STILL TRYING TO MAINTAIN THAT FEELING OF ACTUALLY GETTING SOMEWHERE.

> GRANT DUNCAN

For Duncan, much of the process of guiding the systems that govern *No Man's Sky*'s procedural generation was a matter of backwards engineering the rules of thumb he'd learned when making environments for more traditional games. In the past, he'd have arranged rocks around the base of a tree, then some pebbles and clumps of grass; for *No Man's Sky* he had to codify these principles into sets of rules that a programmer could translate into maths functions. And then, since he was imagining alien worlds, to create the same kinds of rules for how giant mushrooms or spires of honeycombed rock might sit in the world.

Despite this work, for almost all of *No Man's Sky*'s initial development, Murray could only see the code in the terrains. Landing on a planet, he'd see which of the categories of noise and maths functions had generated it, and not the alien landscape they were meant to conjure into being. As the game's designer, that made it difficult for him to understand what kind of experience the player might be taking from the world.

◄ **Point of view**

Some planets have huge and exciting features like kilometre-high mountains. Their scale doesn't tend to play well – walking up a hill for two kilometres is not very interesting – but they do make inspiring vistas.

MY PERSONAL EXPERIENCE IS THAT WITH A GAME
THAT'S OVERLAPPING SYSTEMS, I CAN SEE THEM
ALL. WITH *NO MAN'S SKY*, ON A BAD DAY I WAS JUST
SEEING A SYSTEM THAT PLACES TREES EVERYWHERE
AND A TERRAIN THAT'S A COUPLE OF SINE WAVES
OVERLAPPING. YOU HAVE THAT FEELING OF,
'WHAT EVEN IS THIS?'

〉SEAN MURRAY

But then, uncomfortably close to the game's release, came a breakthrough. Murray and the programming team had been looking for ways to combine the twenty-plus different world generation functions they'd developed into a single 'über' function. With the help of the Superformula, which was proposed in 2003 by a botanist called Johan Gielis and generates with an outwardly simple equation a wide array of natural and abstract shapes, Murray worked out commonalities between the functions so they could coexist. Now the game could blend between them, opening up a vast sea of planetary variety that had been impossible before. This was the moment when *No Man's Sky*'s creators began to be surprised by what they found deep in their galaxy.

Yet too much variety could kill *No Man's Sky*. As a game about exploration, the rhythm of travelling from planet to planet is its heartbeat. While beautiful and diverse environments help players believe that there's a perfect planet somewhere out there for them, if they're too beautiful and diverse, the players will want to put down roots. They'll build a base and stop exploring, their curiosity quenched. So *No Man's Sky*'s planet generation intentionally stops before perfection, holding back some of its riches so that players have a reason to move on. Not every planet presents players with verdant rainforests, and some plants only grow in certain places. Variety stretches across the galaxy, not just on the planets themselves.

▲ **Visual balance**

Artists were still able to apply classic rules of composition to guarantee objects are pleasing to the eye from every angle.

▶ **Natural habitat**

Sets of flora and fauna are generated for different biomes on each planet, whether underground, underwater or on the surface.

▶▶ **Star base**

Players can build bases on planets from a menu of modular components, which are prefabricated by Hello Games' artists.

THERE'S REAL CHAOS TO PROCEDURAL NOISE, AND WE DON'T KNOW WHAT'LL HAPPEN UNTIL WE TURN IT ON. BUT WHEN YOU GET THE RIGHT LEVEL OF CONTROL, YOU END UP WITH SOMETHING THAT'S PROBABLY BETTER THAN IF YOU DID IT BY HAND. MAYBE BETTER'S NOT THE RIGHT WORD. I GUESS YOU'D SAY HAPPY ACCIDENTS. THAT'S NOT SOMETHING YOU HAVE VERY OFTEN WITH COMPUTER ART. WITH TRADITIONAL ART YOU'RE OFTEN THROWING THINGS AROUND TO SEE WHAT YOU'LL GET, BUT WITH COMPUTERS WE'RE SO USED TO EVERYTHING HAPPENING FOR A REASON. HAVING THIS CHAOTIC ELEMENT IS INSTANTLY VERY COOL.

> GRANT DUNCAN

No Man's Sky is, then, a game of competing systems that push and pull against each other. It's not a game of perfection, whether by necessity or design. Its galaxy is a place of balance, where mathematics is tamed just enough that it creates stable, recognizable, interesting places without breaking down into abstraction. Very different to the promise of idealism that lies within most game development, it's clearly taken Hello Games' artists on a journey that's brought them to value the creative side of procedural generation.

▶ **Light touch**
Physically based lighting means materials react to light as you'd expect, but this also means that a green sky will give everything on a planet a greenish tint. Balancing colours has been a challenge throughout development.

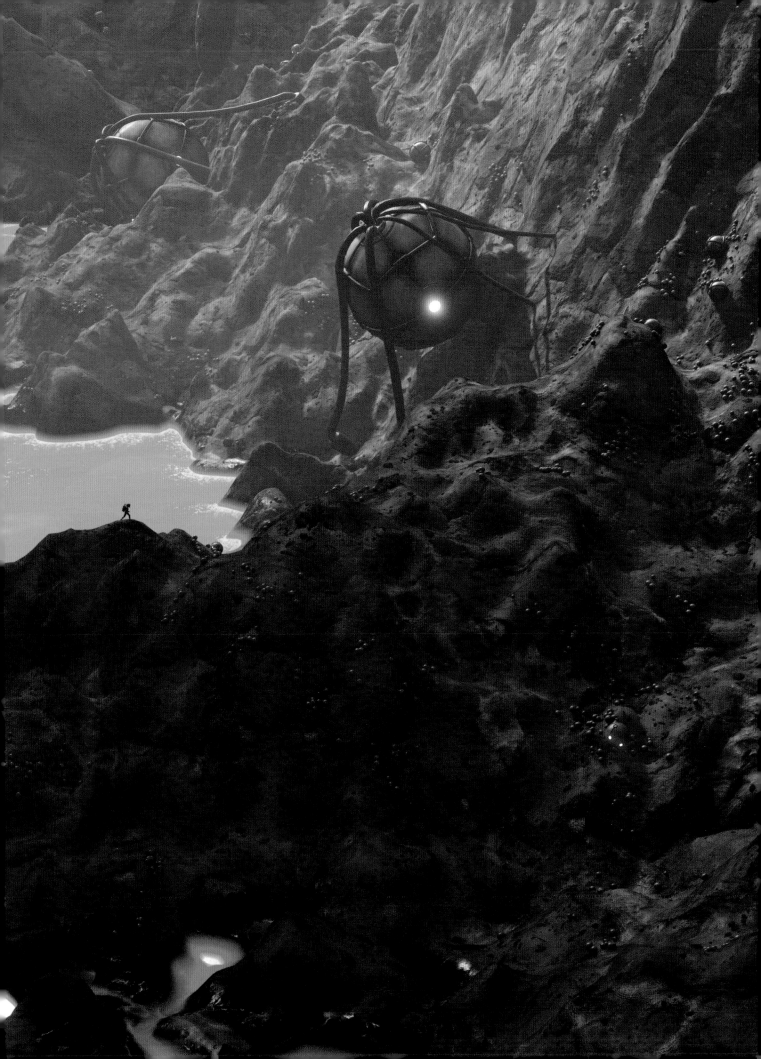

A NOBLE JOURNEY →

5

PLATFORMS PC PLAYSTATION SWITCH XBOX

DEVELOPER ASOBO STUDIO

YEAR OF RELEASE 2019

A PLAGUE TALE: INNOCENCE

RATS SWARM AND FLOW THROUGH THE BLACK DEATH FANTASY OF *A PLAGUE TALE: INNOCENCE*. BURSTING FROM THE EARTH IN PESTILENTIAL HORDES, THIS SUPERNATURAL FORCE HAS EATEN ITS WAY THROUGH VILLAGES, TOWNS AND CITIES, BUT THE SOLDIERS AND LEADERS OF THE INQUISITION, WHO SEEM TO BE TAKING ADVANTAGE OF THE PLAGUE, PROVE EVEN MORE SINISTER.

You play as Amicia de Rune, a teenage noble who fights for the survival of herself and her ailing little brother as they travel the French countryside in search of safety. Asobo Studio, which is also behind the world-spanning realism of 2020's *Microsoft Flight Simulator*, has long been known as an inventively tech-led developer, and *A Plague Tale*'s dynamic swarms of thousands of rats speak to that ability.

In creating Amicia the studio has also proven its skill as a storyteller, focusing the effort of a comparatively small team on creating a character you feel for and want to succeed. Amicia's personal struggle is reflected in every aspect of her visual character design. Her movements convey her vulnerability, yet she's agile enough to stealthily traverse the world. Her character model reflects her origins as an aristocrat and the subsequent strain and struggle of her quest; her open and expressive face exposes her humanity as she desperately resists despair in a world which is filled with it. ▧

▶ **Heart and soul**
Amicia de Rune's eyes encapsulate her perspective on her predicament, a point of instant communication between the player and her fiction

◀◀ **Rat**
A Plague Tale's multitudes of rats swarm and surge to attack Amicia and avoid light, but her character development is what makes players care about the rats' threat

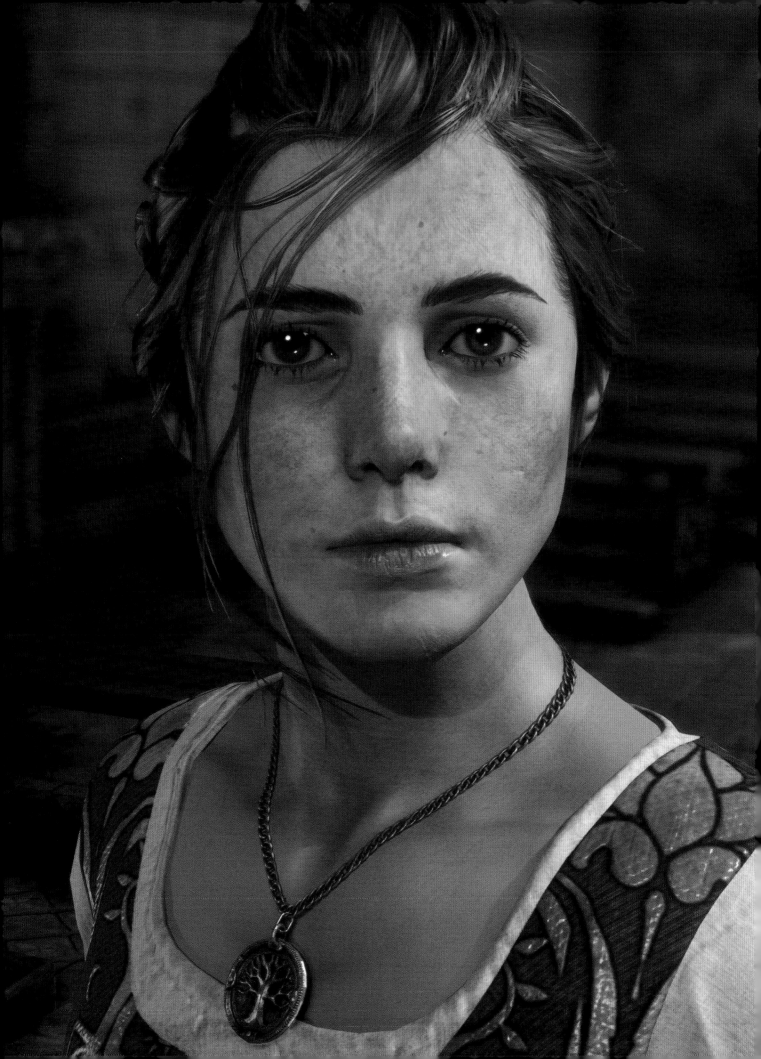

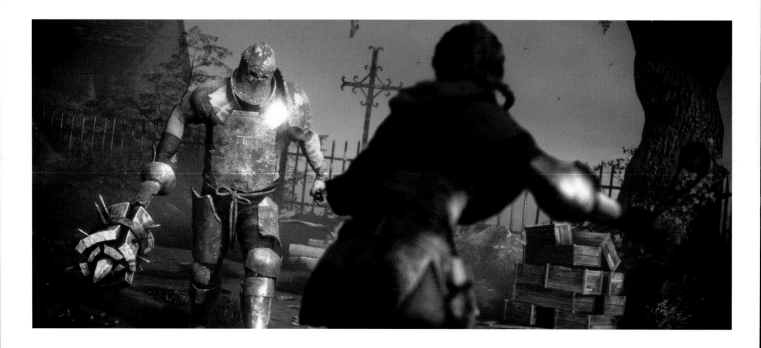

Amicia wears her gruelling journey through rat-infested medieval France. By its end, she has furs across her shoulders for warmth, beneath a hard-wearing leather cape. Under that is a long tunic embroidered with her now-faded family coat of arms. On her belt hang her slingshot and the pouches of stones and alchemical concoctions she throws with it. On her right elbow is a couter, a piece of shining armour. Her clothes are a record of a hard winter, survived by scavenging fallow fields and corpse-strewn town alleys, and augmented by the occasional kindness of strangers, but you can still just about distinguish her noble upbringing.

Amicia's character model changes throughout the game. It begins with a hunting trip with her father in the forest near her family's home. The fabric of her tunic is fine and features her family crest embroidered in gold, but its colours are soon dulled as she's forced to take flight when soldiers, led by a brutal knight, attack her home.

▲ **At large**
Knights are terrifying opponents, not only because Amicia can barely harm them but also because they tower over her

▶ **Tail end**
Players see Amicia from behind for most of the game; to help make her back interesting, her hair braid and pouches at her belt physically bounce with her steps

SHE HAS JUST ONE PIECE OF ARMOUR. WHEN YOU SEE IT, YOU THINK IT'S USELESS, BUT IT BROUGHT SOMETHING COOL IN TERMS OF SILHOUETTE AND MADE HER RECOGNIZABLE, AND IT ALSO TRANSLATES SOMETHING PRETTY STRONG ABOUT THE CHARACTER, WHICH IS THAT SHE'S YOUNG AND NAIVE. IT'S LIKE SHE'S WEARING IT, THINKING THAT IT WILL SOMEHOW PROTECT HER, WHICH IS REALLY NOT THE CASE. IT'S TOTALLY USELESS. EVEN IF IN THE FIRST VIEW IT MIGHT SEEM WEIRD, ULTIMATELY IT SERVES THE CHARACTER.

> OLIVIER PONSONNET, ART DIRECTOR

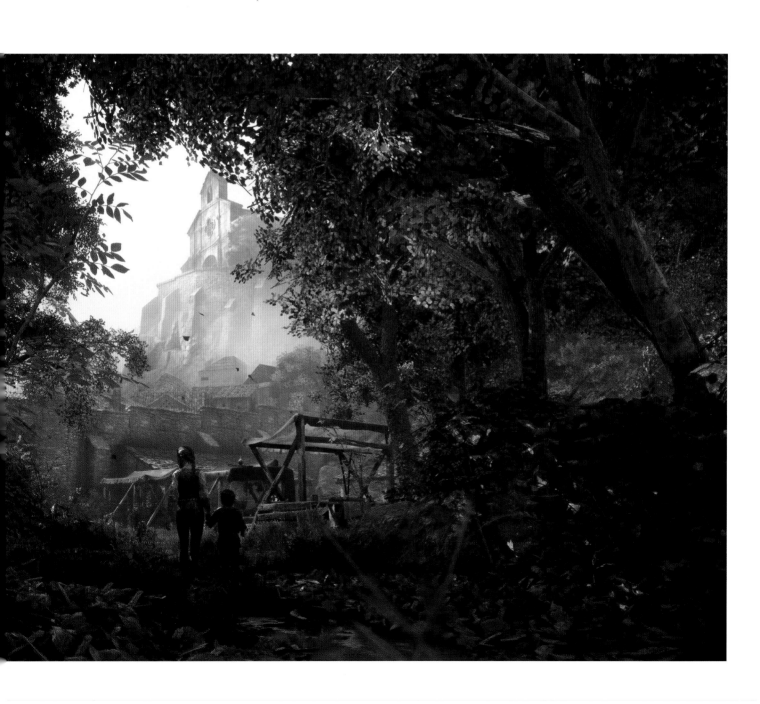

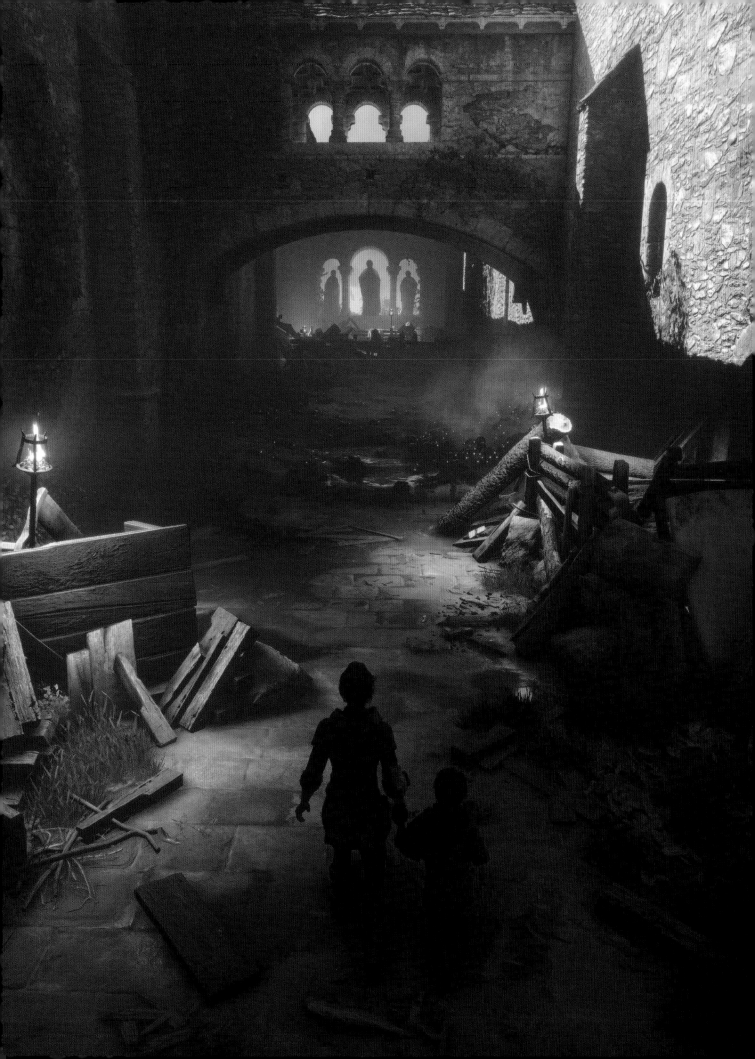

DURING THIS ERA, WOMEN DID NOT WEAR PANTS, BUT A DRESS IS TECHNICALLY REALLY DIFFICULT TO CREATE, ESPECIALLY WHEN YOU HAVE MOVES LIKE CROUCHING UNDER A TABLE, WHICH ARE VERY COMPLICATED. WE'RE NOT A HUGE STUDIO AND WE DON'T HAVE TONNES OF TECH DEVELOPERS, SO WE HAD TO BE CLEVER. BUT WHAT'S NICE WITH HER WEARING PANTS IS THAT THEY TRANSLATE SOME MODERNITY TO HER CHARACTER. AT THE BEGINNING OF THE GAME, SHE SPEAKS TO HER FATHER IN A WAY THAT A YOUNG TEENAGER WOULD TALK NOWADAYS; IT'S AS IF SHE'S A MODERN TEENAGER DROPPED INTO THIS DIFFICULT ERA. SO THAT WAS LUCKY.

> OLIVIER PONSONNET

Amicia's designers wanted her to keep the tunic throughout the game, because it's a direct link to her origins and a reminder of the familial relationships which drive her will to endure. The darker, rougher layers of clothes which she successively adds to her costume – the leather cape and the furs – contrast with the tunic, reflecting the increasingly apocalyptic atmosphere of the world.

Notably, however, Amicia does not wear a dress, as a fifteen-year-old noble-born girl of the Middle Ages would have done. *A Plague Tale*'s artists are acutely aware of the conflicting needs of historical authenticity, game development, and ensuring scenes read to players the way they are intended. Outside of character design, for example, they found that presenting French medieval churches as being newly built, with sharp and clean sandstone covered in colourful paintings, just didn't read as authentic, even though they'd be historically accurate for the era in which the game is set. The team learned to make buildings look old, partly because that's how we're familiar with them looking today, and partly because it's difficult to imply a sense of story on a new surface; faded decorations and worn stone helped ground *A Plague Tale*'s world.

◀ **Rough outline**
Amicia wears a couter on her right elbow, more as a talisman than for practical reasons, and it gives her figure a visually interesting asymmetry

▸▸ **Model citizen**
Players can build bases on planets from a menu of modular components, which are prefabricated by Hello Games' artists.

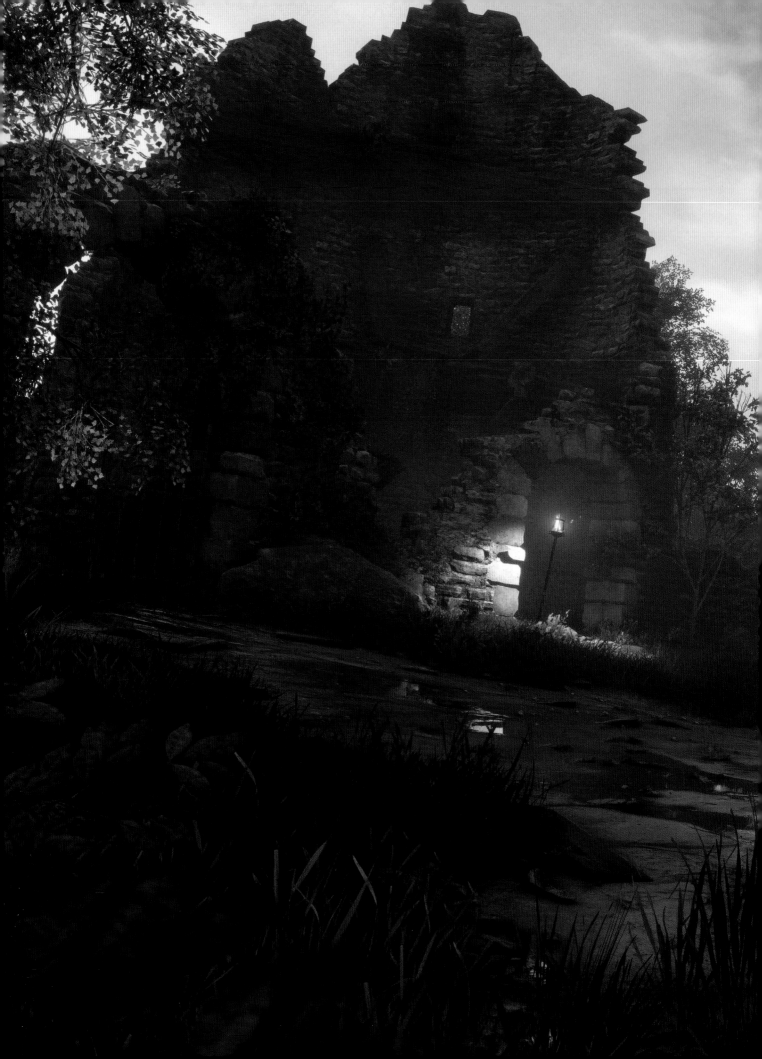

The same went for the peasants Amicia meets. The first iterations of these characters wore clean clothes, but art director Olivier Ponsonnet says that they looked weird to eyes trained on a modern vision of Middle Ages peasantry as filthy and ragged, partly fabricated by films like *Monty Python and the Holy Grail*.

Amicia's animation was also designed to match her background, another close balancing act between credible realism, the needs of the game, and characterization. Her youth had to come through, with a lightness of step which wasn't too childlike and jumpy, and players also needed her to be able to easily traverse the environment, to climb and jump without coming across as too strong and agile. Every time the animators and artists tried something new, they'd ask themselves whether they'd be able to make the same move. If not, Amicia should probably not to be able to either.

Her movements also needed to characterize her relationship with her little brother, Hugo. Frail and even more vulnerable than Amicia, Hugo is his sister's abiding responsibility throughout the game, and *A Plague Tale* has to constantly reinforce Amicia's – and the player's – determination to keep him safe.

CREATING THE ANIMATION OF A SIX-YEAR-OLD WAS REALLY DIFFICULT. A KID JUST DOESN'T MOVE LIKE AN ADULT – THE WAY THEY CLIMB EVEN A LITTLE WALL, THE WAY THEY JUMP. WE WANTED THE PLAYER TO LOVE HIM, NOT TO HATE HIM AS A USELESS LITTLE BUDDY, WHICH IS REALLY EASY TO DO. SO WE WORKED A LOT ON HIM, ON THE NARRATION, THE LEVEL DESIGN, TO MAKE HIM NOT LOOK LIKE A FOOL. IT WAS REALLY DIFFICULT, TRIAL AND ERROR. IT WAS A PAIN.

> OLIVIER PONSONNET

▶ **Dazzling locks**
Hair always presents a challenge for artists. Hugo's makers created special specular reflection so it would shine correctly and not look like plastic

YOU'RE NOT STRONG; YOU CAN'T JUST GO AND KILL EVERYONE. IT'S ABOUT BEING SCARED, HUMBLE, AND BEING SMART. THESE FEELINGS WE WANTED TO CONVEY TO THE PLAYER, AND THEY SUPPORTED THE STORY ABOUT OUR CHARACTERS: THEY'RE LOST IN THIS WORLD AND MIGHT NOT SURVIVE, BUT FINALLY THEY MANAGE. IT'S HARD; IT'S THE MIDDLE AGES; THEY'RE TWO NOBLE KIDS WITH NO EXPERIENCE OF THE NORMAL WORLD.

> OLIVIER PONSONNET

Amicia, controlled by the player, can order Hugo to stay and follow, and she can also hold hands with him, a simple-seeming action which was very difficult to develop. When they're holding hands, Amicia and Hugo merge to become a single, much larger player character which the environments have to take into account, so there's space for them to manoeuvre. What's more, when you turn, Hugo has to move around Amicia in such a way that the turn is quick enough to feel good to control, while also not requiring him to move ridiculously fast to complete the circle.

Scale was yet another consideration in Asobo's continual underscoring of Amicia's imperilled place in the world. The team changed her size three times during *A Plague Tale*'s development, causing them to have to redesign her animation and obstacles she's meant to be able to climb over.

▲ **Crouch**

Amicia's model had to be designed so it would look right in many poses, from any arbitrary angle, and at many different ranges

▼ **Age difference**

The height disparity between Amicia and Hugo imposed many problems, since Hugo has to be able to move as quickly and nimbly as Amicia

All the work was necessary, however, since Ponsonnet and his team knew they needed to ensure players feel clearly that there's a fundamental difference between the adults in the world, most of whom are antagonists, and Amicia and the other young people she meets, all of whom are allies. It's intentional that she's much smaller than the soldiers she faces, heightening the sense of danger and underscoring the fact that she cannot fight them directly.

The strength of this characterization is down to the way it's communicated so consistently through so many different parts of *A Plague Tale*'s visual design, from animation to model scale to costumes. That consistency is, surely, in part due to the team that worked on the game. Some thirty people worked across art and animation – and that meant that no one could specialize on narrow splinters. As art director, Ponsonnet didn't sit on high; rather, he directly contributed to most aspects of the game, including level design, lighting, character models and concept art. That breadth of involvement helped Amicia emerge from the imagination of writer Sébastien Renard, and then freely evolve in conversation with everyone who created her.

◀ ▲ **Ambient tone**

Character models' colour palettes are muted, helping them sit naturally in the environments and atmospheres the game has them explore

▶ **Wet look**

Amicia falls into water and spends ten minutes soaked, her clothes sticking to her skin. The game uses a unique model for this section to sell her cold and discomfort

▶▶ **Point of interest**

While Amicia is *A Plague Tale*'s central character, she can't demand the player's attention all the time. The environments she moves through also need to take central stage

PAINTING HISTORY →

6

DISCO ELYSIUM

PLATFORMS PC PLAYSTATION SWITCH XBOX

YEAR OF RELEASE 2019

DEVELOPER ZA/UM

A DECOMPOSING MAN HANGS FROM A TREE BEHIND A HOSTEL IN MARTINAISE, ONE OF REVACHOL'S MOST DOWNTRODDEN NEIGHBOURHOODS, AND, WITH LOCAL TENSIONS REACHING BOILING POINT, YOU HAVE BEEN CALLED TO INVESTIGATE. YOU, HOWEVER, ARE A BROKEN DEADBEAT OF A MAN WHO WAKES UP AT THE GAME'S BEGINNING WITH THE WORLD'S WORST HANGOVER AND NO MEMORY THAT HE'S A COP.

This computer role-playing game was developed by ZA/UM, an Estonian art collective founded by writer Robert Kurvitz. He'd sketched its 'fantastic-realist' world in a tabletop *Dungeons & Dragons* RPG for friends, then written a novel set in it, and in 2016 he set out with the ambition of using it to advance the CRPG (computer role-playing game) far beyond its antecedents, with an open-ended narrative which seamlessly reacts to the player's choices, and a system of skills which offer deep character development.

Over the course of *Disco Elysium*'s long and difficult development, ZA/UM coalesced from a group of friends teaching themselves how to make a game in a dilapidated squat in Tallinn into a videogame developer with offices in the UK. Through that process, the game went through a number of name changes and the world had to be scaled back from the sprawl of city it was originally intended to cover to a district, but its writers still wrote over a million words of dialogue, words which work in perfect concert with art director Aleksander Rostov's expressive brushstroke art. Together they portray Revachol's dark corners, its living hopes, and the tortured player character at its centre. ▓

▶ **Bird's eye**
Disco Elysium's world is presented from an isometric perspective, which looks down on and across the city and its rooftops from on high

◀◀ **Close up**
The camera can be zoomed in to capture the detail of the world and how it is composed with painterly brush strokes

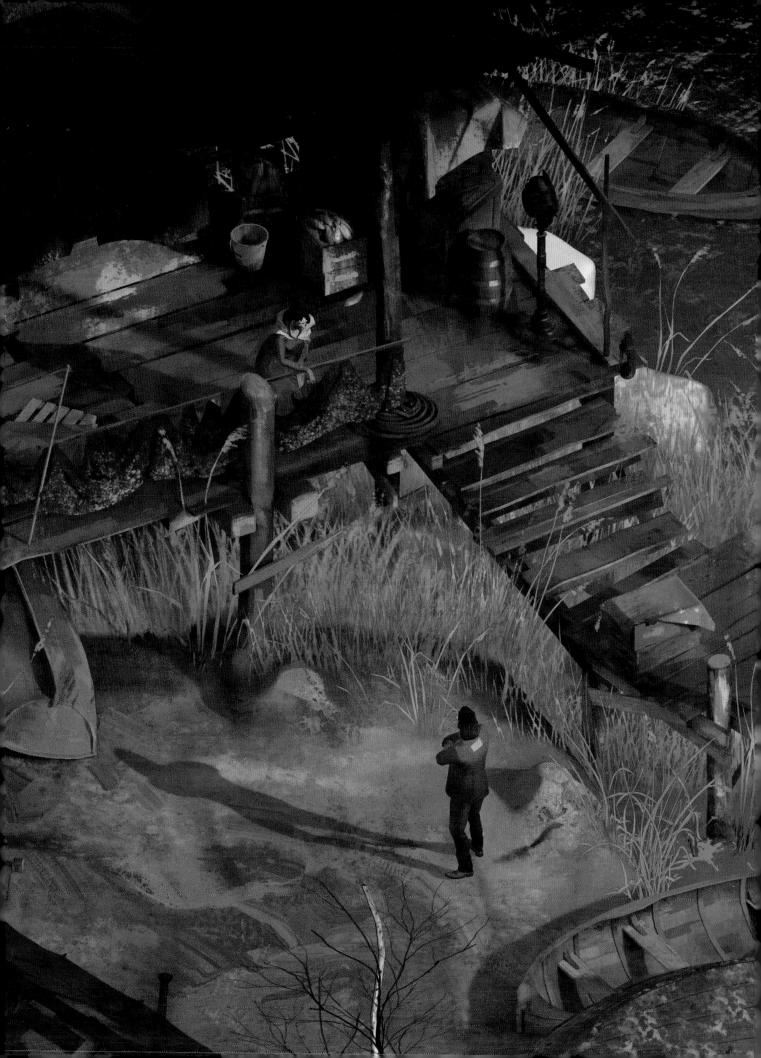

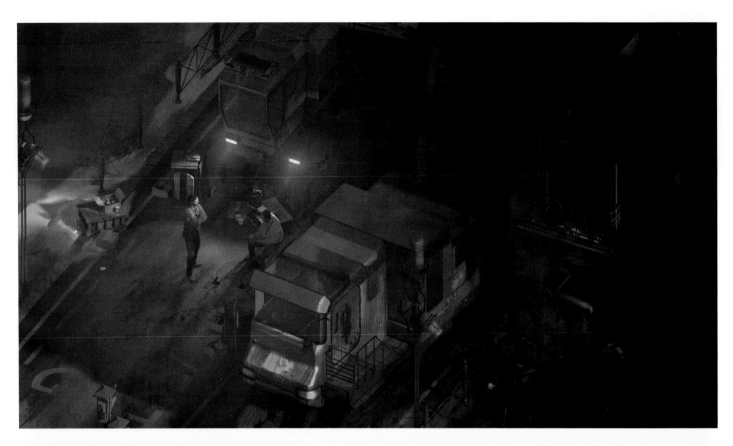

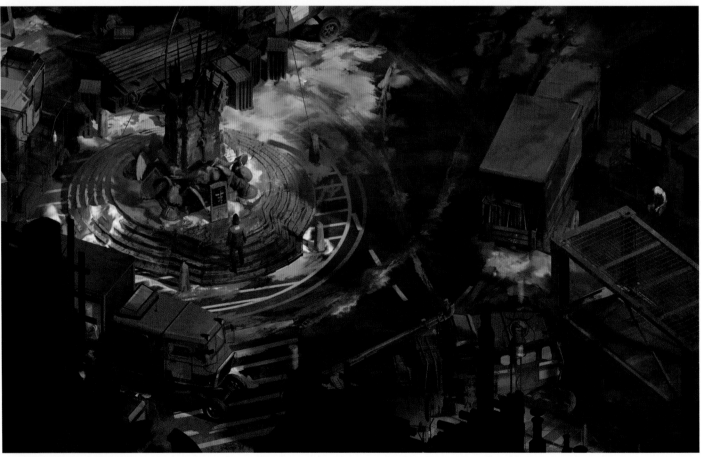

Revachol started with a painting. A monumental raised highway sweeps across the roofs of a crowded European-style city, towards a horizon pierced by the crooked steeple of a broken church and crowned by a setting sun. Its technology is not quite our own. The setting is both familiar and strange, a blend of times and places.

Elysium is a world of words. Its history and geography are explained and expanded upon through dialogue with characters and in descriptions which scroll down the rightmost quadrant of the screen. Every facet of Elysium has been imagined: its economy, politics, tangled ideologies and societal strata. Entire countries that you'll never visit – their borders, cultures and wars – are described, if you can find a character to tell you about them. All these streams of exposition lead to *Disco Elysium*'s setting: Revachol, a maritime conurbation that encrusts the delta of a river running into the vastness of the Insulindic Ocean.

THE PAINTING CONVEYED TO US THIS NINETEENTH-CENTURY IDEA OF REALISM AND ALSO FANTASTICAL ELEMENTS. IT HAD THIS MOTOR TRACK, THIS HUGE, MONSTROUS CONSTRUCTION, AND WHAT LOOKS LIKE A FAVELA CLIMBING UP ITS SUPPORT PILLARS. IT HAD REAL ELEMENTS – THERE ARE HIGHWAYS GOING OVER CITIES ALL OVER THE WORLD – BUT IT HAD THIS MOMENT OF BEING REALISTIC AND FANTASTICAL AT THE SAME TIME. THAT WAS THE EUREKA MOMENT, WHERE THE EMOTION AND TONE WE WERE TRYING TO WRITE WERE UNDERSTANDABLE.

> ALEKSANDER ROSTOV, ART DIRECTOR

▲ **Making contact**
Characters dotted around the environments tell players about their place in the world, its history and their hopes for its future

▼ **Traffic jam**
Outside the docks area of Martinaise is a junction filled with stationary trucks, halted because of the ongoing strike. At the centre is a broken statue

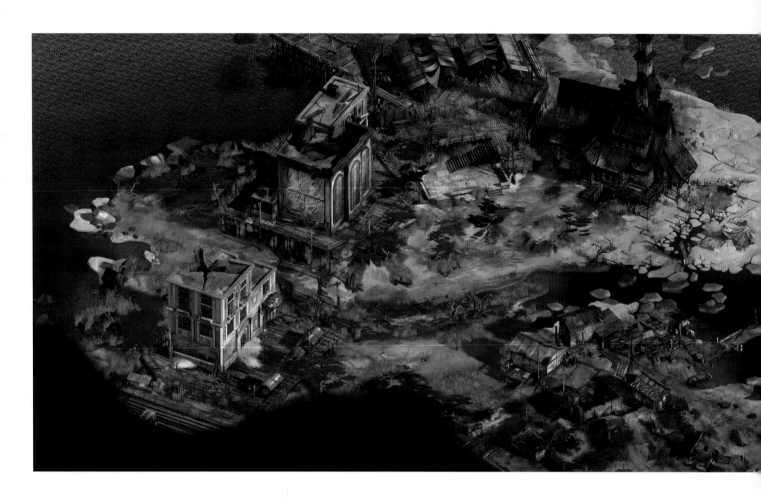

IF YOU LOOK AROUND THE REAL WORLD, NOT EVERYTHING
IS FROM A CERTAIN TIME. YOU MIGHT HAVE YOUR
GRANDMA'S TABLE FROM THE '30S, CURTAINS HANDED
DOWN FROM YOUR PARENTS, AND A PICTURE FRAME
FROM A FLEA MARKET IN DUBAI. ALL THESE CULTURAL
REFERENCES AND HISTORIES, THEY BLEND TOGETHER
TO CREATE THE NOWNESS OF SOMEWHERE. SO WHAT DO
WE CHOOSE FROM THE PAST AND THE OTHER PLACES IN
THE WORLD? WE'D GET CUES FROM THE WRITERS, OR WE
WOULD HAND THEM OBJECTS SO THEY COULD USE THEM
TO EXPRESS MORE OF THE REST OF THE GAME'S WORLD.

> KASPAR TAMSALU, ARTIST

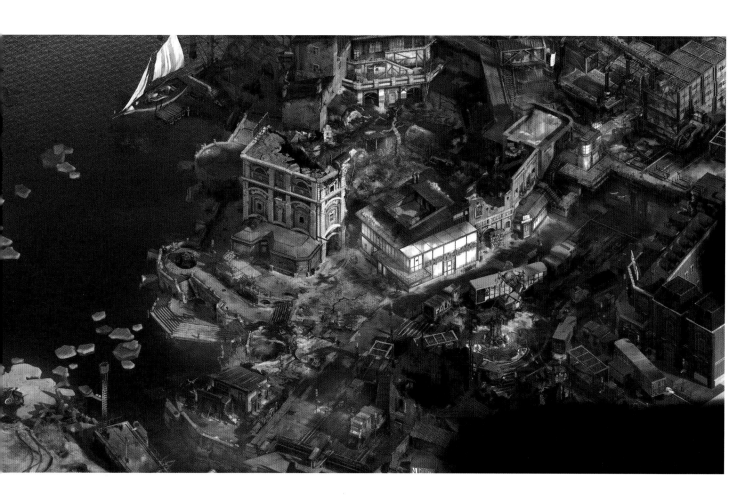

Its central position in Elysium makes Revachol one of the most important places in the world, and also the most exploited. This is a city peopled by the powerless, where every nation vies for control. Its history is written into its very fabric, its bullet-riddled advertising hoardings, decaying hovels and shuttered businesses.

As such, Revachol isn't only expounded in words; it's also an intensely visual place. As the player, you see the city from a high isometric angle, watching your broken policeman run across squares and along alleyways far below. This viewpoint – a deliberate reference to the classic CRPGs that inspired *Disco Elysium*, including *Baldur's Gate*, *Planescape: Torment* and *Fallout* – gives you an encompassing view of the world. While your amnesiac, substance-addled, psychosis-suffering character wrestles with understanding himself and the situation in which he's landed, you can see everything, articulated through the texture of Rostov's rough brushstrokes and meticulously detailed, intimate ephemera and city clutter.

▲ **Play space**

The entire story, more or less, takes place within this play space, a size small enough for players to internalize and become invested in its past and present

Once Rostov's painting had defined Revachol's tone, its physical geography first came together on a map drawn on lunchtime napkins. Eminent Domain, the district depicted in the painting; Jamrock; Grand Couron; and Martinaise, the declining waterfront where the game itself is set, were laid out. Key locations were initially constructed as a series of story points, places that characters would inhabit, and where their narratives and quest-lines would play out: Whirling in Rags, the hostel where the player character stays; the square outside the Whirling, the scene of a strike, with a crowd of protesters at the closed entrance to the dockyards and a line of backed-up trucks; and the area behind the Whirling, where hangs the corpse the player is here to investigate. Between these places was empty space, ready for the artists to fill in.

Sometimes the writers paid close attention to the locations the artists imagined, steering the images to match their own visions. In other cases, the writers left the artists to their own devices, and later wrote characters, histories and quest-lines to fit the spaces the artists had visualized.

◢ **White cube**

The bright modernity of the Whirling in Rags hostel sits like an alien intervention in the war-broken remains of the older city

▶ **Figure study**

Characters are smoothly animated 3D models which helps bring them to life against the game's static backgrounds

◀ **Pull back**

The isometric view allows glimpses of areas, such as this rooftop space on top of the Whirling in Rags, that players can't initially access

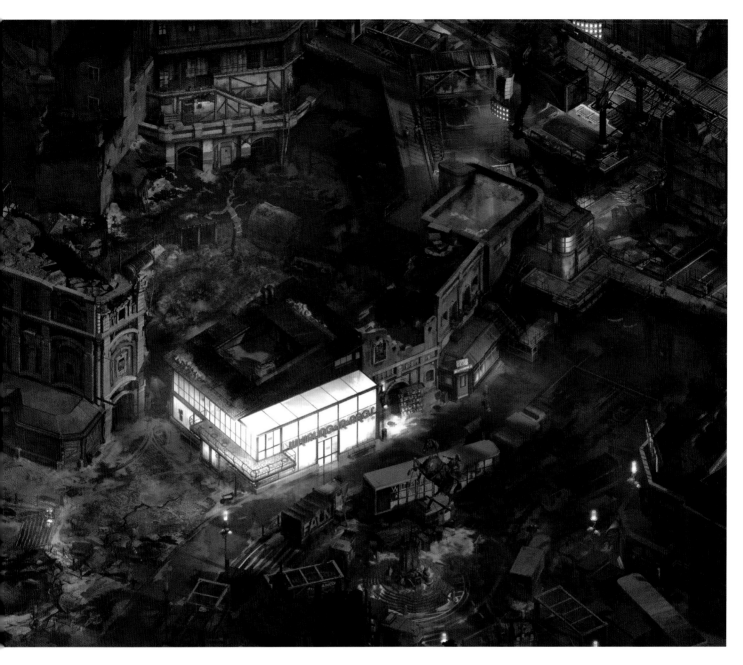

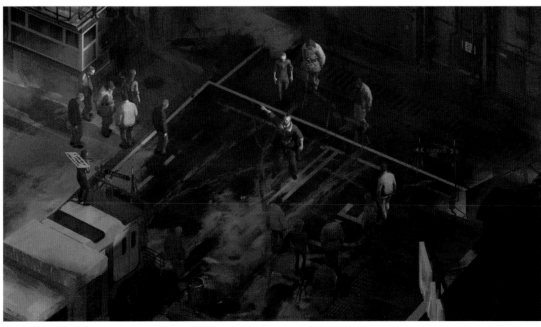

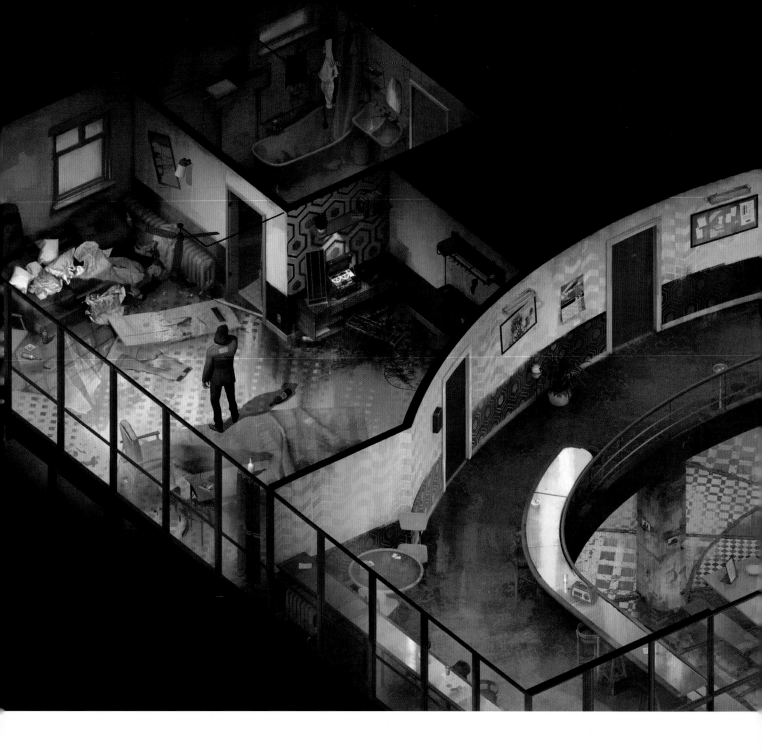

◤ Changing rooms

The Whirling in Rags geometric interior decoration has become scruffy but still contrasts wildly with the state of your character's room

▸▸ Doomed Commercial Area

Left: Exterior of what was once called the East Delta Commercial Centre; Right top: The failed ARTEMITEP boxing gym; Right bottom: The DCA's dusty basement

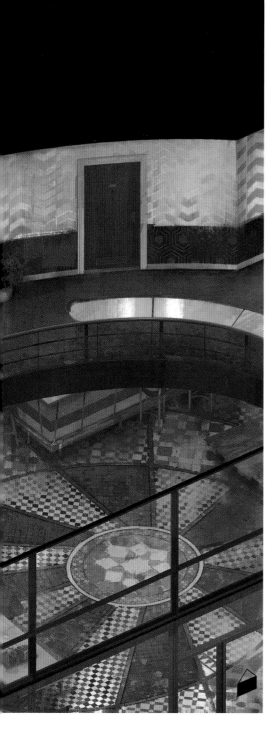

IF THERE WAS SOMETHING
IMPORTANT, CENTRAL TO THE
STORY, THAT ROBERT [KURVITZ]
OR THE OTHER WRITERS WERE
WORKING ON, THEN THAT
MIGHT GET A MORE DETAILED
DESCRIPTION, BUT SOMETIMES
IT WAS JUST THAT THEY NEEDED
SOMETHING LIKE THIS OR THAT,
AND WE'D GET A FRAMEWORK OR
A MOOD OR A CHARACTER WHO
INHABITS THAT SPACE, AND WE
STARTED TO GO MORE INTO DETAIL
FROM THERE.

> KASPAR TAMSALU

A couple of times the artists ended up creating far more than was intended. A writer worked with artist Kaspar Tamsalu to build the Capeside Apartments, originally meant to be the location of a couple of plot-important characters. But when the writer moved on to work on other characters, Tamsalu found himself adding more rooms; the main hallway soon featured seven apartments, along with two more accessed by a balcony at its back and a coal chamber on an upper floor. Capeside Apartments became a significant part of the game, a chance to explore the domestic existence of a cross-section of Martinaise's inhabitants: the elderly, embittered youth, communist dreamers, desperate estate agents, gentrifiers.

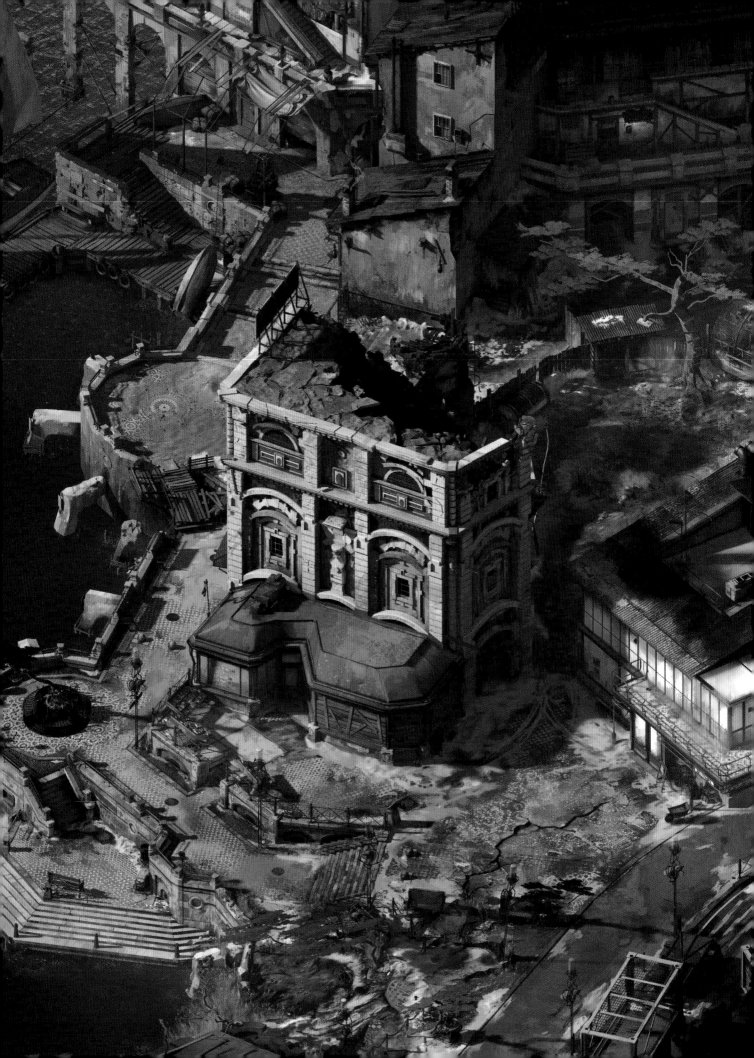

Sometimes, the objects and details Rostov and Tamsalu imagined for the world led to storylines. Next to Whirling in Rags is an abandoned office building, known by residents as the Doomed Commercial Area. Almost every business that has set up in it has failed, from a boxing gym to a propeller manufacturer. The most iconic location in the building is the office once occupied by an ice-cream maker called Revachol Ice City and now dominated by a full-height refrigerator presented in the body of a stuffed bear, which was commissioned from a taxidermy company that also set up in the building. As you explore, you learn that kids were so afraid of the bear that the ice-cream company went bust.

The stories of all the businesses in the Doomed Commercial Area originated from Rostov and Tamsalu's sketches – except for one: the failed game developer Fortress Accident. This company is a representation of ZA/UM, which was originally named Fortress Occident; its deserted studio features a tiled wall scrawled with marker-pen notes, just as ZA/UM's early members, lacking whiteboards, would draw on a tiled fireplace in their tumbledown Tallinn squat. 'Fortress Accident was a reminder for us to get our shit together,' says Rostov.

◀ **Bear witness**
Revachol Ice City's stuffed bear freezer stands menacing in the dynamic light and shadows thrown by your character's torch

▼ **Arrested development**
Fortress Accident's studio remains littered with notes. Many details are taken directly from the squat that ZA/UM started out working in

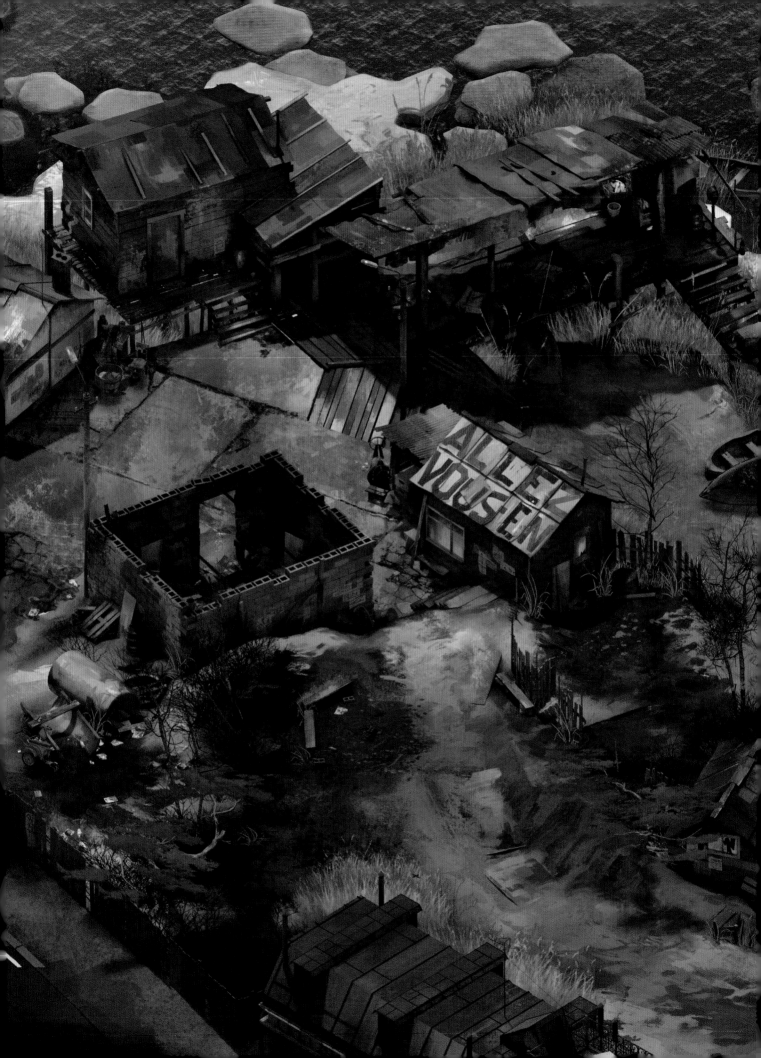

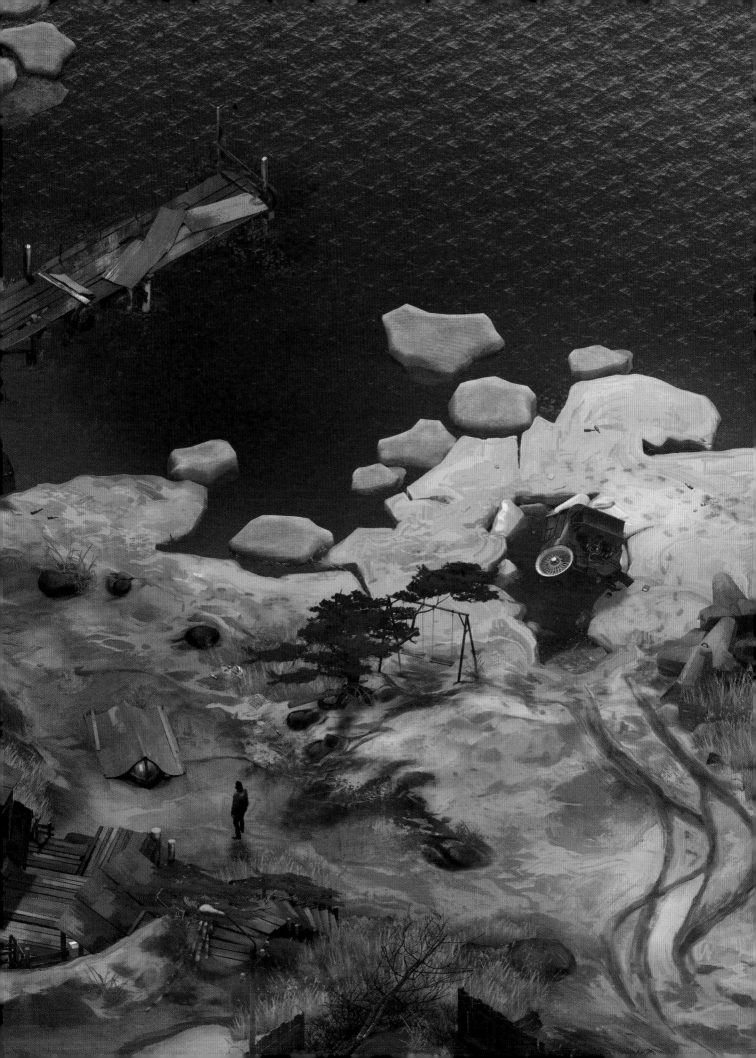

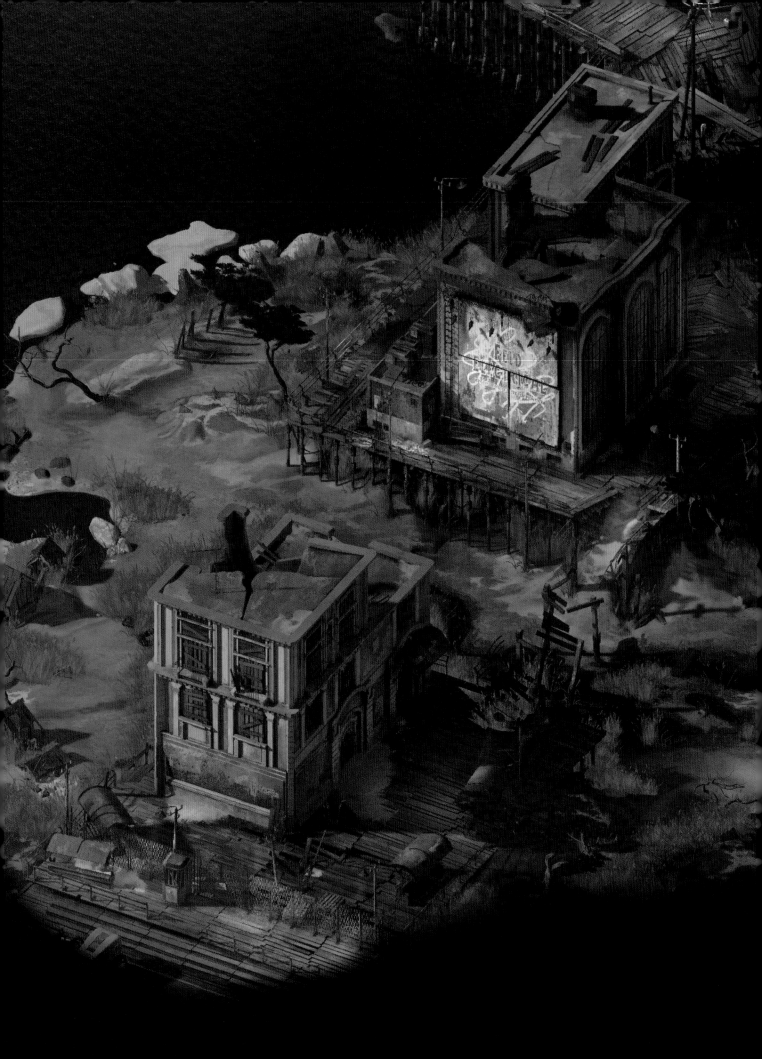

Every environment started with Rostov and Tamsalu producing sketches, and then sometimes also creating quick mock-ups in 3D. Next, a 3D modeller built the space before handing it back to Rostov and Tamsalu to tweak and ensure that the balance of traversal, exploration and discovery was right. To create the final render of an area, Rostov painted over the surfaces of the space, adding the brushstrokes which make *Disco Elysium* so visually distinctive.

Rostov's expressive brushstrokes bring interest to environments, creating atmosphere while also steering the player's eye and creating rhythm and pacing. In contrast with the visually crowded centre of Martinaise, the dilapidated fishing village to the west is open and points of interest are sparse, opening the player to the sound of waves and birdsong. This area is an opportunity for the player character – and players themselves – to rest from the intensity of the investigation and reflect on what they've learned.

I WAS VERY EXCITED TO GET TO THE COASTLINE AREA, BECAUSE IN MARTINAISE PROPER YOU HAVE ALL THIS GEOMETRY AND MAILBOXES AND FENCES – ALL THESE OUTLINES YOU HAVE TO COLOUR WITHIN. THEY FORCE YOU TO PAINT IN THIS TIGHT, NARROW, DILIGENT WAY. MY HOPE WAS THAT I COULD GET ABSTRACT IN THE SANDY AREAS, WITH WIDE SWASHES OF BRUSHSTROKES. BUT WHEN IT CAME TIME TO PAINT IT, I REALIZED, WAIT, NOBODY LIKES ABSTRACT ART! IT HAS NO FOCUS, NO FINE ATTENTION, AND ALL OF A SUDDEN, I HAD TO PAINT IT FULL OF LITTLE DIVOTS, EVEN MORE PRECISE AND CONTROLLED THAN USUAL!

> ALEKSANDER ROSTOV

◀ **Sunset**

Disco Elysium features a day–night cycle, so that the city's atmosphere shifts as twilight settles and darkness falls

◀◀ **Shore shacks**

The near-abandoned fishing village sits on the shore opposite Martinaise's centre

THE MAIN THING THAT I HAVE COME TO REALIZE IS
THAT THESE ARE ENVIRONMENTS WITH SILHOUETTES.
THE FIRST THING YOU NOTICE WHEN YOU GO INTO AN
AREA IS THE BLACK SHAPE AROUND IT, AND THEN
THE LITTLE BIT OF EXISTENCE IN THE MIDDLE. THIS
DOESN'T HAPPEN IN FIRST-PERSON GAMES; IT DOES
A LITTLE BIT IN PLATFORMERS, BUT IN ISOMETRIC
GAMES YOU GET A SHAPE, WHICH IS YOUR FIRST
VISUAL IMPRESSION WHEN YOU GO INTO AN AREA,
IN THAT FIRST FRACTION OF A SECOND WHEN YOUR
VISUAL ANALYSIS TAKES IN THE ENVIRONMENT.

> ALEKSANDER ROSTOV

A keen sense of time pervades Revachol. Every area is
shot through with relics from the past and present, whether
in the form of buildings and architecture, where modern
signs overlay the old, or in characters' clothes and their
possessions. Finding the moment of Elysium's nowness
was difficult; the team bounced between 1920s tweed and
1970s neoprene windbreakers before arriving at a layered
mix of styles which is both recognizable and yet very much
Elysium's own.

It was all there, of course, in Rostov's original painting,
which showed modernity sweeping above the old city,
a visual map of everything ZA/UM would go on to
create in exquisite detail. Every building, every relic and
every character has a past and a present, conjured by a
conversation between visual and textual imagination.

Interior silhouettes

Top: The large bar-cafe downstairs in the
Whirling in Rags; Bottom: The office of the
union secretary is one of Martinaise's few
bright and comfortable spaces

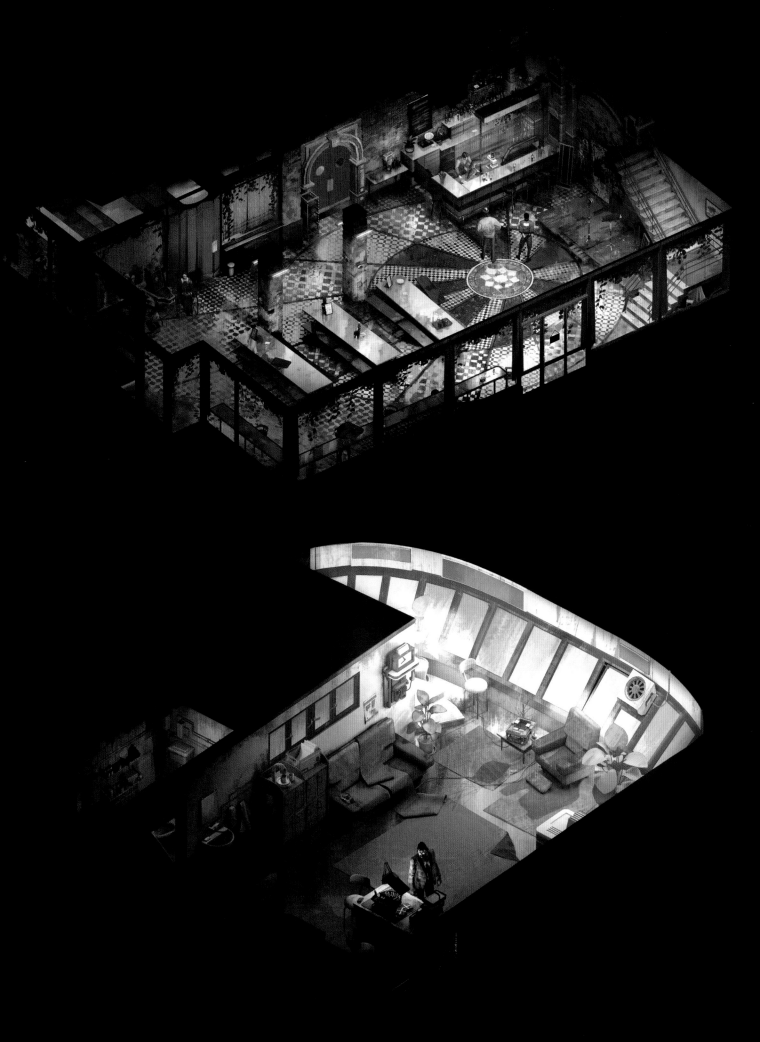

SOLO
SAILING →

7

PLATFORMS PC PLAYSTATION SWITCH XBOX

DEVELOPER LUCAS POPE

YEAR OF RELEASE 2018

RETURN OF THE OBRA DINN

IT WAS FAR FROM HIS FIRST GAME, BUT LUCAS POPE MADE HIS NAME AS AN INDIE GAME MAKER WITH *PAPERS, PLEASE*, IN WHICH YOU PLAY AS A BORDER GUARD OF A FICTIONAL EASTERN BLOC-LIKE COUNTRY. PRESENTED IN 2D PIXEL GRAPHICS, PLAYERS CHECK THE PASSPORTS AND VISAS OF PROSPECTIVE TRAVELLERS AND DECIDE WHETHER TO LET THEM IN – A SIMPLE PREMISE WHICH DEMANDS WEIGHTY MORAL DECISIONS.

Return of the Obra Dinn was his next, very different, game, but it's just as thematically rich and boldly experimental. Set in 1807, you are an East India Company insurance inspector who's been charged with investigating the *Obra Dinn*, a merchant ship that has reappeared after a five-year disappearance. You must identify the bodies of the ship's crew and determine what killed them with a device called the Memento Mortem, which allows you to visit the frozen instant of their death.

Armed with fragmentary information about the crew, you'll explore each death, attempting to recognize faces and work out relationships between the characters through clues worked into the ship itself – the seamen's poses, the details of its decks – and as you piece them together, following threads woven through time and space, you'll discover the story of the *Obra Dinn*'s final and horrifying weeks at sea. The game's stark visual design plays a strong part in its sense of mystery, and is a style that was intended to make such an ambitious project possible for a solo developer. ▓

▶ **Memento Mortem**
The player's key tool is a pocket watch which rewinds time to the moment of a body's death.

◀◀ **Joining dots**
Obra Dinn's visual design emphasizes the pixel, building 3D space from outlines and shading.

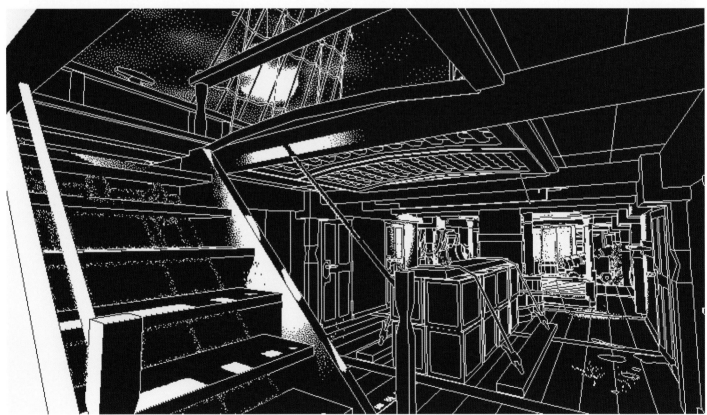

After Lucas Pope completed *Papers, Please*, he wanted to return to developing first-person 3D games, the format in which he'd started his career in the late 1990s. Feeling a little rusty and unfamiliar with Unity, which had since become the leading 3D engine among fellow indie creators, he thought he'd take on a short six-month project to freshen his skills. *Obra Dinn* ended up taking a lot longer. Many decisions Pope made for the game led to unforeseen challenges, not least around his early commitment to its award-winning one-colour pixellated visual design. The style was meant to be simple, ideal for implementation in the kind of small game he was intending to make.

Pope loved Hypercard, an application that allowed users of the original Macintosh to create 'stacks' of hyperlinked cards laden with 2D text, pictures and animation, which prefigured the interconnected multimedia that would come to comprise the World Wide Web. He remembered the way Apple had used it to create an interactive tutorial for his Macintosh Plus's mouse, which on the machine's launch in 1986 was still new. He used it to make a tool that could convert piano notes to guitar tablature for his speed metal band. Hypercard graphics were necessarily pixellated and restricted to the system's black and white display. They look simple, but the style ended up anything but simple to achieve in a modern, 3D first-person game.

I REALLY LIKED THE WAY MACINTOSH PLUS GAMES LOOKED WHEN I WAS A KID. THEY WERE REALLY SPECIAL TO ME AND MAGICAL. I DIDN'T REFLECT ON IT THEN, BUT STARTING ON *OBRA DINN* I REALLY REFLECTED ON HOW THOSE LIMITATIONS NEVER STOOD OUT TO ME AS LIMITATIONS. THEY STOOD OUT AS SOMETHING SPECIAL AND UNIQUE ABOUT THE MACINTOSH, THAT TINY NINE-INCH SCREEN WITH ITS SQUARE PIXELS.

> LUCAS POPE, DEVELOPER AND DESIGNER

◀ **On deck**

Conveying the packed decks of the *Obra Dinn* through outlines and minimal shading reduced visual noise, allowing geometric complexity despite the game's low-resolution display.

Pope aimed for a resolution for the game of 640 by 360 pixels, similar to the Macintosh's 512 by 342. He knew that it would impose a very hard limit on the amount of information the image could carry visually, but Pope used outlines to clearly set out the 3D space, evoking both Hypercard style and also the wireframe 3D that was used in games at the time. The geometry is very sparsely textured and simply lit, so even though it was depicting the complex 3D of a merchant ship's decks, Pope was able to keep the image clean enough that the space would be easy to navigate and read.

However, one early realization was that, while the Macintosh's crisp and legible pixels looked great on its small, nine-inch screen, *Obra Dinn* would be played on large, modern displays. One of the core ways black and white Macintosh pixel graphics communicated gradations of shading was to use Bayer dithering: chequerboard patterns of black pixels which the eye can read as grey. It was obvious to Pope that his game should feature it, so the game renders the scene in 256 shades of grey, and then uses a post-process pass to convert it to one-colour, creating the dither pattern as it goes. But he found that on a large monitor, half a metre from the player's face, those pixels were huge, and that the high contrast between dark and light was crushing visual clarity and preventing dithering from softening into shades.

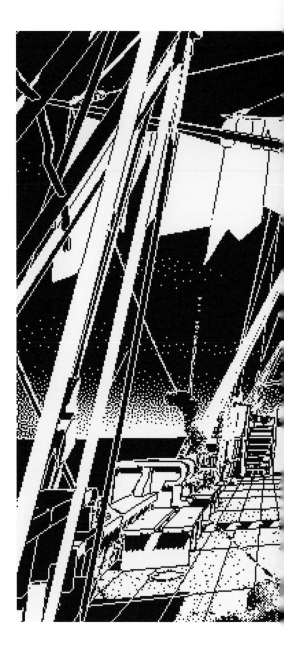

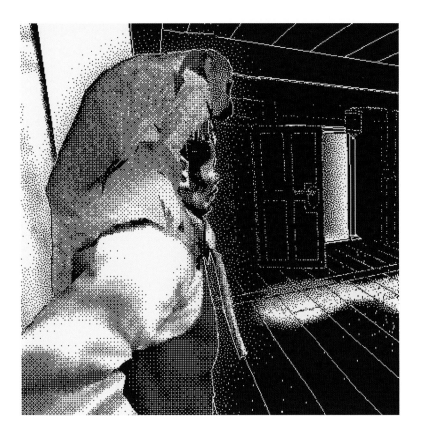

◀ **Watch man**

The hard surfaces of the ship contrast with the heavily shaded shapes of its crew, directing player attention.

▲ **Shipwright**

Pope began creating the ship before he knew exactly what kind of game he'd be creating or how it would play.

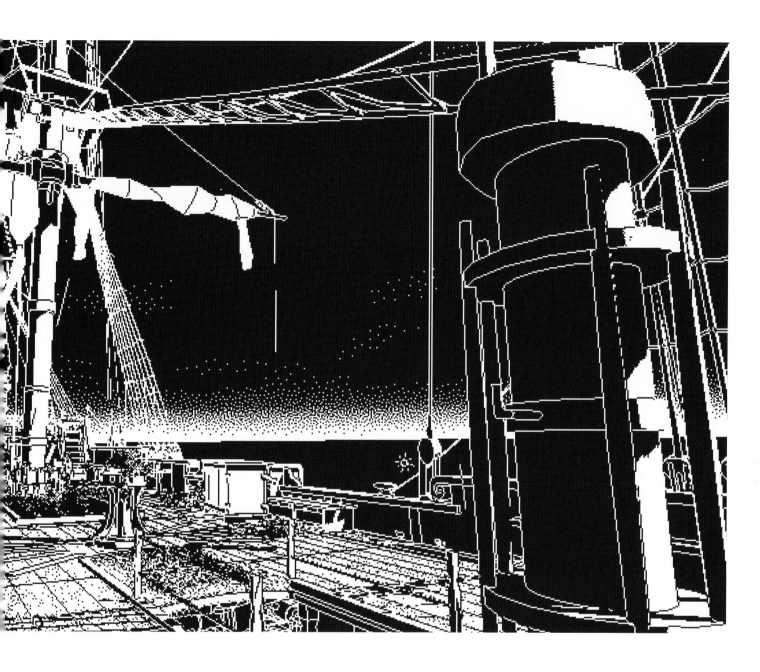

I RAN INTO A LOT OF CHALLENGES I DIDN'T PREDICT.
THEY WERE FUN TO SOLVE, SO IT WAS STILL A
HOMERUN FOR ME AS FAR AS PICKING THE STYLE
AND STICKING WITH IT WENT. BUT A LOT CAME
UP ALONG THE WAY THAT MADE ME QUESTION –
NOT REGRET, BUT QUESTION IT – OR AT LEAST
BE SURPRISED WITH ITS COMPLEXITY.

> LUCAS POPE

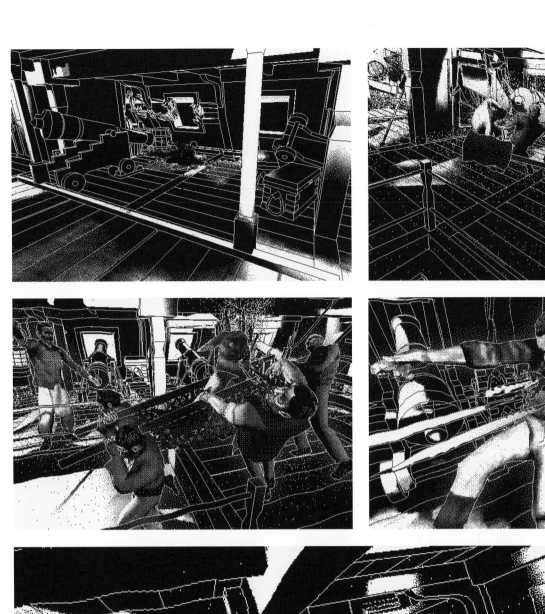

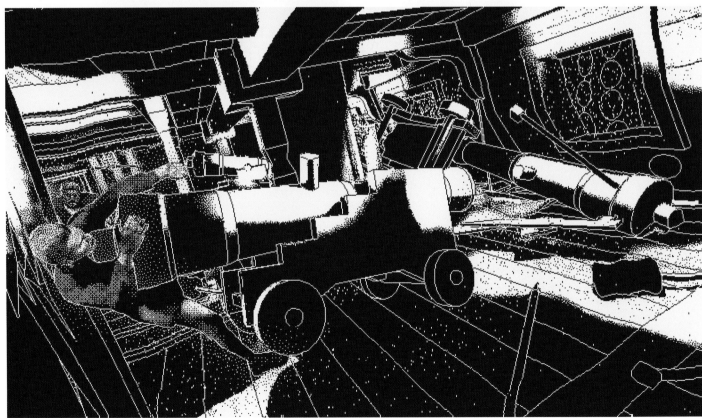

ADDING VISUAL COMPLEXITY WAS A NICE BALANCE OF ADDING GEOMETRY JUST TO GET OUTLINES TO MAKE THE SCENE FEEL FULL, BUT I DIDN'T REALLY UNDERSTAND THE AMOUNT OF WORK IT WAS GOING TO BE IN THE END. IT WAS FUN, JUST TO BUILD A WHOLE SHIP AND TO PUT ALL THIS STUFF IN IT. I GOT LUCKY, BECAUSE AT THE TIME I WAS BUILDING THE SHIP I DIDN'T KNOW EXACTLY WHAT KIND OF GAME IT WOULD BE, BUT I COULD JUST KEEP BUILDING THE SHIP AND FIGURE, WELL, IF IT'S A REASONABLE SHIP, I COULD PUT A GAME IN IT NO MATTER WHAT. THAT WORKED OUT OK.

> LUCAS POPE

What's more, dither patterns were created for static images, and in *Obra Dinn* they were being applied to a constantly shifting perspective. The pattern would shift and march over objects, so Pope went to extraordinary lengths to work out a way to stabilize the dithering: fixing the pixels on surfaces as you move the view, so shadows look solid and consistent. The solution was technically complex, resorting to using different types of dithering – random blue noise and a Beyer pattern – for different parts of the image. But more than that, it meant forfeiting the purity of the whole art style.

Pope made another sacrifice in raising *Obra Dinn*'s resolution to help counter the size of its pixels. The final game displays at 800 by 450 pixels, a decision which took a single line of code but added a wealth of worry. He'd modelled all the game's environments, characters and objects, and created all its textures for the lower resolution, and he knew that the higher resolution would make it easier to see the polygons and the textures that made up the scenes. Every extra pixel on the screen cleaned the lens through which the player would be viewing the world a little bit more, pulling back the curtain on the artifice that he'd used to create *Obra Dinn*'s style.

◄ **End times**
The moment of death is captured for all sixty members of the *Obra Dinn*'s crew, each a dramatic scene which tells a story in itself and also fits into the much longer tale of the ship's last voyage.

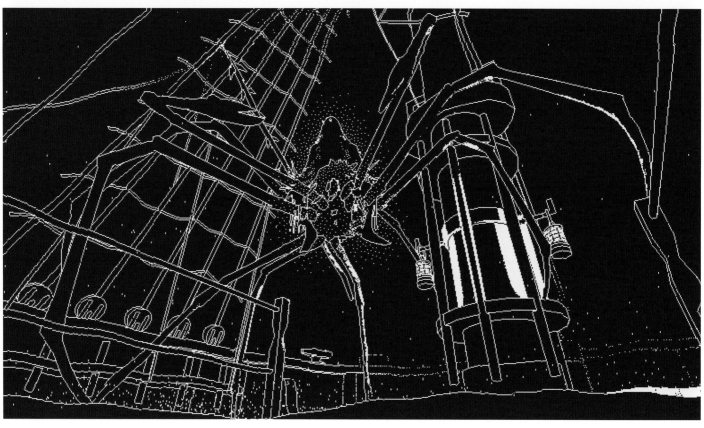

▲ **Doomed voyage**

As they progress through the game, players see the ship face many forms of disaster, from storms to bizarre and terrifying supernatural threats.

▲ Ocean deep

Under the apparent simplicity of the game's
presentation lies wild complexity. The sea's
surface comprises millions of polygons,
which are visually related by dots.

Obra Dinn took four years to complete, and Pope says he spent a year of that time feeling burned out and desperate to finish it, but the process of solving the technical and creative problems remained fun. It helped that he was working alone, so the artist in him understood exactly what technical limitations he was working within, while the programmer in him knew exactly what the game needed creatively. But it wasn't until the end of the project that Pope was able to step back and consider what he'd made. What did it mean to represent a historically accurate early nineteenth-century ship with a visual design that referenced the Apple Macintosh? Was the game a monument to 1980s games? Or was it a period high-seas mystery?

Towards the end he realized that the visual design he'd worked so hard to preserve and bend into functioning in real-time 3D evoked something he hadn't considered when he'd set out on this voyage: woodcut printmaking. He leaned into the relationship between old computer games and woodcut as he continued to draw textures and create the in-game ledger which records your progress and displays the drawings that you reference as you find the ship's crew. Like woodcut, the imperfect and anachronistic nature of *The Return of the Obra Dinn*'s 1-bit graphics lends the game a presence, a deeper meaning that exists between its pixels and reflects the ship's many mysteries.

▶ **Marine vignettes**
Much of the game is about the player examining closely the set scenes aboard the ship to trace the crew's actions and relationships with each other. By using this information, it's ultimately possible to identify all of them.

IT'S KIND OF PRESUMPTUOUS FOR ME TO MAKE A PLAYER SIT DOWN AT A GAME LIKE THIS. I WAS REALLY TERRIFIED OF PEOPLE EXPERIENCING IMMEDIATE DISCOMFORT AND ASKING, 'WHAT THE HELL WAS THIS GUY THINKING? WHY DID HE DO THIS?' SO I WORKED, AND I'D MAKE SACRIFICES, BECAUSE TO DO THE STABLE DITHER I NEEDED TO GIVE UP ON THE FULL 1-BIT THING. I NEEDED IT TO BE A LITTLE BLURRY AROUND THE EDGES, BUT FOR ME, IT WAS WORTH GIVING UP THAT PURITY, JUST TO MAKE IT SO THE QUESTION DIDN'T POP INTO EVERY SINGLE PLAYER'S HEAD.

〉LUCAS POPE

AT THE BEGINNING I WANTED TO SAY, WHAT IF THIS GAME EXISTED IN 1987 AND WE JUST FOUND IT NOW? BUT I NOTICED THE CLASH WHEN I STARTED TO THINK ABOUT USING A CRT EFFECT [TO EMULATE A CATHODE RAY TV'S DISPLAY]. IT FELT LIKE THERE'S THE GAME OVER THERE, AND BETWEEN THE GAME AND ME IS A SCREEN. IT FELT LIKE I WAS PUTTING THE SPOTLIGHT ON THE SCREEN AND NOT ON THE GAME ITSELF. BUT YOU COULD HAVE MADE THIS GAME TWENTY, THIRTY YEARS AGO IN HYPERCARD. IT'S JUST AN OVERLOOKED WAY OF DESIGNING A GAME, AND SO IN THAT SENSE, *OBRA DINN* WAS ALWAYS THERE, WHICH IS WHY I STRUGGLED WITH WHETHER I WANTED IT TO LOOK LIKE AN OLD GAME OR WHETHER I WANTED TO FOCUS ON SOMETHING BEYOND THE SCREEN.

> LUCAS POPE

◄ Video mode

Knowing how important YouTube and Twitch would be to his game's success, Pope worried about how its high contrast and low resolution would look when compressed into streaming video. Smoothing the pixels and using less high-contrast colour schemes helped.

DRIVING REALISM →

8

PLATFORMS **PC PLAYSTATION XBOX**

DEVELOPER **CODEMASTERS**

YEAR OF RELEASE 2019

GRID

GRID HAS EXISTED IN MANY FORMS THROUGH ITS LONG HISTORY. IT BEGAN AS 1997'S *TOCA TOURING CAR CHAMPIONSHIP*, A PLAYSTATION-AIMED SPORT SIMULATION, BEFORE MORPHING INTO THE STORY-LED *TOCA RACE DRIVER* IN 2002, AND THEN REFORMING INTO *RACE DRIVER: GRID* IN 2008.

Race Driver: Grid introduced a muscular physicality to the real-world track racing game, with a new generation of technology serving visual effects that emphasized the drama of the competition: the setting sun gleaming from downtown multi-storeys; daring and pushy AI drivers; smoke and grit on the tarmac.

Though Codemasters' series transformed itself over and again, each game stayed true to a rendition of real-life racing, with accurately modelled cars sporting authentic liveries on licensed tracks, and a fine simulacrum of actual physics. Its 2019 edition, simply called *Grid*, furthered the pursuit of realism and endless thirst for detail that are so important to track racing games, while also building on the thrill of videogame excess by focusing on the stuff between the cars – the noise and the dust and the sweat of it all. Through a balance of hard realism and dirty spectacle, *Grid* wants to take you there. ▨

▶ **Real racing**

The cars are licensed from their manufacturers and feature real-world advertising, so accuracy was important.

◀◀ **Scene set**

Grid's makers based much of the visual style on the fundamentals of the scene: the time of day, the sky above, and where the sun is.

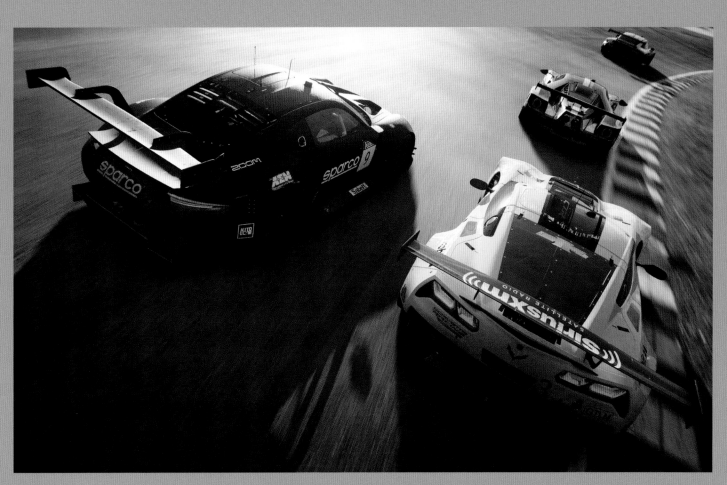

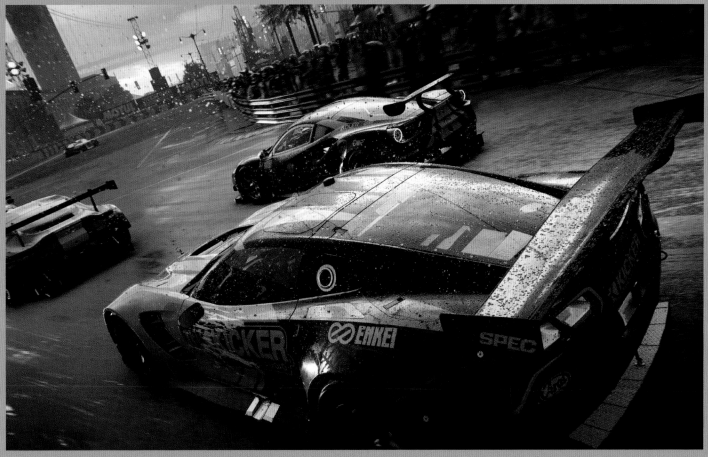

Track racing games have always looked keenly towards the photographic image. As projects that attempt to recreate real-world pursuits, they've always had reality as a benchmark, which is most familiar through TV coverage. And Codemasters knows that racing fans care very much about realism, from the accuracy of the car models and livery designs to the soft shadows of an overcast day. But it also wants to engage audiences beyond the pure enthusiasts, because the high-speed cut and thrust of motorsport is as much an appealing power fantasy as the knight setting out on a quest or the ranger hefting an assault rifle. In fact, the fantasy of driving fast hits closer to home than either.

The question for *Grid*'s makers, then, was where the game would sit on the spectrum between realism and fantasy. Games like *Forza Horizon* can play to an open world of fun roads to hurl your real-world car down, and a wide range of different events, from stunts to head-to-head duels. *Gran Turismo* soberly embraces a kind of perfect form of racing in which crash damage is non-existent. *Project CARS* aims at a simulation which samples tyre physics 200 times a second. *Grid* takes a path between all these – a path set out by its visual design, which renders in a realistic way its real cars and real locations, but everything is a little intensified. A key tool Codemasters uses to achieve this is colour grading, a process that tweaks the contrast, saturation, brightness and tone of the rendered image.

▶ **Dirt course**
Grid's sense of moment-to-moment drama is down to kicked-up dust, the tyre smoke, the sparks and collision debris.

◀ **High street**
Racing game developers routinely model trackside detail from real-world sources, such as Havana.

▼ **Track star**
The Aston Martin Vulcan AMR Pro is accurately represented in the game, down to its cockpit.

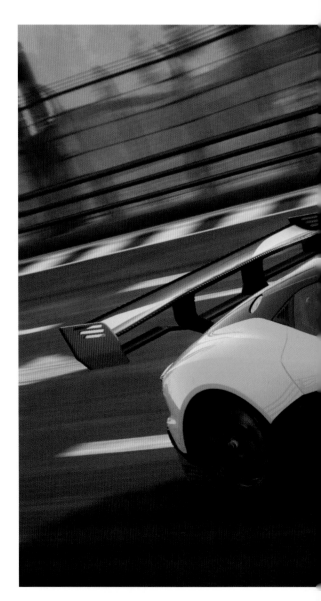

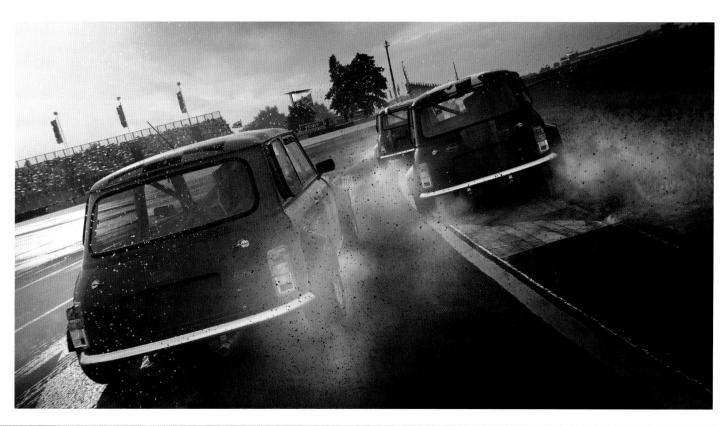

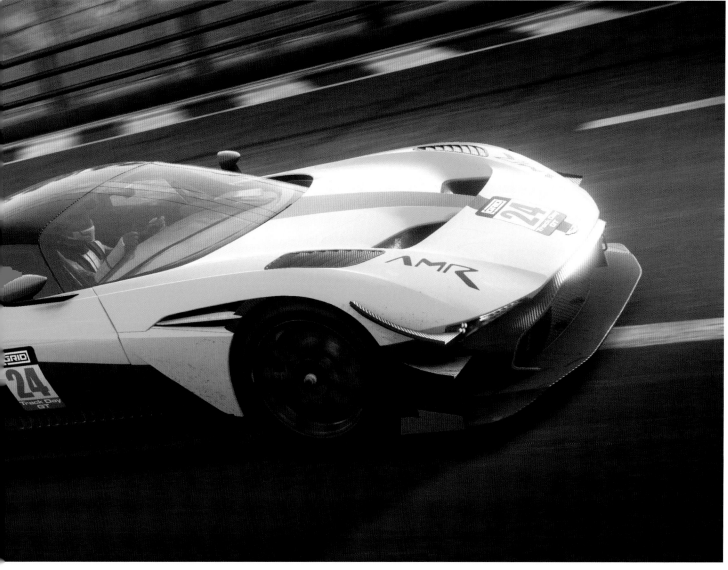

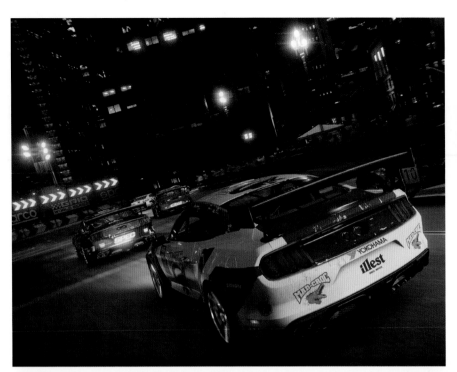

I LOOK AT IT MORE AS A HOLLYWOOD RACING GAME. OBVIOUSLY WHEN YOU GO TO THE CINEMA AND WATCH A MOVIE IT TENDS TO BE A BIT MORE STYLIZED, JUST WITH THE GRADING, THE COLOUR. GAMES LIKE *GRID* HAVE THAT IN COMMON WITH MAINSTREAM HOLLYWOOD MOVIES OR HIGH-END ADVERTISING. NOW, IF YOU WATCH A PORSCHE ADVERT OR SOMETHING, THE CAR IS THE STAR THERE, BUT IT'S A SLIGHTLY PUSHED IMAGE, SO YOU'VE GOT A BIT OF A VIGNETTE OR WHATEVER TO MAKE IT LOOK A BIT MORE POLISHED. YOU KNOW YOU'RE LOOKING AT SOMETHING THAT'S A BIT MORE TREATED, BUT NOT SO FAR THAT IT BECOMES OVERBEARING.

> MARK GREEN, DEVELOPMENT DIRECTOR

◀ **Wide vehicle**

Grid's developers use the word 'muscular' to define their approach to realizing the game's cars. Some feature bigger body kits or thicker tyres than they'd have in reality to give them a larger-than-life presence on the screen.

Race Driver: Grid (2008) was distinguished by its desaturated, sepia-tinged colour grading. That style was in vogue at the time, but Green says that for a lot of players it went too far. It detracted from the core of the game: the cars, the circuit and the race. It was a little too unreal, which could hamper the player's practical need to see clearly enough to race the course effectively. For 2019's *Grid* the team aimed to step the colour grading and lens effects back, and allow the main elements of the race location to define the image.

It's therefore important that realism forms the foundation of *Grid*'s visual design. First, the team ensures the artwork – the models and textures – for the cars and environments is correct. The cars are modelled either by laser-scanning a real one or from its manufacturer's CAD files, so in proportion and form they're identical to the real thing. This step is especially important because Codemasters must license every car, not only from its manufacturer but also from the manufacturers of any body kits it might have and the team that it's raced by, and every licensed asset must be approved before use. It can get complicated.

Then, as the game runs, it uses physically based rendering (PBR) as its principles for creating a photorealistic image. Here, every surface, whether car body, asphalt or grass, is to an extent shiny, so by modelling the way light bounces from different surfaces and creating layers of different textures, *Grid*'s developers can create cars and tracks that respond realistically to different times of day and weather conditions.

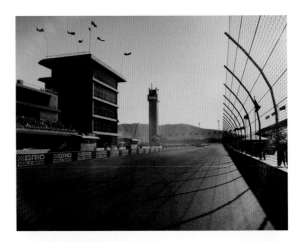

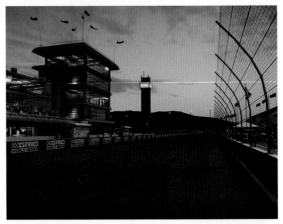

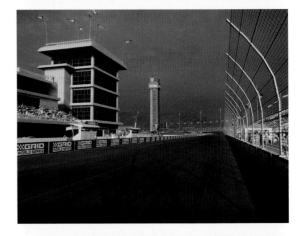

▶ **Time of day**

The lighting system is designed to represent different times of day, with the sun changing position in the sky, throwing different shadows, and artificial lights illuminating things at night.

▶▶ **Dazzle pattern**

Driving at 150 miles per hour means players need a clear view in all light conditions. The team wanted the sun to glare, but not so much that it obscures the view.

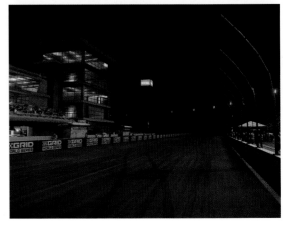

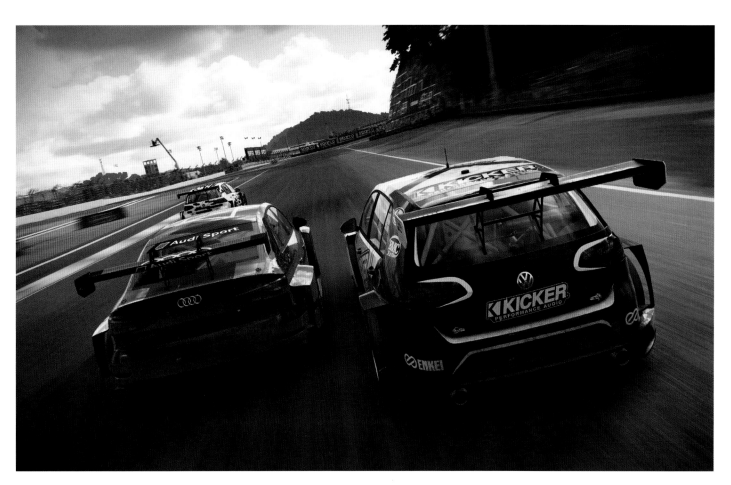

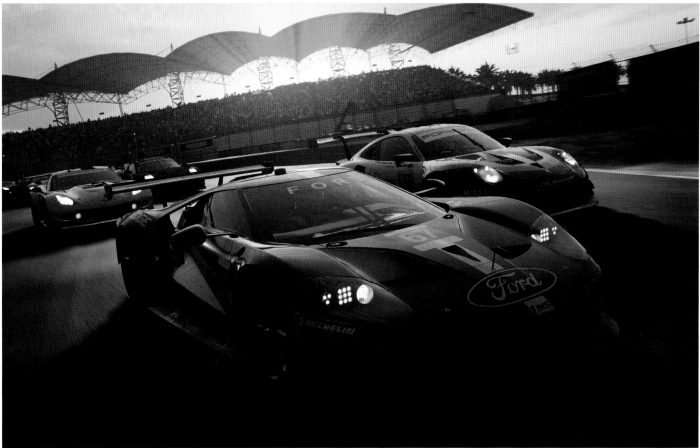

AN AWFUL LOT OF *GRID*'S LOOK
COMES FROM THE COLOUR OF THE
SKIES, THE CHOICE OF TIME OF DAY,
WHERE THE SUN POSITION IS; THOSE
ENVIRONMENTAL EFFECTS THAT HELP
GIVE IT A SENSE OF STYLE, EVEN
THOUGH THE TRACK YOU'RE RACING
ON IS PERHAPS A REAL TRACK.
BRANDS HATCH IS ALWAYS GOING TO
BE BRANDS HATCH, THE ROUTE IS THE
SAME, BUT WE TRY TO PUT A LITTLE
EXTRA DRESSING INTO IT. A *GRID*
EVENT IS MORE LIFESTYLE, MORE LIKE
HOW AN ENERGY DRINK COMPANY MIGHT
SET UP AN EVENT. IT'S A LITTLE BIT
MORE THAN YOU'D SEE IN REAL LIFE.

> MARK GREEN

▲▶ Shanghai Street Track
This real-world street track in the Pudong
district of Shanghai features distinctive
buildings like the Oriental Pearl Tower and
Shanghai Tower as landmarks.

▶▶ Wear and tear
Dirt, oil and wear marks develop over
the course of a race, helping to relay the
intensity of the action and give a sense of
realism to the car.

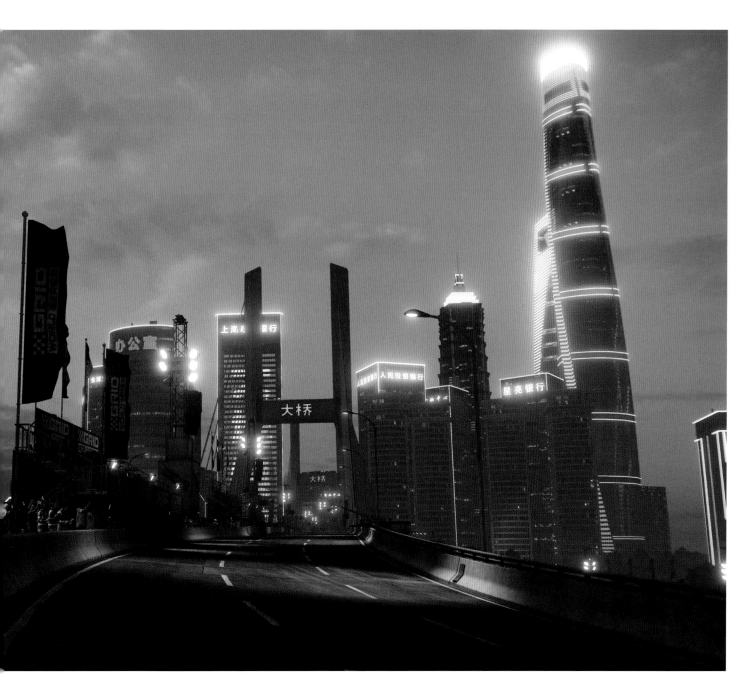

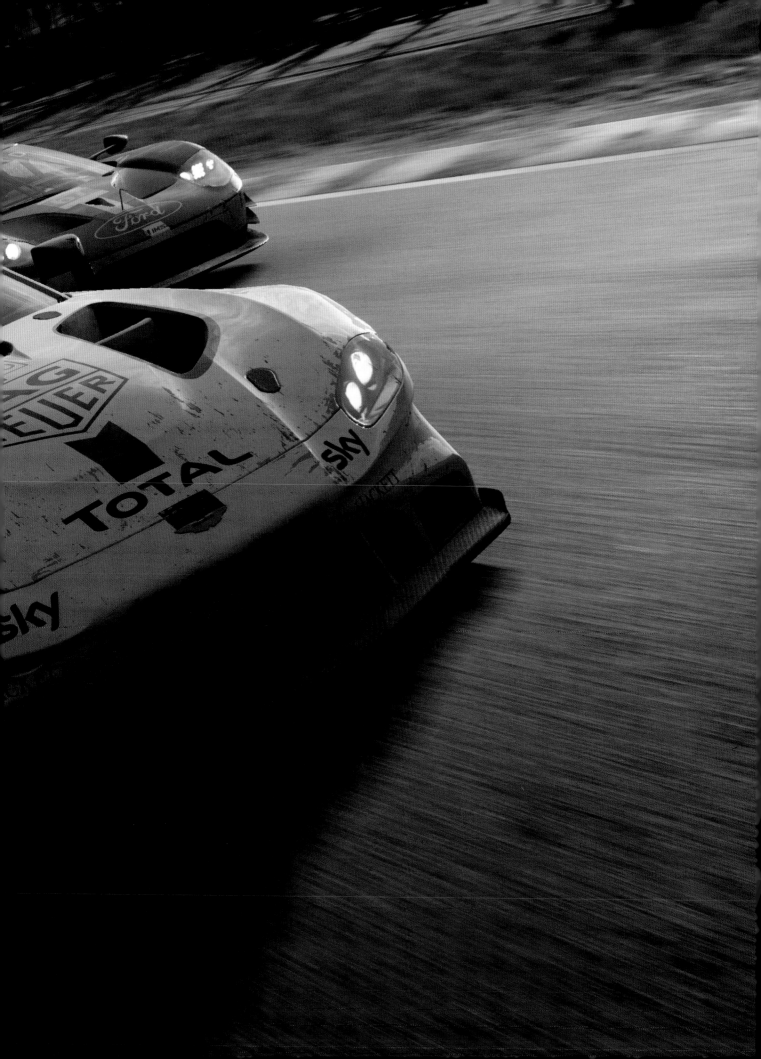

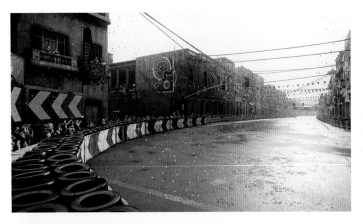
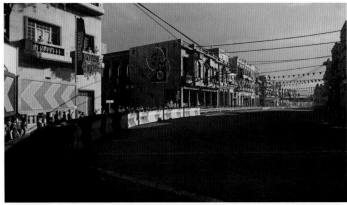
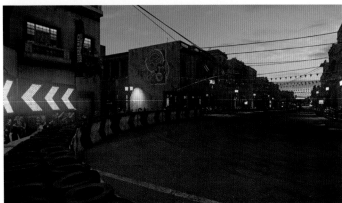

PBR isn't a magic bullet. It takes calibration to ensure that all materials look right in every condition, but trying to light the world realistically is where Codemasters' artists started. Then it was a matter of tweaking things to balance the heightened reality the visual design called for with serving gameplay. For example, headlights only project a certain distance before they stop illuminating the environment. But is that far enough for the game to remain fun? And if the team increases the distance at which headlights remain bright, how does that affect every other light that's been placed on the track for the different times of day you might be racing? It was a complex task, but critical in establishing a consistent base from which to apply further visual effects.

Some of these further post-process effects are there to make *Grid* look a little imperfect; to lose the clean sharpness that naturally accompanies the computer-generated image. You see particles of dust on the lens of the theoretical camera through which you're viewing the game, and water droplets land on it. The effect is intended to emphasize the feeling that you're driving on the edge, distinguishing it from the much cleaner look of a simulation game, which tends to focus on the feeling of control.

▲ **Havana Street Track**

Grid conveys the humid heat of a Cuban day and night with colour grading, fog in the distance and wet roads.

▶ **Driving motion**

A wide-angle view gives an additional sense of speed, shake adds a precariousness, and push and pull on turns gives momentum.

ONCE YOU'VE GOT EVERYTHING LIT, THEN YOU DO YOUR POST-PROCESSING ON TOP, AND BECAUSE YOU'VE LIT EVERYTHING ACCURATELY, YOU KNOW YOUR POST-PROCESSING IS GOING TO WORK IN EVERY CONDITION. GAME ART IS MORE TECHNICAL NOW THAN IT'S EVER BEEN. IT'S MORE COMPLICATED, BUT AT THE SAME TIME THERE ARE MORE TOOLS AVAILABLE TO HELP US GET THAT REFERENCE CORRECT THAN THERE HAVE EVER BEEN. IT'S MUCH EASIER NOW.

> JOHN LEWIS, ART DIRECTOR

THE SHAPE OF A CAR WILL CATCH THE LIGHT IN
CERTAIN WAYS TO PRODUCE LITTLE GLINTS AND
HIGHLIGHTS, AND THE MORE POLYGONS YOU CAN PUT
INTO THAT MESH TO CREATE THAT SHAPE, THE MORE
YOU'LL BE ABLE TO CATCH THOSE SUBTLETIES. IN
REAL LIFE, THERE'S NO SUCH THING AS A PERFECT
SURFACE. YOU MIGHT HAVE SOME KIND OF SUPERCAR,
BUT IT'S STILL GOT A LITTLE BIT OF IMPERFECTION
TO THE PAINT WHEN YOU LOOK AT IT UP CLOSE, A
SLIGHT RIPPLE DOWN THE SIDE OF THE BODYWORK.
THAT'S WHAT REALLY STARTS TO SELL IT AS A
PHYSICAL OBJECT, AND NOT JUST A CG MODEL.

> JOHN LEWIS, ART DIRECTOR

In addition, *Grid* wants you to look at its cars and know they're not new and perfect. It wants you to see their imperfections so you believe they're racing cars that have picked up nicks and scratches, they might bear the marks of their conversion from road vehicles, and might even have been repaired in the past. Racing games like *Gran Turismo* capture a pristine kind of realism; *Dirt* wants to be realer.

Realism is as subjective a pursuit as any other form of videogame art, which makes it as much of a creative act. While technology makes it easier to cross the uncanny valley than ever before, game developers must still focus on capturing what fuels our momentary recognition of reality: sunlight glancing off a scratched bonnet; tyre smoke obscuring the start line. Our appreciation of those moments is personal, down to our individual experience and values; to see them reflected is one of gaming's most profound thrills.

▶ **1978 Pontiac Grand Prix**

Scrapes and damage are applied as a secondary texture. Car interiors also feature chips around switches, light scratching on glass, and other signs of wear.

▶▶ **Close quarters**

Grid always tries to keep the driving action close, with competitors' cars going nearly bumper-to-bumper with the player's: all the better to see their detail.

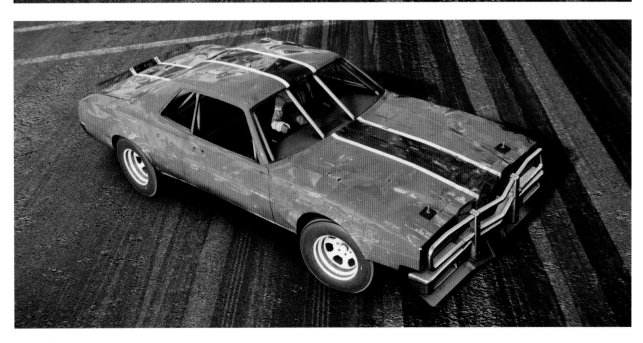

PIXEL
PERFECT →

9

RIVER CITY GIRLS

PLATFORMS PC PLAYSTATION SWITCH XBOX

DEVELOPER WAYFORWARD

YEAR OF RELEASE 2019

KUNIO-KUN HAS GROWN TO BE A SPRAWLING SERIES OF OVER FIFTY GAMES SINCE TECHNŌS JAPAN'S *NEKKETSU KŌHA KUNIO-KUN* (KNOWN IN THE WEST AS *RENEGADE*) KICKED OFF THE ARCADE BRAWLER CRAZE IN 1986. IT WAS ITS SEQUEL, HOWEVER, WHICH STILL PROVIDES INSPIRATION TODAY.

River City Ransom (1989) was designed for the Nintendo Entertainment System (NES) home console, exchanging the original's short and linear stages, which suited the pay-per-play nature of the arcade, for an RPG-like freely explorable world in which players complete quests, earn money for defeating enemies, and spend it on equipment in shops. This formula is so strong that, thirty years later, it directly fuelled 2019's *River City Girls*, which swapped *Ransom*'s meathead duo Alex and Ryan for peppy fighter schoolgirls Kyoko and Misako.

River City Girls was made by WayForward, a prolific American developer with a particular fascination for making 2D action games. The studio was founded in 1990 by Voldi Way, an entrepreneur who'd made a fortune pioneering CAD for sheet metal fabrication, which makes it just about old enough to be part of the very history it reveres today through licensed games like *Aliens: Infestation* and *Double Dragon: Neon*, alongside its own lauded series, such as *Shantae*. Perhaps that's what lends it such sensitivity to pixel graphics, bridging the gap between nostalgia and celebration of their inherent qualities. ▨

▶ **Character building**

WayForward started the project by asking American comic-book artist Priscilla 'Rem' Hamby to draw a comic as a pitch to the game's publisher, Arc System Works.

◀◀ **Background art**

The levels feature densely detailed art of their urban settings, which rewards close examination, even if the action is usually far too intense to allow it.

The vanguard of graphics technology has spent the past twenty-five years charging at 3D, but 2D pixel art is far from forgotten. Once the only form of videogame graphics, pixel art is now just another stylistic and technical choice. For some games it's an expression of nostalgia; for others, pixel art enables an efficient form of asset creation, especially for small teams. But pixel art is also just as capable of inspiring awe and emotion, and just as demanding of creative skill as any other visual design. Today, though, it doesn't labour under the severe hardware restrictions that defined the look of the games which inspired it. Instead, pixel art faces the challenge of limitlessness. When you can do anything with them, how do you find a truth in abstracting videogame worlds into pixels?

Let's get this out of the way: *River City Girls* is made in Unity and is technically a 3D game. If you were to see it as its level designers do, you'd understand how every visual asset – the characters, backgrounds, foreground details – is a 2D textured polygon which floats in 3D space. The trick *River City Girls* pulls is to make the scene look flat by setting up the camera from which you view the action so that it doesn't scale objects by their distance. This is the basis of a lot of modern 2D games, but *River City Girls* does a lot to preserve *Kunio-kun*'s spirit – particularly 1989's *River City Ransom* – while embracing an aesthetic of its own.

▶ **Pixel projection**
WayForward uses various forms of 2D in its games, including *Shantae*'s combination of 2D characters and 3D backgrounds, but *River City Girls*' presentation is entirely 2D, which is significantly cheaper to produce.

WE REALLY WANTED TO HAVE THE NAKED ART ON THIS, SO TO SPEAK. WE GO DYNAMIC IN SOME OF THE VISUAL EFFECTS, BUT WE PURPOSELY WANTED TO STRIP OUT ANYTHING THAT WOULD MAKE A WEIRD AMALGAM OF LOW-RES DETAILING AND MODERN LIGHTING. THE RULE WAS THAT ANYTHING WITHIN THE WORLD WOULD BE PIXEL ART – WE EVEN RENDERED SOME 3D EFFECTS AS PIXEL ART – AND THEN ANYTHING OUTSIDE WE COULD GO WILD ON, AS HIGH-RES AND DYNAMIC AS WE WANTED.

〉 ADAM TIERNEY, CO-GAME DIRECTOR

MISAKO: We're looking for our boyfriends, remember?

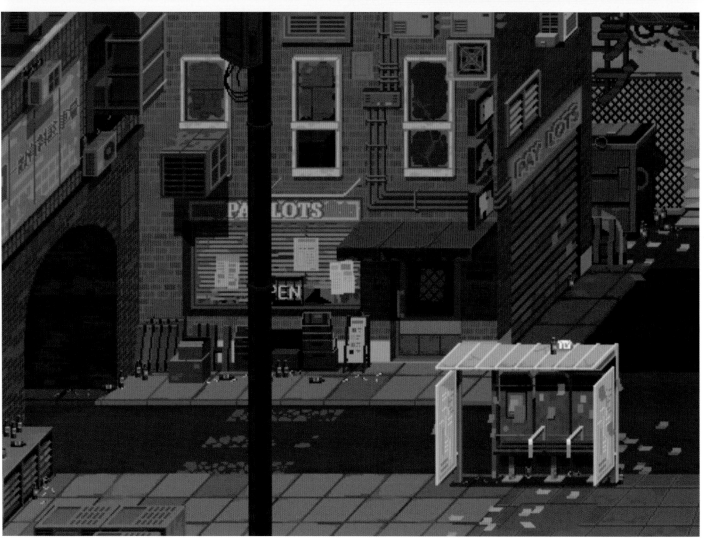

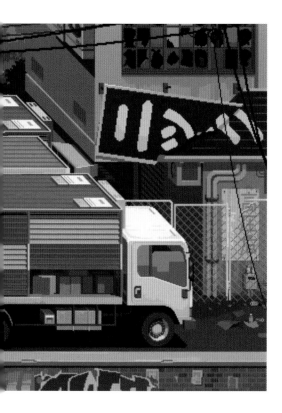

River City Girls' flat, pastel look is down to WayForward's choice not to light any scenes spatially, so that everything has the same tone. But it could have gone many other ways, as modern game engines give 2D game creators a multitude of options that can dynamically affect pixels in ways that were impossible on any 8- or 16-bit console. Scenes can use dynamic lighting to change the shading of background art or characters in accordance with the lights around them, for example, picking out highlights as they move past a lamp. Objects can cast shadows and colours can shift according to the ambience of the scene.

For WayForward, though, each process cuts further from the roots of pixel art craft. But *River City Girls* was never meant to be a pure exercise in nostalgia. WayForward wanted it to express a modernized version of the pixel art form, and not simply evoke the tight limitations of the past, for example by restricting the palette to the forty-eight colours of the NES. For Tierney, that might lead to art and animation that didn't look good, and wouldn't hold true to the spirit of the art produced for true 8- and 16-bit games.

FOR SUPER NINTENDO OR NES GAMES, THOSE DEVELOPERS WEREN'T TRYING TO BE RETRO, THEY WERE TRYING TO DO THE BEST ART THEY COULD WITHIN THE LIMITATIONS OF A SYSTEM. THAT'S ESSENTIALLY WHAT WE'RE STILL DOING. WE DON'T HAVE THE EXACT LIMITATIONS ANY MORE. EVER SINCE THE GAME BOY ADVANCE ERA WE DON'T REALLY HAVE TO DEAL WITH PALETTES OR TILE COUNTS ANY MORE. BUT WE'RE STILL PUSHING THE BOUNDARIES TO AS HIGH A QUALITY AS WE CAN, WITHIN THE FEASIBILITY OF PRODUCTION TIME.

> ADAM TIERNEY

◀ **Background artist**
River City Girls' main background artist was Valeriya 'Waneella' Sanchillo, who is well known in pixel art communities for creating scenes comprising flat colours.

So, since he directed WayForward's *Aliens: Infestation* in 2011, Tierney has avoided using tilesets. This old method of creating level art involved an artist creating a series of assets themed to an area, such as trees and rocks and tessellating ground tiles, which a level designer would then use to build an environment. For Tierney, this method tends to lead to repetition, where one area feels much like another within the same theme, so for *River City Girls* backgrounds are large and unique pieces of art that allow the design of the world to come first.

The process started with the team listing around ninety places in which the action should be set: a fashion district, a theme park, the school, a dodgeball court. Then fellow director Bannon Rudis would build them out so the team could design and test the encounters. If a fight were to break out in a mall, would there be enough space for enemies to surround the player and still give room to run around? Once perfected, Rudis's blocked-out space was sent to background artists who were told to simply go wild and draw what they wanted, safe in the knowledge that they weren't restricted by tile counts. This is, however, a very time-consuming process. Tierney estimates that the tileset method would have taken perhaps a quarter of the effort, but it was important to give detail and variety to a game in which players would return to areas over and over again.

▶ **Scrolling action**

Background art is drawn in long sections, because it's designed to scroll as players walk and fight along it. The perspective is skewed, but as it's viewed in sections during the game, it looks consistent.

▶▶ **Scale up**

A challenge with using pixels is ensuring they look clean when scaled to different screen resolutions. Tierney's ideal is that they're sharp enough that the source art is clearly visible.

▶▶▶ **Development time**

Despite the richness of its artwork, *River City Girls* was completed in just a year of development by its tight team of artists and animators.

YOU'RE NOT SEEING THE SAME THING OVER AND
OVER. YOU'RE SEEING VERY DIFFERENT STORES
AND BACKDROPS; YOU'RE GOING INTO ARCADES
WHERE IT'S ALL DIFFERENT MACHINES AND STUFF
... THAT'S VERY IMPORTANT FOR ME IN A GAME
BECAUSE I LIKE THE IDEA OF BEING SURPRISED
BY LOCATIONS AND I'M IMPRESSED BY CONSTANTLY
GETTING NEW EYE CANDY.

> ADAM TIERNEY

In front of the background stand the characters, where WayForward also lavished a great deal of attention. *River City Girls'* principal animator, Kay Yu, was anxious to convey their personality in every frame, so Misako's movements are driven and serious while Kyoko's are playful, finishing in a pose that looks as if she acted half by accident. Apart from making them both distinct, this frame-by-frame attention to expressiveness also helped to sell the variety of moves the player will unlock and use over the course of the game. Their animation sets out the spatial aspect and directionality of each attack, which naturally hints at when it's ideal to use it.

That expressiveness is down to *River City Girls'* animators thinking not about the frames of animation so much as the objects they're trying to relate. To create fluidity, they think about the hand behind the pixels to imply the movement it makes between the frames. For Tierney, a key benefit of this approach is that it taps into the emotion of the characters.

WHEN I WAS STARTING OUT AS A PIXEL ANIMATOR, I'D STUDY *METAL SLUG*, WHERE YOU'D HAVE THINGS LIKE IDLE ANIMATIONS WHERE A CHARACTER'S JUST BREATHING. THE MOTION OF THE CHARACTER MIGHT NOT CHANGE AT ALL; IT MIGHT JUST BE THEM PLAYING WITH COLOUR VALUES ON THE CHEST TO IMPLY THAT CHEST WAS MOVING UP AND DOWN. THERE'S THAT SUBTLETY TO ALL OF IT.

> ADAM TIERNEY

▶ **Dropping outlines**

Lead sprite artist was Hunter Russell, who draws characters like Abobo without outlines, building them from intersecting planes of flat colours.

▶▶ **Flat shading**

Tierney saw in Russell's style the chance to grant *River City Girls* a less serious look than it would have had with outlined sprites like those of Misako.

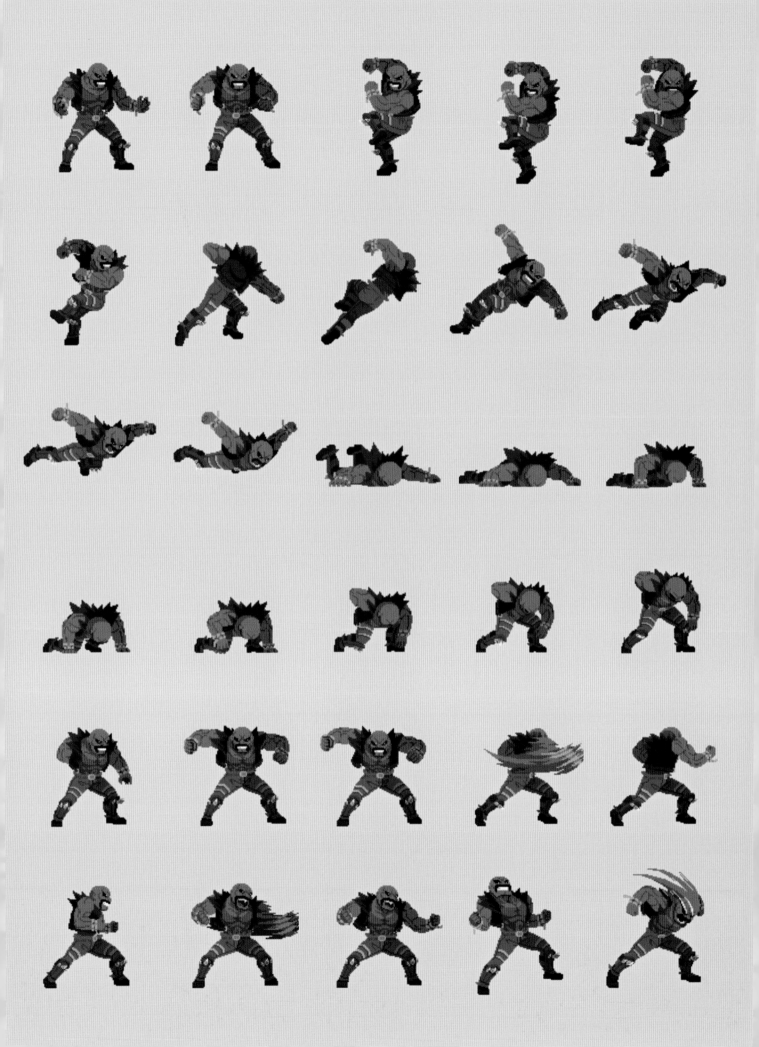

River City Girls' animation is not all subtle, however. It uses the large-headed character design which *River City Ransom* used so successfully to emphasize the characters' reactions to the action. To pull it off, the team had to establish a minimum relative head size. When Kyoko's carrying around a heavy crate, for example, she squints her eyes and puffs out her cheeks to show how she's really struggling to lift it. And when Misako gets punched in the gut, her eyes expand into softballs and pop out of her head, a movement that could look goofy if it weren't for the fluidity of the animation, ensuring that no single frame sticks out.

The team didn't start with these super-deformed sprites when they designed Misako and Kyoko. Their more naturally proportioned portraits in the menus are closer to the designs the game set out with. But big heads and long limbs could better reflect personality and perform all the kinds of attacks they'd be given. Observe the game closely, though, and you'll notice that it's careful to establish the characters with the portraits before showing you their sprites. It wants to give you a detailed first impression which remains in your mind when you see them fighting.

All through *River City Girls* there is a conversation between the past and the present. It celebrates and respects the art which founded the classic brawler, while taking parts of technology and development processes that suit its contemporary expression. The result is clear-eyed, bold and exciting: something modern which finds the best in the games that came before it.

◀ **Boss encounter**

Abobo is a boss who has appeared in several *Kunio-kun* games, starting with 1987's *Double Dragon*.

▲ **Cutscene action**

Rem's comic book was expanded into anime cutscenes which help tell the story between stages.

▶ **Emote**

Character faces had to be as expressive as in-game super-deformed sprites as they are in cutscenes.

THE ARTISTS WE HAD ON *RIVER CITY GIRLS*, THESE
ARE SOME OF THE MOST IMPRESSIVE PIXEL ARTISTS
I'VE EVER SEEN. THEY'RE EXPERIMENTING, THEY'RE
DOING WILD COLOUR COMBINATIONS AND PALETTES.
IT'S VERY NICHE, OF COURSE – THERE AREN'T THAT
MANY PIXEL GAMES ALREADY, AND FEWER STILL
THAT DO SUCH A DEEP DIVE – BUT THERE ARE
COMMUNITIES AND WE'RE DEFINITELY TAPPING INTO
THEM, AND ON A SUBCONSCIOUS LEVEL THAT MAKES
IT FEEL MORE ALIVE AND ROBUST THAN IF YOU'RE,
SAY, TRYING TO EMULATE A NES GAME.

> ADAM TIERNEY

PHYSICAL BEATS →

10

PLATFORMS ANDROID iOS PC PLAYSTATION SWITCH XBOX

DEVELOPER DROOL

YEAR OF RELEASE 2016

THUMPER

DROOL DESCRIBES IT AS 'RHYTHM VIOLENCE'. *THUMPER* TRANSPORTS MUSIC GAMES INTO A NEW SPACE, WHICH YOU FEEL IN YOUR GUT. LIKE *GUITAR HERO*, ITS PLAY CENTRES ON BEAT-MATCHING, BUT RATHER THAN LANE-BASED CALL-AND-RESPONSE THAT FOLLOWS THE VERSE AND CHORUS OF A LICENSED SONG, *THUMPER* IS MORE EXPRESSIVE AND ABSTRACT.

It's about clinging on tight to your controller as your steel-carapaced beetle hurtles along a twisting, plunging track into neon hell; tapping and holding the buttons that will see you survive the next threat. The soundtrack is written by the walls you'll grind along, the percussive jumps you'll make, and the barriers you'll smash through. This is an exquisitely intimidating game which you feel in your bowels.

Thumper's visceral nature is conjured by a remarkable meeting of music and image, courtesy of a unique collaboration between its two makers: artist-designer Brian Gibson, who works out of Providence, Rhode Island, and programmer-designer Marc Flury, who lives in Seoul. They met at Boston-based Harmonix, which made its name creating *Guitar Hero*. Gibson is also half of Rhode Island noise rock duo Lightning Bolt, so that helps to explain *Thumper*'s unforgiving sound design. But both have a remarkable grasp of how to convey speed and action through visual effects. Few games look this perfect in every frame, and few games use every wash of colour and light so effectively. ▨

▶ **In control**
Thumper's storm of light and sound can seem overwhelming, but it's all about the track, which presents a series of cues to hit five different inputs: four directions and one action button.

◀◀ **On track**
The surreal world is built from a combination of computer and music logic: a tracked sequence of obstacles which unfurls as you speed along.

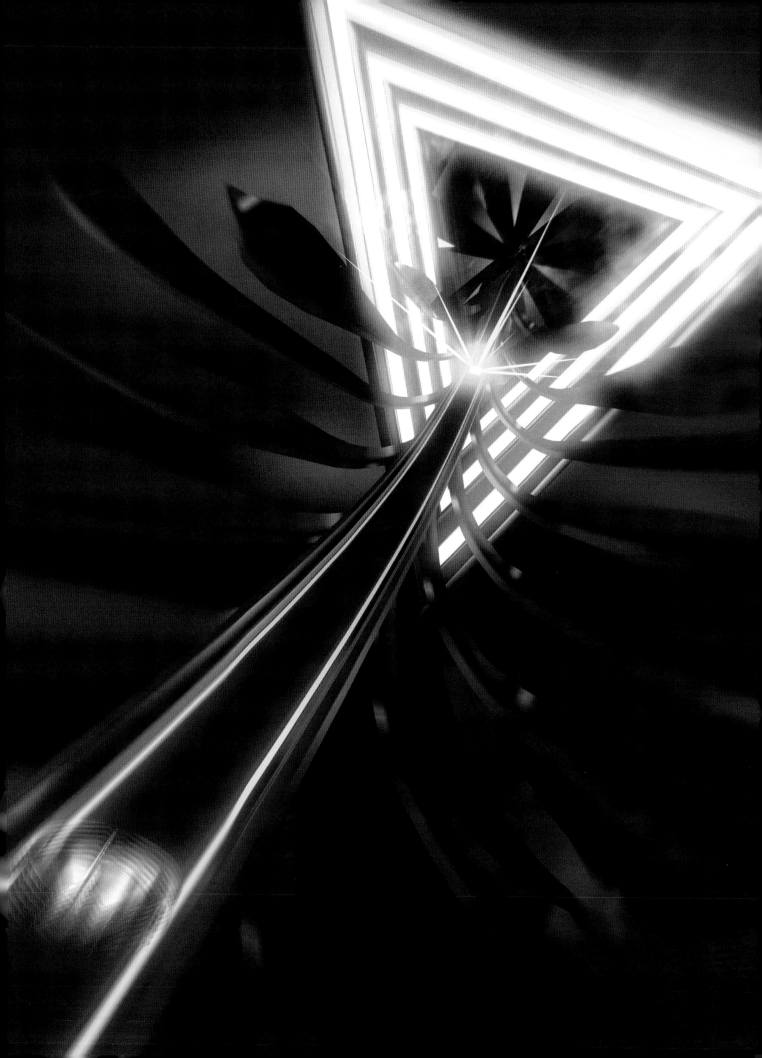

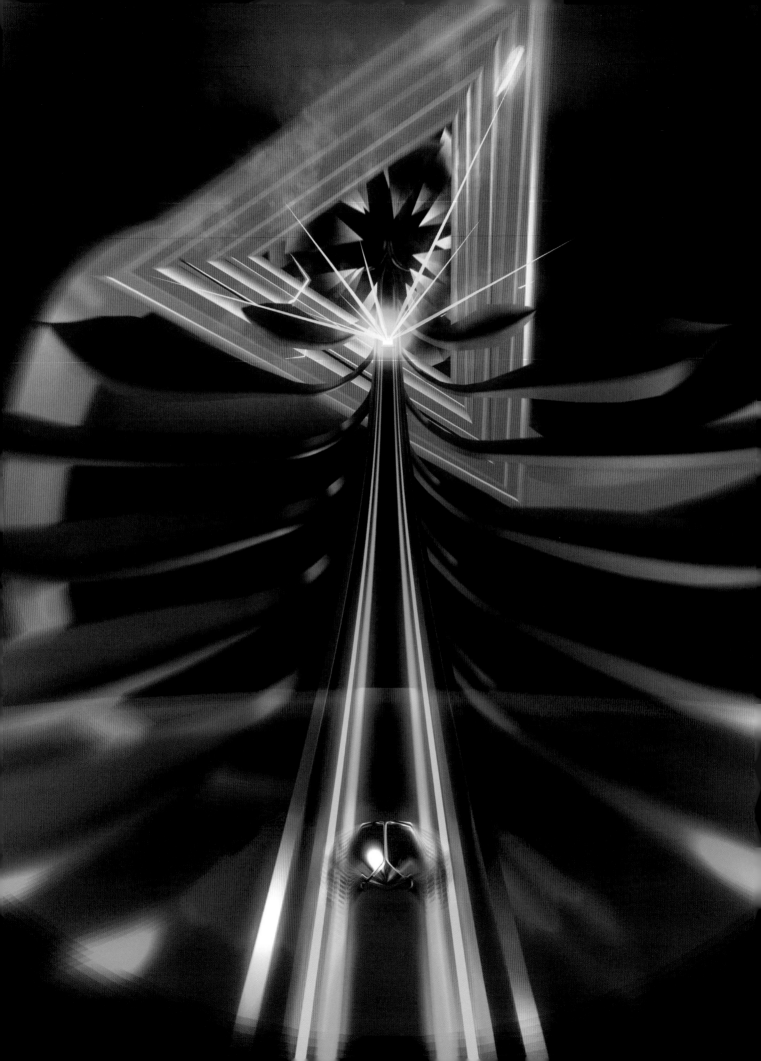

One of *Thumper*'s most important visual inspirations is the Star Gate sequence towards the end of *2001: A Space Odyssey*. Two wide-angled fields of patterned colours roll towards the viewer, giving the sense of a voyage into some unknown dimension; a journey of unstoppable momentum that has obvious thematic parallels with *Thumper*. But designer Brian Gibson was most interested in 2001's analogue quality, because its Star Gate effects are all practical, made through slit-scan photography of filmed images and paint swirling in a tank. Naturally, all of *Thumper*'s effects are entirely digital, but they don't feel that way. Their distorted fuzziness enhances the game's feeling of physicality and pulls it away from the nature of the music games from which *Thumper* evolved.

Flury and Gibson also wanted to make a difficult game, or at least a game with aesthetics that faithfully reflected its challenge. And that's how they set out on the project that became *Thumper*. Other than knowing the player would be flying along some kind of course, nothing else was set until Flury made a tool which defined everything *Thumper* would become.

'RHYTHM VIOLENCE' WAS A SATISFYING INTERACTION, THE FEELING YOU GET FROM GAMES THAT HAVE A SIMULATED SENSE OF SPACE, THAT CONTINUOUS FEEDBACK. THAT WAS MAYBE SOMETHING WE FELT WAS LACKING IN A LOT OF MUSIC GAMES. THEY TEND TO BE KIND OF ABSTRACT AND HAVE A UI [USER INTERFACE] THAT WORKS WITH ANY TYPE OF MUSIC. A LOT OF THE EYE CANDY IS NOT IN THE IMMEDIATE SPACE THE PLAYER'S INTERACTING WITH, IT'S IN THE BACKGROUND.

> MARC FLURY, PROGRAMMER-DESIGNER

◀ **Boss attack**
The glowing light on the track is the cue to hit the action button when the beetle touches it, thus sending a pulse of energy forward to hit the boss. Succeed three times and the stage is won.

⏶▶ **Visual music**

Gibson admires the band Suicide's stripped-down style: a metronomic kickdrum, a couple of repeated notes and minimal vocals. He also seeks to reduce his work to the simplest elements.

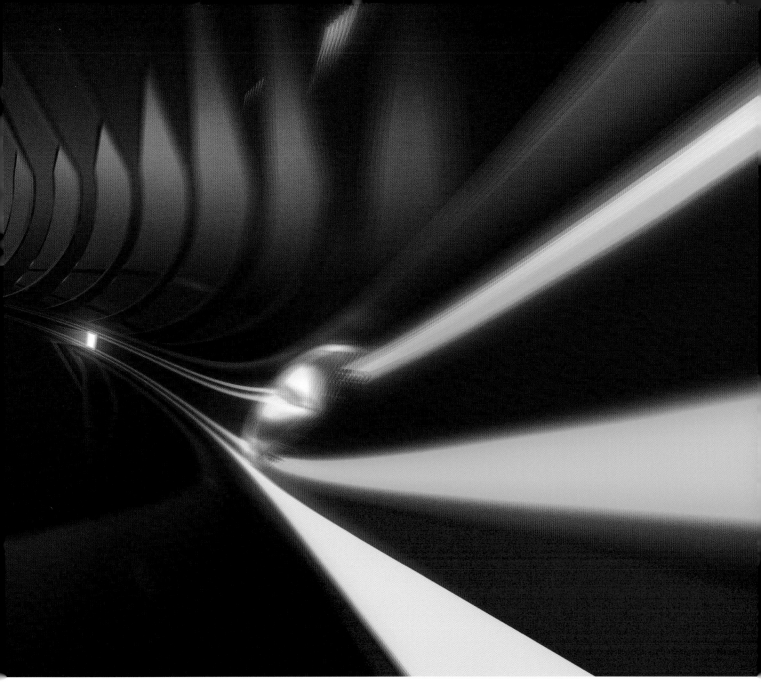

I WANTED THE GAME TO BE BRUTAL. MUSIC GAMES
ARE ALWAYS ABOUT GETTING INTO A FLOW STATE
AND FEELING GOOD, BUT VIDEOGAMES, AT LEAST
TO ME, ARE STRESSFUL AND THEY STIMULATE, AND
MAYBE THEY ALSO SCARE YOU. A LOT OF PEOPLE
THINK MUSIC GAMES SHOULD BE ABOUT BEING IN THE
FLOW AND FEELING GOOD, BUT I LOVE THE FEELING
OF BEING ADDICTED TO SOMETHING AND TRYING TO
OVERCOME A CHALLENGE, AND IT'S THREATENING AND
SCARY. I HADN'T SEEN A MUSIC GAME WITH THAT GOAL.

⟩ BRIAN GIBSON, PROGRAMMER-DESIGNER

Flury called this tool a linear sequencer, and it defined
Thumper's levels. It works a lot like a music sequencer or
a video track: each level is broken into a series of segments,
one per beat. Each segment can be set with a feature –
a bend for the player to grind through, a thump to tap the
button on, a barrier to break. This allowed Gibson, who
designed all the levels and wrote all the music, to sequence
the music precisely to the fabric of the tracks.

But the linear sequencer went even deeper than simply
blocking out the level design. It also gave Flury and Gibson
a way of technically implementing the emotion of *Thumper*'s
wild rush, since every segment can also be set with a
range of different parameters that lend it various effects.
What's more, as far as the game is concerned, the track is
a sequence of Lego-like 3D objects that are defined by the
linear sequencer. The game then uses a shader to bend,
scale and rotate them so they perfectly fit, one after another.

▶ **In sequence**

The track and the things that exist around
it are all 3D objects, which are arranged by
the same sequencer that determines the
obstacles along the track. Shaders then
deform and scale them so they fit together
into a continuous flow.

◀ Crakhed

Bosses such as Crakhed add further
stress, requiring the player to loop
through challenging sets of obstacles,
but their bombastically tongue-in-cheek
appearance is a distraction: the track
remains the real enemy.

▶ Effects pedal

A bewildering sense of speed is relayed
by post-process effects that blur trackside
objects into streams of light as they pass
into peripheral vision.

The game's ability to morph the segments is at the heart of many of the visual effects that create *Thumper*'s constantly shifting nature. For example, the linear sequencer can taper the track into a thin tentacle and apply animation to it, so it ripples and changes scale. It can set the course on steep inclines and into tunnels lined by pincers – the strange configurations of structures and almost organic forms that move and array themselves alongside the track are all down to this same system. Gibson likes the concept that everything in the world you speed through is made from the same essential stuff.

It's flexible, too. One powerful experiential effect is to change your perception of speed as you race along by stretching the length of a segment. Each segment takes a fixed time – a single beat – to traverse, so by making it look longer, it appears that you're travelling faster because it takes the same time for the next segment to get to you.

Part of *Thumper*'s strong sense of physicality is also down to its chrome beetle, which percussively slams and scrapes along the tracks in such a way that it feels part of the soundtrack. The beetle was conceived by artist and musician Mat Brinkman, a friend Gibson had gone to for ideas on what the player would be. He felt that Brinkman's interest in fantasy art might hold an answer, and it did.

IT'S ALL SUBJECTIVE IN TERMS OF WHAT'S HAPPENING IN THE FRAME. IT WAS GETTING THAT FEEL, STRETCHING THINGS OUT SO IT FEELS FASTER. BUT I COULDN'T GIVE YOU AN EQUATION THAT DESCRIBES WHY A PARAMETER FEELS FAST. THE NUMBERS WE CHOSE JUST FELT INTENSE AND FAST AND CRAZY, BUT NOT SO THAT YOU COULDN'T PARSE WHAT WAS GOING ON. IT'S ON THAT BORDERLINE OF BEING TOO FAST, BUT PLAYABLE. I HAD A VISION OF A FAST AND INTENSE GAME, SO I TWEAKED IT TO THAT.

> BRIAN GIBSON

◀ **Virtual scale**

The game's VR version has half the field of view of the flat-screen version, making the action seem much slower. To match the flat-screen version's intensity, Drool stretched out track sections by up to four times so it feels faster.

I WAS THINKING THAT THE BEETLE SHOULD LOOK CHROME AND THAT THE TRACK IS A HARD SURFACE, SO YOU'RE SELLING THIS IDEA OF METAL ON METAL, AND IT SOUNDS LIKE A HAMMER HITTING AN ANVIL WHEN YOU HIT A TURN, AND WHEN YOU LEAN INTO THE TRACK, SPARKS FLY OUT. IT TOOK A WHILE TO FIGURE OUT HOW TO MAKE A CHROME THAT LOOKS GOOD. HIS SHELL DOESN'T REFLECT THE WORLD, JUST A BLACK AND WHITE TEXTURE. IT DOESN'T MAKE ANY SENSE, BUT IT LOOKS CHROME, AND IT ENABLES THE BEETLE TO STAND OUT IN FRONT OF EVERYTHING ELSE.

⟩ BRIAN GIBSON

⏶▶ Visual lead

The hard metal that underscores *Thumper*'s visual design helped to set the musical tone for the game, which reflects, in Gibson's words, 'a universe of clanging things'.

▲ **Generation game**

Thumper often celebrates the procedural nature of its visual design; its spaces are intentionally abstracted into form and noise.

▶▶ **Action prompt**

Despite the sound and fury, cues for interaction are always clear. They're mirrored in the soundtrack; it's even possible to play simply by listening.

WHEN WE WERE TESTING WE COULD SLOW THE GAME TO .05 OF NORMAL SPEED. I TRIED TO ENSURE THAT THERE'S NOT ONE MILLISECOND THAT DOESN'T LOOK CONVINCING. WHEN YOU HIT THE THUMP, THIS BRIGHT FLASH APPEARS, IT SCALES INTO NOTHING, THIS SHOCKWAVE COMES, AND THEN SPARKS. THE GAME IS SO FAST THAT YOU CAN'T NOTICE HOW WELL EVERYTHING IS TIMED, BUT WE HAVE THIS BELIEF THAT ON SOME LEVEL IT MUST MAKE A DIFFERENCE.

> BRIAN GIBSON

Thumper also extracts physicality from distorting the screen, subtly stretching out the image at its edges, as if you're seeing the world through a lens, or, Gibson says, a space helmet. Blurring the periphery contributes a little to the sense of speed, but it also quietly evokes the cinema – namely, *2001*'s Star Gate sequence – at the heart of its visual inspiration. Contributing to this effect is a film grain treatment applied only to the skybox, because Gibson didn't like the way it detracted from the clean precision of the edges of the track. When he limited the grain to the background, he discovered it gave the background a greater impression of distance, while also helping to glue together the morphing washes of nebulae-like colour that give it form. These nebulae are yet another aspect of the game that's controlled through its linear sequencer, since it can change them. Gibson wanted to use the background colour to give tonal variety during the level, as if you're travelling through a space that's changing. You might not notice that the background was blue when you entered a tunnel but when you emerge it's red, but it still affects you on some deeper level.

And to push the physical sensation of being in this cosmic netherworld still further, the view wobbles and shakes, as if the camera is having a hard time keeping up with a beetle moving at 10,000 miles an hour. Yet the camera is snappy, reflecting every turn. *Thumper*'s visual design is down to a pinpoint attention to its details; an absolute focus on every interaction to maintain a sense of physical weight and clarity.

This is a spare game, made of just a few elements: a beetle, a track, speed. Flury and Gibson's dedication to ensuring that every millisecond feels right is why they carry such audiovisual weight.

BUILDING FOR VIRTUAL REALITY →

11

DEVELOPER VALVE SOFTWARE

YEAR OF RELEASE 2020

PLATFORMS PC

HALF-LIFE: ALYX

PART GAME DESIGN BUSHWACKER, PART ACTION BLOCKBUSTER, *HALF-LIFE* IS A LEGENDARY SERIES. FROM ITS OUTSET, IT HAS DEFINED MANY OF THE CORE PRINCIPLES OF THE STORY-LED FIRST-PERSON SHOOTER (FPS).

In its 1998 debut, it laid down the mechanics and forms of telling a story through the eyes of a player-protagonist. In its 2004 sequel it explored the procedural opportunities of introducing real-time physics to first-person play. From there it began to experiment with format by releasing two episodic games – until a promised third part never materialized. Then silence, until, thirteen years later, *Half-Life: Alyx* appeared.

Alyx's experiment in first-person play was about taking the experience from flat screen to virtual reality. Cash-rich and talent-soaked, Valve was already immersed in VR, developing both hardware and games in order to research the creative and business potential of a technology which has seemed on the cusp of exploding for close to a decade. In retrospect, *Half-Life* was the perfect foundation for the studio to prove one of its core beliefs: that VR only builds on and heightens the sense of presence and richness of interaction which already infused all the other *Half-Life* games. But its journey to doing so in *Alyx* was beset by creative challenges that Valve's developers had no idea they were letting themselves in for. ▓

▶ **Watch the hands**

Alyx's hands are profoundly important to the player's sense of presence in the world, because they match up perfectly with their positions in the real world.

◀◀ **Safe room**

The Resistance are forced to huddle with their equipment in makeshift rooms. Every surface and screen is worth looking at closely for jokes and references.

From its outset, *Half-Life* has struggled with a simple problem. Players can never be trusted to look where they're supposed to. That would be easy to solve, if it weren't for Valve's iron commitment to never take control from players. *Half-Life* games never wrest the player's view to gaze at what they need to see, because they're anxious never to break the player's belief that they're a character who is present in a world. As soon as the player loses control, they're reminded that there's a screen between them and the game world, and that they're being led by the nose through someone else's adventure.

So, over the twenty-two years between the first *Half-Life* and *Half-Life: Alyx*, Valve became celebrated for the subtle ways it learned to direct players' attention with tricks of sound, light and architectural detail, wordlessly directing them along city streets, through apartments, across rooftops and into storm drains. That was great for flat-screen games, but, as *Alyx*'s developers found, the old attention problem was exacerbated by VR, and the traditional techniques weren't enough to solve it.

▼ **Partition**

The Combine's mysterious and inhuman technology smothers the Eastern European metropolis that's become City 17.

▶ **Occupation**

The Combine's presence is impossible to escape – reflecting the almost absolute control it has over the life of the city.

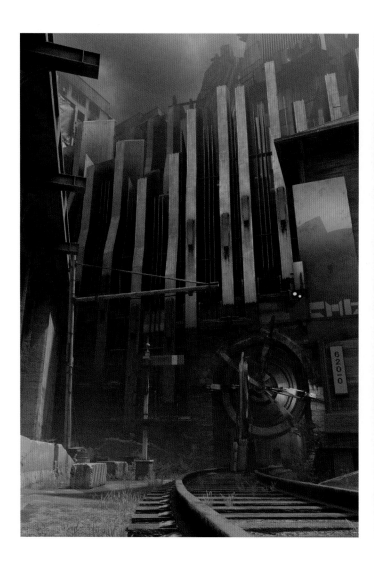

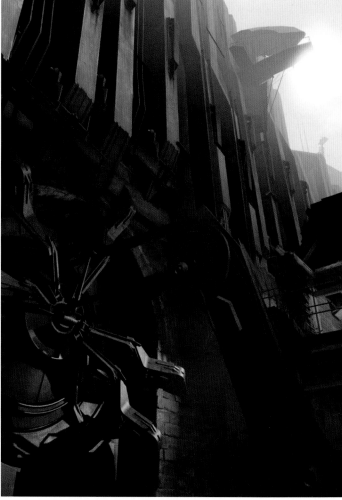

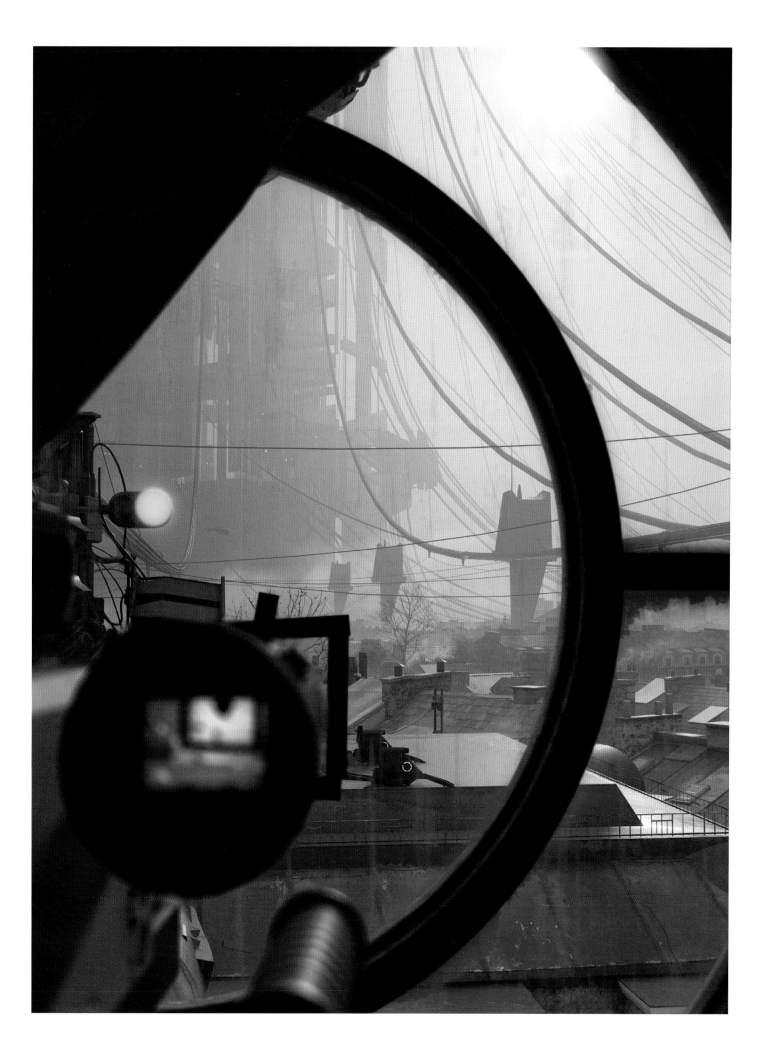

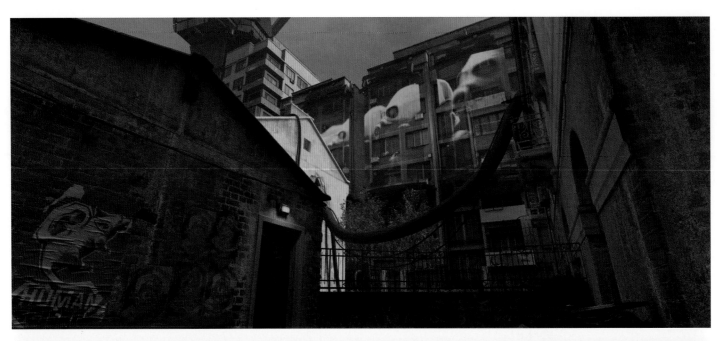

▲ **In proportion**

Virtual reality means that the scale of the world is 1:1, and it maps the player's virtual body to the height of their actual one.

▶ **Back light**

Lighting is one of the ways *Alyx*'s environment designers draw attention to things they want the player to notice.

ONE OF THE PROBLEMS WE HAD WAS THAT SOME
OF THESE SET PIECES HAD THINGS WE WANTED
THE PLAYER TO LOOK AT, AND A LOT OF THE TIME
PLAYERS PREFERRED TO BE LOOKING AT THE GROUND
AROUND THEM. IT WAS REALLY HARD TO MAKE PEOPLE
LOOK UP. IN NORMAL 2D VIDEOGAMES YOU CAN TAKE
THE CAMERA AWAY FROM THE PLAYER AND YOU CAN
GO INTO A CINEMATIC CUTSCENE AND DIRECT THE
VIEW EXACTLY WHERE YOU WANT IT TO BE, BUT YOU
PHYSICALLY CAN'T DO THAT IN VR WITHOUT MAKING
PEOPLE THROW UP.

> ROB BRISCOE, ENVIRONMENT ARTIST

VR, it transpired, is much more of a distracting environment to be in than the flat world of conventional first-person games. Nearby things become fascinating, especially if a player is new to VR, while distant scenery tends to flatten out and grab less attention. Players pick objects up and study them, appreciating at a close distance fine detail that a 2D screen and traditional FPS controls can't serve. Moreover, in VR, players must physically crane their heads upward in order to look up. Especially if a session has lasted over thirty minutes or so, they become less and less inclined to make the physical effort. As a result, Valve had to think constantly about highlighting and literally framing the important things in a scene to ensure players notice them.

For example, early in the game you're given a clue about looking to the 'northern star' in order to save Alyx's father. Later, you walk up the stairs from a subway to see the exit framing precisely the sign of a hotel opposite called Northern Star. The framing isn't subtle, but Valve's environment artists originally placed the exit on another part of the street, and they found that players simply weren't noticing the hotel so couldn't make the connection. In VR, subtlety can't compete with all the other things a player wants to do in a richly interactive and detailed world like City 17.

▶ **Northern Star**
Players must take literally an instruction to look to the Northern Star, but getting them to notice it was surprisingly difficult because the immediacy of virtual reality tends to make every element in the world distracting.

Because players can manipulate objects with their hands, VR gives them new expectations of being able to interact with many of the dials, knobs, foliage and other details that artists use to decorate objects and the world. The team watched testers going around rooms, trying door handles, only to find that just a few of them function. They realized that if something looks like it's interactive and it isn't, it's a rude reminder of the artificiality of the world. The environment artists therefore learned to be careful with what the world suggested was possible, removing a lot of details from props and environment features, and to be very clear about what players can interact with, particularly at the start of the game, when they're learning about what its designers want them to mess with and what they don't. For areas that come later in the game, the art team allowed themselves a little more latitude with popping the odd ornamental switch here and there, more comfortable that players will have picked up an implicit understanding of the world's rules.

I THINK PLAYERS' INITIAL FASCINATION COMES FROM THE DISCOVERY THAT THEY HAVE HANDS AND FINGERS. THEY'D IMMEDIATELY WANT TO INTERACT WITH STUFF AND PICK IT UP. AT THE START OF THE GAME WE HAVE THE VISTA OF THE CITADEL AND IT WAS REALLY HARD TO GET PLAYERS TO LOOK AT IT AND GET ACROSS ANY OF THE STORYTELLING WE WERE TRYING TO PUT IN THERE. ALL THEY WANTED TO DO WAS TO REACH OUT FOR A MATCHBOX AND PLAY WITH IT. SO WE HAD TO GIVE THEM TIME TO GET USED TO THE FACT THEY HAVE HANDS.

> TRISTAN REIDFORD, ENVIRONMENT ARTIST AND MODELLER

◀ **Opening**

The opening of the game features a balcony and a room filled with objects for the player to investigate and play with, introducing the characters and world while helping the player learn the mechanics of virtual reality.

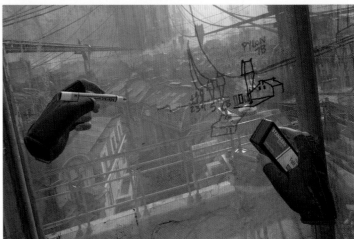

◀▶ Keeping faith

Objects in virtual reality must behave
more realistically than they do in flat-
screen games, so they don't break the spell.
Pens actually write on windows and liquid
sloshes around inside bottles, and they're
modelled precisely so they fall and roll in
the ways players expect.

◀ **Breathing room**
The team had to consider the physicalized nature of the player's body when they designed spaces, even allowing them to put their hands through small apertures.

▶ **Keeping real**
Half-Life's commitment to realism gave *Alyx*'s environment design welcome constraints: it could be fantastical, but it also had to look like it could really exist.

Half-Life: Alyx can directly trace its technical roots to *Quake*, id Software's 1996 full-3D follow-up to *Doom*, because its engine, Source, was based on a modification of *Quake* that Valve created for the original *Half-Life*. This technical palimpsest means that every successive Source game has inherited and built on art conventions set for previous games. *Half-Life* inherited *Quake*'s vast scale and then reduced it so it could credibly introduce door frames and other details that had been technically impossible in *Quake*. *Half-Life 2* then had to scale down the world further to fit its new bar for realism. When it came to *Alyx*, *Half-Life 2*'s scale still turned out to be twice as big as it needed to be.

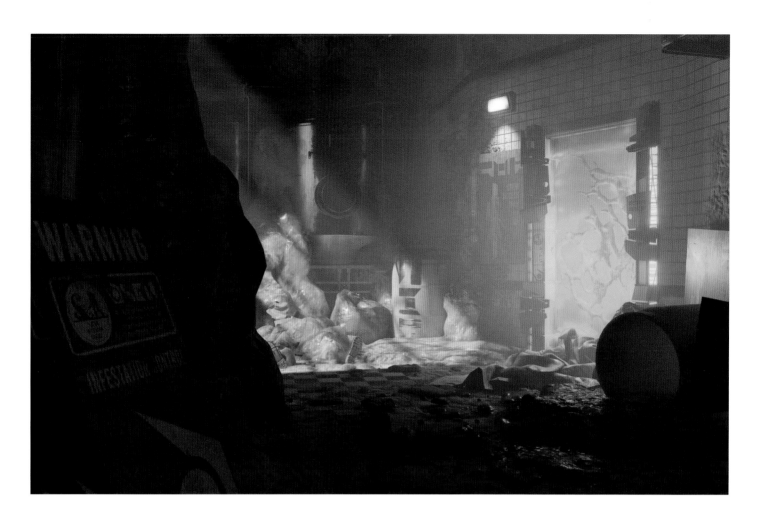

◀ **Headcrab infection**

Strongly backlit spaces create sharp silhouettes. Along with these zombies' sense of presence, they further heighten *Alyx*'s frequent horror sequences.

▲ **Containment field**

The Combine appear to be attempting to control the alien infestation by smothering it in a glutinous orange matter.

Even more than perception, the scale is further complicated by the fact that in *Alyx* the player character's height is the same as the player's real height. This was vital to preserve the player's natural expectation of their place in the world, but it also meant taller players could bump their heads on ceilings, while shorter ones couldn't see over walls. Even level designer Dario Casali, who has worked on every Valve game since *Half-Life*, made simple mistakes: in an early version of the Vault area, he designed an upside-down room with a door you'd have to open to exit. He's tall and could easily reach up to turn its upside-down handle; it wasn't until someone shorter tested it that he realized he'd designed a showstopper: a bug so serious that it would prevent a player from progressing. And then there were problems with scale at a distance, too.

Valve's artists describe *Alyx*'s development as a constant voyage of discovery, one on which unforeseen consequences were routine. Every rule of thumb they'd learned for creating games for flat screens had to be reconsidered and reinterpreted. Then again, *Half-Life* has always had to solve the fundamental challenges of its medium to build new standards.

▲▶ Taking liberties

The Combine's parasitic architecture gave level designers the freedom to connect and create spaces which wouldn't be credible in real-world settings. They could smash through walls and dress the scene with Combine equipment to add to the player's appreciation of the game's story.

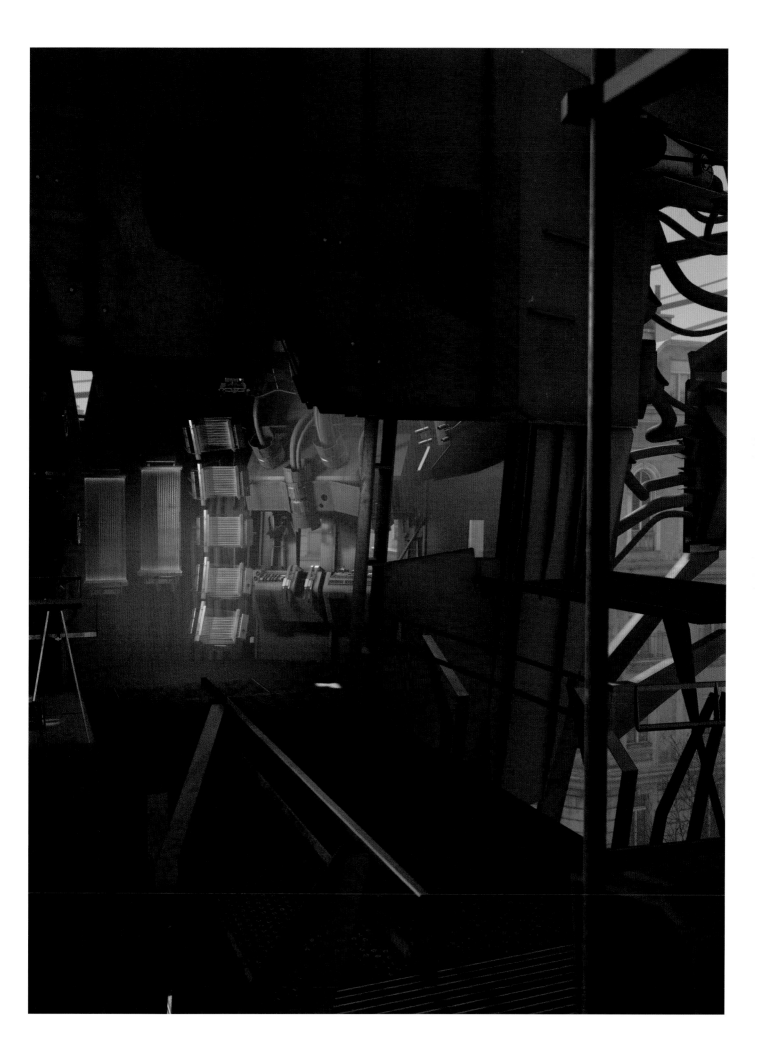

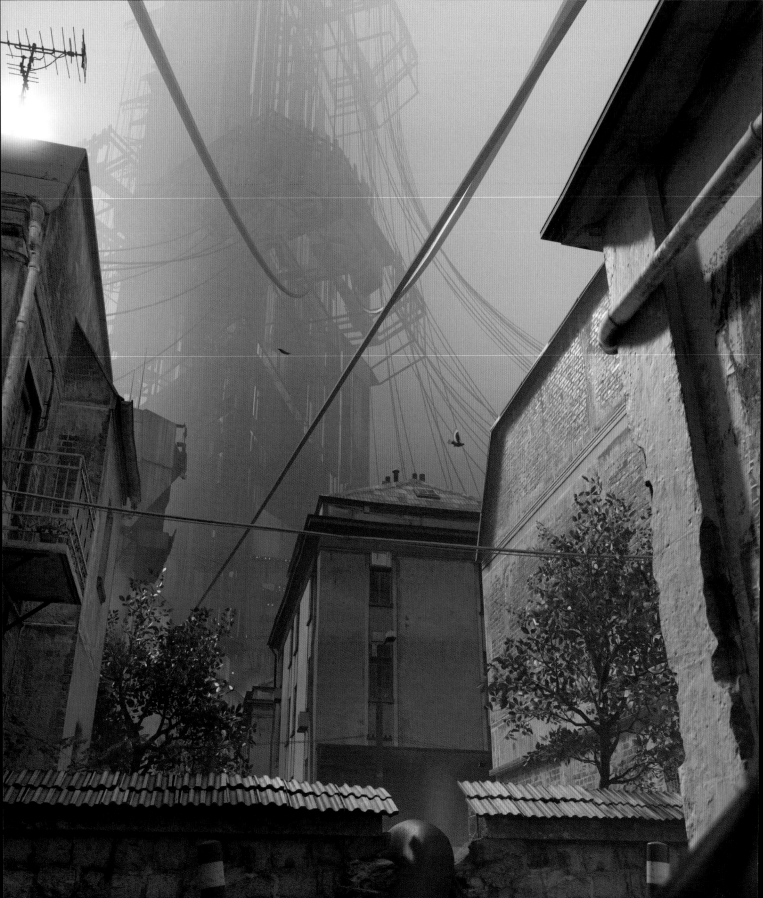

AT A CERTAIN DISTANCE YOU CAN'T REALLY
TELL SCALE ANY MORE, SO WE HAVE TO USE
OTHER TRICKS TO MAKE THINGS SEEM THREE-
DIMENSIONAL. THAT'S WHERE LIGHTING AND
FOG COME IN. WE COULD PULL DOWN THE CLOUDS
A LITTLE SO THE VAULT LOOKS LIKE IT'S
SITTING HALFWAY IN THE CLOUDS. WE ALSO USE
PERSPECTIVE GEOMETRY TRICKS LIKE HAVING
A CABLE NEARBY THAT'S STRETCHING INTO THE
DISTANCE – IF YOU CAN MAKE THE CONNECTION
OF SOMETHING CLOSE-BY THAT'S CONNECTED
TOWARDS SOMETHING IN THE DISTANCE IT GIVES
A GOOD THREE-DIMENSIONAL READ OF THE SPACE.

> BRAM EULAERS, ENVIRONMENT ARTIST

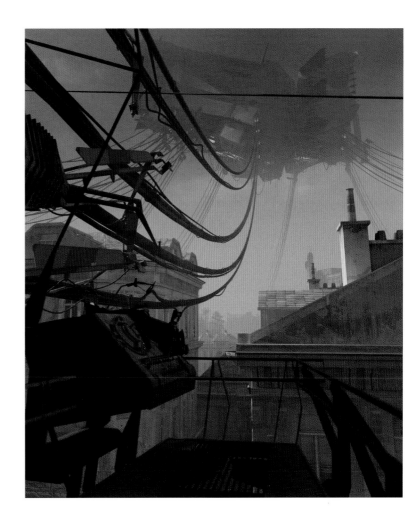

◀ ▶ **Cable ties**

As well as drawing players' eyes to the
Citadel (left) and Vault (right), cables
also reflect the idea that *Alyx* takes place
before *Half-Life 2*, when the Combine are
still establishing themselves and before
they've tidied up the physical artefacts of
their occupancy.

FIRST-PERSON FEAR →

12

DEVELOPER FRICTIONAL GAMES

YEAR OF RELEASE 2015

PLATFORMS PC PLAYSTATION XBOX

SOMA

SWEDEN-BASED FRICTIONAL GAMES HAS BUILT A UNIQUE PLACE FOR ITSELF AS AN INDIE DEVELOPER OF FIRST-PERSON HORROR SINCE RELEASING ITS DEBUT GAME, *PENUMBRA: OVERTURE*, IN 2007.

Across seven titles and three series, it has honed a narrative-rich approach to dealing first-person dread, which centres on combining lonely exploration of the dark and a pervasive feeling of powerlessness with a richly interactive world through real-time physics and stealth.

In *SOMA* you play Simon, a car-crash survivor whose symptoms qualify him for an experimental brain scan. On waking up, however, he finds himself transported not only to PATHOS-II, a stricken research facility at the bottom of the Atlantic, but also a hundred years into an apocalyptic future. As in most Frictional games, the story veers from grisly exposé to worldview-changing revelation, and the answers Simon finds to his situation lie as much within him as they do without. But the real star of this horror show is the thick atmosphere that Frictional generates with dark and light, supported by superlative sound design, and deep knowledge of how to frame and also hide the bumps in the night that drive your progression through it. Experiencing all this through Simon's eyes only heightens the fear. ▓

▶ **Sub-marine**
The underwater setting led *SOMA*'s environment artists to use lots of evocatively organic shapes in its human-constructed buildings.

◀◀ **Dread medium**
Creative director Thomas Grip believes that videogames have the potential to bring something new to any genre, but with horror they can truly create better experiences than film.

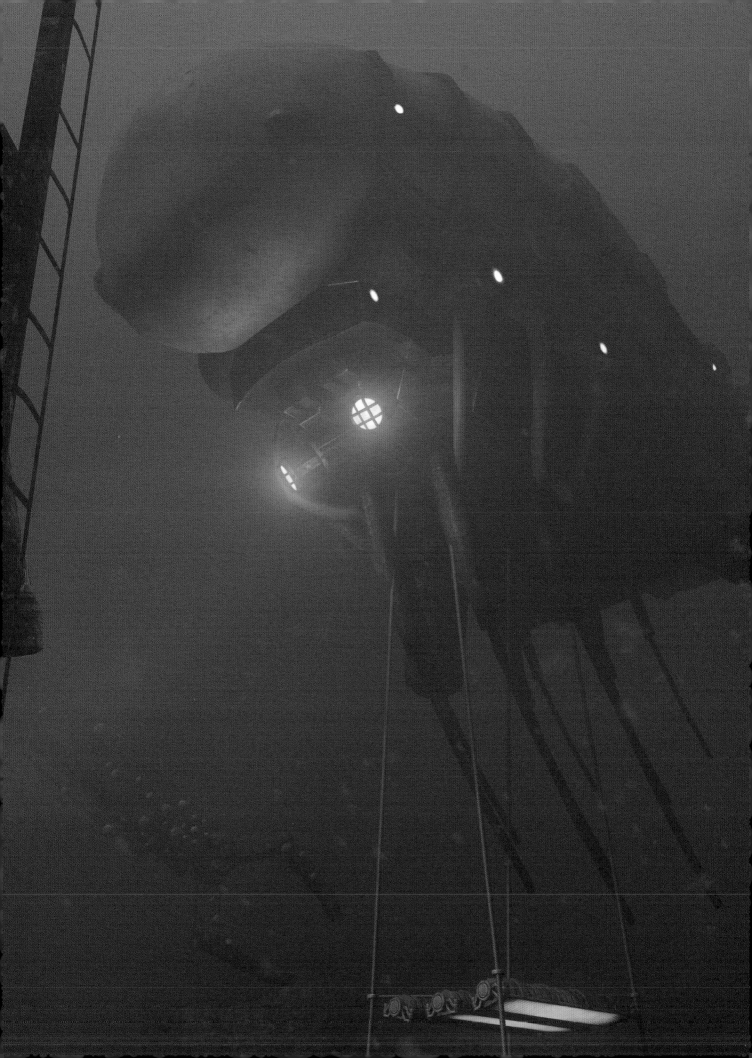

If the participatory nature of videogames elevates one type of story above all, it's horror. When so much of a genre is a proxy for the audience's thoughts and senses, of course it's going to be scarier to creak open the door yourself, or move the view to look behind you. But this goes much deeper when you view the world from the eyes of the protagonist, because now you're the person experiencing it. Frictional Games has traded on this dark pact since the mid-00s, when it transposed the third-person horror of *Resident Evil* and *Silent Hill* to first-person in *Penumbra: Overture*.

But while making the player the protagonist is horribly effective at doubling a sense of menace, it also makes them the director of cinematography. Horror is a genre that's particularly dependent on carefully managing a player's awareness. It trades on building expectations and delivering payoffs that the player didn't quite see coming – but players can't feel dread if they aren't aware of the threat, and they can't be shocked if they aren't looking at the scare. This has been a constant challenge for Frictional throughout its history.

FIRST-PERSON ALLOWS YOU TO CREATE SPACES THAT CAN FEEL MUCH MORE INTIMATE THAN THIRD-PERSON, BECAUSE YOU'RE JUST THAT MUCH CLOSER TO EVERYTHING AND YOU CAN TREAT YOUR SPACES WITHIN REALISTIC CONSTRAINTS. OFTEN IN THIRD-PERSON GAMES YOU HAVE HALLWAYS THAT ARE SUPER-WIDE BECAUSE EVERYTHING NEEDS TO FIT THROUGH THEM. WE CAN WORK WITH VERY NARROW AND TIGHT SPACES AND CREATE FEELINGS OF CLAUSTROPHOBIA.

> RASMUS GUNNARSSON, ARTIST

▶ **Close in**

An open space collapses into a narrow one which leads to a doorway, giving the player a rising sense of claustrophobia.

▶▶ **Safe space**

Though dimly lit, mundane settings tend to put the player at ease, priming them for a nasty shock or providing a moment to breathe.

SAY YOU HAVE A MONSTER CRAWLING OUT OF A VENT AND RUNNING ACROSS THE CORRIDOR. IN A THIRD-PERSON GAME LIKE *RESIDENT EVIL* YOU'D JUST GO TO A CUTSCENE, BUT YOU DON'T WANT TO DO THAT IN FIRST-PERSON BECAUSE IT MEANS TAKING OVER PLAYER CONTROL. YOU WANT TO KEEP ITS IMMERSIVE ONE-ON-ONE ASPECT AS MUCH AS YOU POSSIBLY CAN, ESPECIALLY DURING A MONSTER-REVEAL MOMENT, WHEN IT'S VERY IMPORTANT THE PLAYER FEELS THEY'RE THE ONE BEING THREATENED. BUT THE PLAYER CAN LOOK ANYWHERE, SO HOW DO YOU MAKE SURE THAT THE PLAYER HAS A GOOD FRAMING OF EVENTS AND MAINTAINS AGENCY?

⟩ THOMAS GRIP, CREATIVE DIRECTOR

◀ User interface

PATHOS-II is littered with technology with which Simon is as unfamiliar as the player; with no one around to explain it, it maintains an air of inscrutability.

▶▶ Data point

Information about the story and world is delivered through notes and audio logs, as well as posters, computers and objects players can interact with.

If you look carefully at *SOMA*'s levels, you might notice the subtle cues their designers use to ensure you look the right way. For example when you walk into an area, you'll have your attention naturally pointed in the direction of what you need to see. On the other hand, it is important that the player never feels as if their attention is being railroaded, as this would lay bare the game's intent and damage their sense of agency.

Like many games, *SOMA* uses light to attract attention. Here, its future setting proved more flexible than in previous Frictional games, which tend to have historical settings. To illuminate an important feature in the *Amnesia* series, for example, Frictional either had to place a window to let daylight in, which wouldn't make sense if the scene was meant to be underground or set at night, or place lit torches or candles, risking the player finding it unrealistic for flames to be burning in places that are meant to be abandoned and forgotten. The simple existence of electricity in *SOMA* opened out the possibilities, though the challenge remained to make the lighting feel natural and unforced, and to manage the use of darkness, which is so effective in horror games because it limits how much players know about the environment around them.

ONE OF THE HARDEST THINGS FOR US IN MAKING
A HORROR GAME IS THAT USUALLY DARKNESS IS
WHAT'S SCARY, BUT THAT'S NOT VERY HELPFUL
FOR THE PLAYER TO NAVIGATE. SO, WE HAVE A
BIG PROBLEM WHEN WE WANT EVERYTHING TO BE
SUPER-DIM. I DON'T THINK WE COMPLETELY SOLVED
IT IN *SOMA*. IT'S VERY HARD; YOU CAN TRY TO MAKE
IT CLEAR WHERE THINGS ARE SUPPOSED TO BE
COMPLETELY DARK, BUT IT'S REALLY TOUGH.

> RASMUS GUNNARSSON

▲▶ Spatial dimension

SOMA's environments mostly follow a realistic scale, but some objects and spaces had to be adjusted. Desks had to be raised, so players would notice their tops, and objects made larger, so they're easier to pick up.

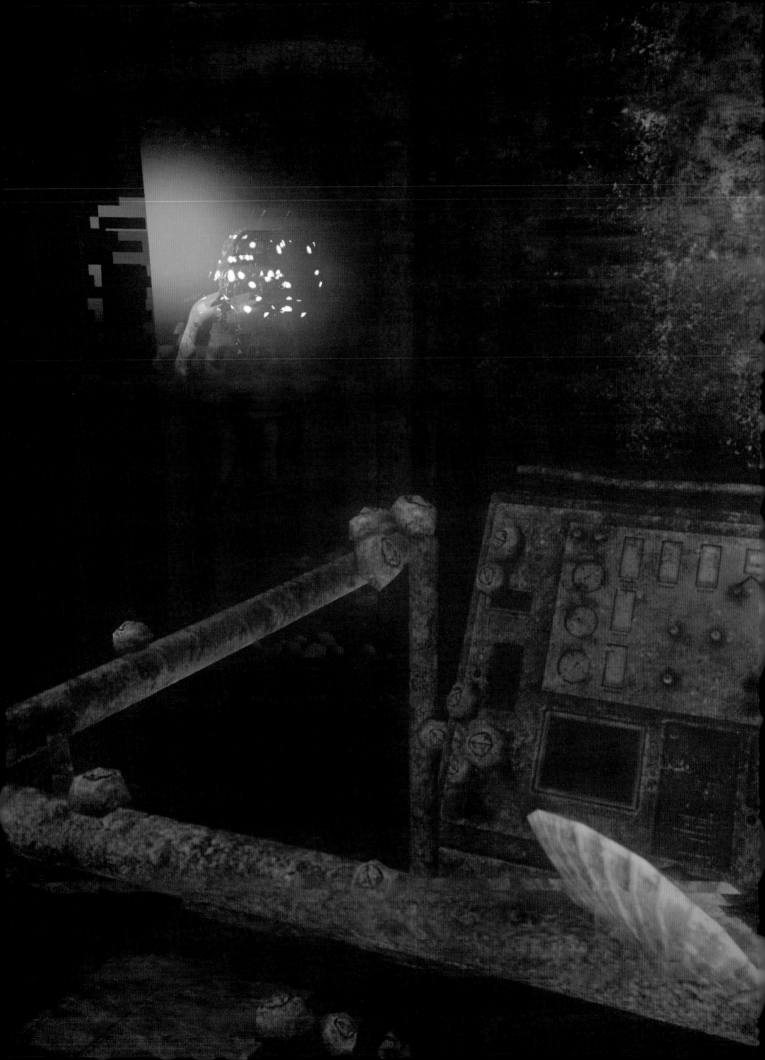

With darkness, Frictional must also think about players' monitors, which will be set to a wide range of contrast and brightness values. Some players might not be able to see things that they're meant to, or their settings might reveal everything in a scene that was meant to be only just perceptible. And then there's *SOMA*'s torch, about which creative director Thomas Grip still has many mixed feelings. It's a welcome part of the experience, because it's exciting to explore a dark space with a thin beam of light. But to aid the player agency that's foundational to *SOMA*'s delivery of horror, players are allowed to use the torch at any time. And that means they can be shining it at things that the team didn't want to be so brightly illuminated.

The answer, as with so much of game development, was to simply accept that some players won't have the perfect experience. But the continual sense of first-person control was sacrosanct. As an idea of how hard *SOMA* works to keep you from feeling control is taken from you, Frictional imposed a rule of thumb for how they could use camera movements to impart an idea to the player of Simon's body. If in real life they'd mind someone messing with where they're looking in a particular way, then they'd avoid it.

WE HATE THE FLASHLIGHT. SAY YOU HAVE A PERFECT REVEAL OF A MONSTER COMING OUT OF THE SHADOWS, TRYING TO CLUTCH YOU WITH ITS CLAWS, AND ONE PLAYER HAS THEIR FLASHLIGHT SHINING AND ANOTHER DOESN'T. HOW DO YOU ADAPT THAT SCENE TO BOTH PLAYERS? YOU REALLY CAN'T. THERE ARE SOME SCENES WHICH LOOK AWESOME WITHOUT THE FLASHLIGHT AND THEN IT'S TOO REVEALING WHEN THEY DO HAVE ONE. WE'VE HAD LOTS OF DISCUSSION ON IT.

> THOMAS GRIP

◀ Flesher

SOMA's enemies echo its undersea setting, with bioluminescent growths which, on closer inspection, are revealed as partly machine. The Flesher can teleport, emitting a loud cracking sound.

If Simon is meant to be stumbling because he's been injured or stunned, Frictional were careful to have the camera communicate a lurching gait without making the player feel as if it's impeding them or taking away precise control. But if in the story Simon has been bludgeoned and is losing consciousness, the team figured the player wouldn't mind losing control because it's a logical result of what's happened. Frictional pulled a few tricks: there are a couple of places in the game where, for pacing reasons, players couldn't be allowed to run. To avoid frustrating them, Frictional let the view bob in the same way it does when running, but without raising the movement speed. But for the most part, the first-person perspective is part of a greater aspiration for naturalism: preventing the game standing in front of the world and the story that plays out within it.

▲ **Character building**

SOMA features more humans than Frictional's previous games, though the team were nervous about how well they could realize them with their available resources.

▶ **Iron man**

Body horror plays a strong part in *SOMA*'s design, subjecting human bodies to the strange privations of the AI that has taken over PATHOS-II.

The fact that *SOMA* rarely shows Simon's arms further limited the opportunity to present information. Some first-person games, particularly shooters, permanently display arms and guns on-screen and serve as a permanent canvas for ammo counts, compasses and other particulars, which can give the player what they need to serve gameplay systems. But in *SOMA*, the only way Simon's arms are regularly visible is when the player pulls up the Omnitool handheld computer, which opens doors.

The studio didn't initially plan on giving Simon any visible body parts, since every little extra required more work for its small team. But when the team tried it out in a couple of scenes, including one in which Simon meets the Catherine Chun character, who reveals to him that he's a robot, they realized it was the difference between the moment succeeding and falling flat. Simon looks down at his arms, a common gesture used by games to hint at a moment of internal reflection. It's a rare moment of the game telling you what Simon is feeling, rather than letting you feel the horror of that revelation yourself. All games wrestle to some degree with the fine balance of directing a player's experience while letting them feel as if they have full control over their actions, but while that challenge is amplified by the first-person perspective, the payoff is amplified, too.

▶ **Ocean abyss**

From the claustrophobia of the station, the sea floor opens up the potential for agoraphobia as shapes loom in the distant gloom. Encrusted with life, the architecture takes on an even more unsettling otherness.

GLOSSARY

Colour grading
A process by which the colour balance, contrast and brightness of an image are adjusted, often using shaders. It is usually used to create the desired mood and atmosphere for an area of a game.

CPU
The central processing unit sits at the heart of a modern computer or game console, performing calculations according to instructions in a program.

Demoscene
A movement of programmers and artists who created 'demos', self-contained showcases of animation and sound which pushed computers beyond their apparent limits. It emerged with the first home computers, but the scene reached heights of creative ingenuity and notoriety in Europe in the late 1980s and 1990s, especially around the Commodore 64 and Amiga.

Engine
A software environment designed to run games. Engines vary in their scope, but can generally take player inputs, run game logic, output sound and render images for display. Key examples are Unreal Engine and Unity, which also include extensive tools for game development.

Global illumination
A process that dynamically emulates the way light bounces around an environment, creating subtle shadows and brightness, and enabling coloured surfaces to reflect their colour on to others. Often used in partnership with physically based rendering.

GPU
Graphics processing units are a computer component dedicated to performing very efficiently the kind of calculations used to render graphics. While CPUs commonly only have four or eight processing cores, GPUs routinely have hundreds.

Lightmap
A set of pre-calculated data which defines the light and shadow in an environment. Generated during development, it cannot react to the way the environment changes during play, but it's much quicker to render than dynamic solutions such as global illumination.

Mesh
Meshes are the geometry which defines a 3D object. They consist of faces, edges and vertices: faces are a closed set of edges, and are often triangles. Edges connect vertices. Vertices are points where edges meet. Meshes can move and be deformed, thus animating them.

MIP maps
A technique that makes graphics rendering more efficient by storing several progressively higher-resolution versions of a texture and displaying it according to the distance from which it's being viewed. The highest-resolution MIP map is only displayed when close to the camera.

Noise function
A mathematical function that outputs patterns of random-like values often used by procedural generation to create terrain, or to mask regular-looking patterns.

Photogrammetry
A semi-automated technique for creating photo-real 3D models by taking multiple photographs of real-world objects and scenes from many angles, and measuring their shapes with laser-scanning technology such as lidar.

Physically based rendering
A graphical effect process, often abbreviated to PBR, by which surfaces are given properties that affect the ways they absorb light, allowing realistic effects such as reflections on polished floors, shiny metals, translucent leaves and subtly diffuse-looking skin.

Physics
Many games use physics systems to emulate physical forces, allowing objects to be affected by gravity and for them to shatter and break in realistic ways.

Post-process
Once an image is rendered, post-processes can modify it, applying colour grading, darkened shadows, anti-aliasing to smooth pixellated edges, glowing lights, fog, lens distortion and many other effects.

Procedural generation
A technique which uses sets of rules and mathematical processes to generate variations of content, enabling the creation of large worlds. It can create character names, scatters of vegetation, rivers, city streets, naturalistic textures, trees, mountains, solar systems, creature bodies and much more.

Ray tracing
A rendering process which traces the passage of light from sources, calculating how it's affected as it bounces from surfaces. It is computationally very expensive, and games can still only use it sparingly, often to create highly accurate reflection and refraction rather than to render an entire scene.

Rendering
The process of preparing a frame of imagery based on a 3D scene for display on a 2D screen. It comprises information about the camera from which the image is being taken, the 3D models in view, and other factors such as lighting conditions.

Shader
Usually defined as programs that run on a GPU rather than the CPU, shaders are often used in games to create post-process visual effects by running code on each pixel in a rendered image to modify its colour. But they can also transform geometry and perform many other functions.

Skybox
The visible world around the player which is not part of the active play space, including the distant horizon and sky. In early 3D games, skyboxes were a static 2D image that scrolled as the player looked around; today they usually comprise low-detail 3D models and dynamic cloud effects.

Sprite
A 2D image or bitmap commonly used by 2D games to represent active and moving parts of the image, such as the player, objects and enemies. Sprites, often called billboards, are also used by 3D games for distant objects and showers of particles.

Texture
A bitmap that's mapped on to a mesh to give it various surface effects. The simplest textures are an image that gives a model colour and visual detail, but most games use several layers of different textures to define PBR properties, creating scratched surfaces and differing levels of shininess.

PICTURE CREDITS

All images, with the exception of those in Chapter 8 which were provided by Codemasters, were captured from the following games by Duncan Harris, courtesy of:

PAGE 2
Thumper
© Drool LLC, 2017

PAGE 6
Paper Beast
© Pixel Reef, 2020

CHAPTER 1
Hardspace: Shipbreaker
© Focus Entertainment, Blackbird Interactive, 2020

CHAPTER 2
Control
© 505 Games, Remedy Entertainment, 2019

CHAPTER 3
Paper Beast
© Pixel Reef, 2020

CHAPTER 4
No Man's Sky
© Hello Games, 2016

CHAPTER 5
A Plague Tale: Innocence
© Asobo Studio and Focus Home Interactive, 2019

CHAPTER 6
Disco Elysium
© ZA/UM, 2019

CHAPTER 7
Return of the Obra Dinn
© 2018, 3909 LLC. Used with permission.

CHAPTER 8
Grid
™ Electronic Arts

CHAPTER 9
River City Girls
© 2019 ARC System Works Co, Ltd. and 2019 WayForward Technologies

CHAPTER 10
Thumper
© Drool LLC, 2017

CHAPTER 11
Half-Life: Alyx
™ Valve Corporation

CHAPTER 12
SOMA
© Frictional Games AB, 2015

PAGE 256
Half-Life: Alyx
™ Valve Corporation

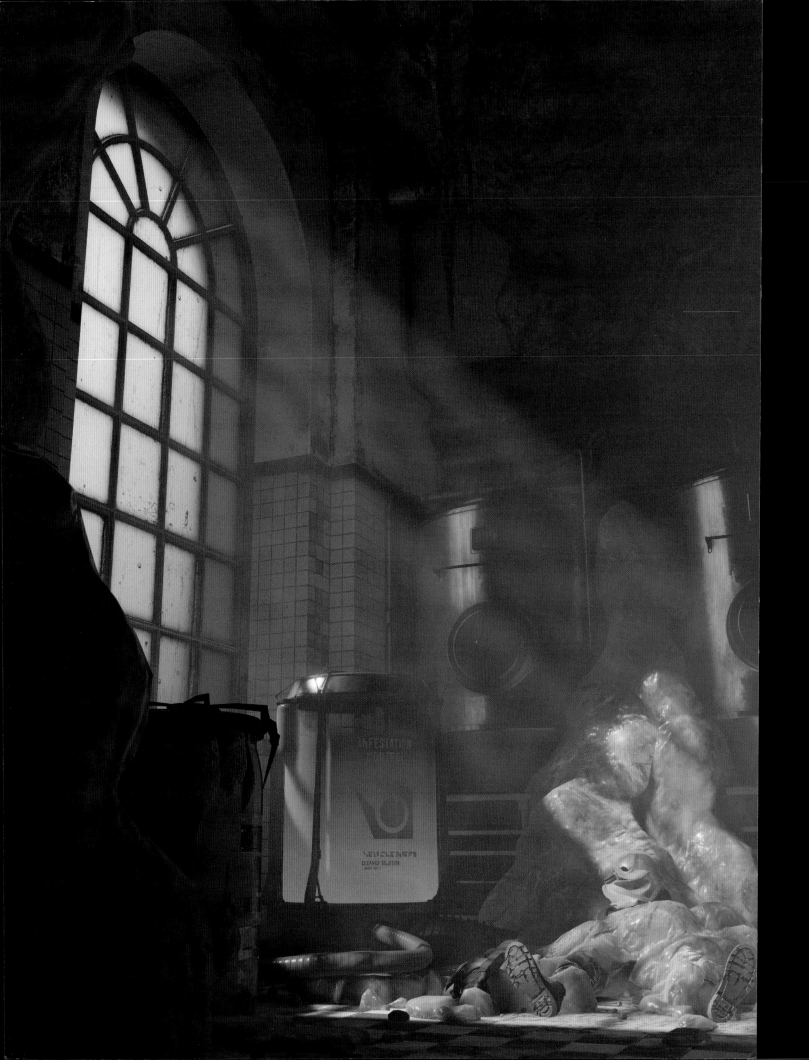